THE HOURS OF
CATHERINE OF CLEVES

INTRODUCTION AND COMMENTARIES

by John Plummer

GEORGE BRAZILLER / NEW YORK

Reproduced from the Illuminated Manuscript

Belonging to THE GUENNOL COLLECTION

and THE PIERPONT MORGAN LIBRARY

Contents

Introduction

Mᴵɴᴵᴀᴛᴜʀᴇѕ in illuminated manuscripts, though their measurements are small, are not thereby limited in their imaginative range, their intellectual content, or the skill and care of their execution. It is therefore misleading to speak of them as belonging to the "minor arts," an old-fashioned, somewhat disparaging classification that was popular at the end of the nineteenth century and is still occasionally used. The connotation of inferiority is not only inaccurate when applied to the smaller arts of the Middle Ages, but also obscures the significance of smallness in the art and thought of that time. Mediaeval taste treasured such works as gold retables, ivory crosses, enameled reliquaries, jeweled book covers, and illuminated liturgical manuscripts, upon which it expended its finest workmanship and most precious materials, and all were esteemed for their aesthetic qualities, as well as for their hallowed roles in the rites of the church. And mediaeval thought, preoccupied as it was with parallels, analogies, and symbols, found the broadest meanings in small things, as Adam of Saint Victor found Christ and the meaning of His passion in a walnut.

At no time was smallness more evidently prized as a quality in paintings, in both panels and miniatures, than at the end of the Middle Ages, especially during the first half of the fifteenth century in northern Europe. In any of the wonderously subtle and intricate panels by Jan van Eyck, perhaps the purest examples, we are struck by the sheer number and variety of things and are drawn into an ever closer examination of individual objects, of their parts, of details of the parts, of details of details; never do the elements, however small, appear composed of mere brush strokes and painted surfaces. This illusion of limitless penetration has been called an "infinitesimal calculus" by Professor Panofsky. The same pursuit of the "infinitesimal" is also to be found, and found earlier, in miniatures, perhaps

because, among other reasons, they were more restricted in size than panel paintings. Whatever the influences of either kind of painting on the other—and it is clear that they influenced each other—to Jan van Eyck and other fifteenth-century panel painters, miniature painting must have seemed an ideal art in its refinement and exactitude. Certainly some of the greatest panel painters of the century were also miniaturists, including probably Jan himself, to whom are often ascribed some of the miniatures in the famous Turin-Milan Hours.

During the first four decades of the fifteenth century, illuminated manuscripts were produced in unprecedented numbers in the North, particularly in centers distributed roughly along a large geographical arc between Paris and Utrecht and swinging through such places as Tournai, Ypres, Bruges, Ghent, and Brussels. But it was at the two ends of this arc, in Paris and Utrecht or Utrecht-Guelders (to admit for the present the commonly accepted localization in Guelders of an important group of manuscripts) that the pre-eminent miniatures of these decades were painted. For Paris the most important manuscripts and the artists of their miniatures are widely known: the *Très Riches Heures de Jean de Berry* by the Limbourg brothers, Paul, Herman, and John Malouel, who came originally from Guelders; the Hours of the Maréchal de Boucicaut by an anonymous artist called simply the "Boucicaut Master"; two manuscripts, a Book of Hours and a Breviary, made for John of Lancaster, Duke of Bedford, by a miniaturist known thus as the "Bedford Master"; the *Grandes Heures de la Famille de Rohan* by the so-called Rohan Master. Less widely known are the miniaturists of Utrecht-Guelders and their manuscripts; because, in part, their books usually lack those large elaborate miniatures that lend themselves to reproduction as separate pictures; in part, their illustrative programs were less ambitious than those in the French manuscripts; but also their development, broadly speaking, lagged behind that of Paris until the 1430s, or perhaps a little earlier. By then miniatures of a comparable richness were being made in Utrecht, particularly by two nameless artists identified as the Master of Zweder van Culemborg and the Master of Catherine of Cleves. The major work of the latter artist—and the masterpiece of Dutch miniature painting—is a manuscript made about 1440 for

8

Catherine of Cleves, Duchess of Guelders. It is this masterpiece, now divided into two volumes, one but little known and the other only recently discovered, that is reconstructed in this book and illustrated with all of its surviving miniatures.

Catherine's manuscript, like most of those mentioned above, is a Book of Hours, the most popular devotional book of the later Middle Ages, and the most common of all types of surviving illuminated manuscripts. A Book of Hours is a compendium of devotional texts that takes its name from its one essential text, the Hours of the Virgin, or more properly the Little Office of the Blessed Virgin Mary. It is called an "Hours," or *Horae* in Latin, because it is subdivided into eight parts, one for each of the "hours" of the liturgical day— Matins, Lauds, Prime, Terce, Sext, None, Vespers, and Compline. Although the Little Office was composed as early as the ninth century—we do not know where, by whom, or precisely when—it was only with the grafting of the Little Office onto the Psalter in the late twelfth century that all of the characteristic components of the Book of Hours were brought together: the liturgical calendar, the Little Office, the Penitential Psalms, the Litany, the Suffrages or Memorials to the saints, and the Office of the Dead. Later this grafted book, the Psalter-Hours, was transformed into the pure Book of Hours by dropping the full Psalter; and many supplementary texts, mostly prayers and various short offices modeled after the Little Office, were added. The surviving manuscripts differ greatly in their selections of supplementary texts, following local customs, the interests of patrons, and the practices of different scriptoria. All of the characteristic and supplementary texts in Books of Hours, except for the occasional insertion of Masses, are supererogatory materials augmenting that daily, weekly, and annual cycle of public prayer known as the Divine Office and compiled in the Breviary. Since the Divine Office itself is very complicated in structure and its observance requires the concentration of clergy, the devout layman found a substitute in the simpler, almost unvarying observances composing the Book of Hours. For this reason the Abbé Leroquais has aptly called the Book of Hours the breviary of the laity. And, even more than the Breviary, the Book of Hours lent itself to private devotions, as well as to public observances.

From the first known mention of the manuscript, by the dealer Jacques Joseph Techener in 1856, at which time he was offering it for sale at 15,000 francs, until its exhibition at the Pierpont Morgan Library in 1964, the Book of Hours of Catherine of Cleves was regarded as the single volume that passed into the collections of the Dukes of Arenberg sometime before 1896, and into the Guennol Collection in 1958. This volume, though often discussed and reproduced in the last sixty years, has been examined by only a few scholars. For this reason, the descriptions of its contents have usually been incomplete, vague, and inaccurate. It has been frequently said, for example, that it has a calendar, which has even been described as being for use in the diocese of Utrecht, but the volume has no calendar. However, since some scholars did see it, there must be other reasons why its incompleteness was never recognized. First, the volume gives the impression of completeness; it is of a normal size for a Book of Hours, and has more miniatures than is usual for such a book. Second, it has the one essential text for a *Horae*, the Little Office of the Blessed Virgin, and several of the more or less normal texts, such as the Penitential Psalms, Litanies, Office of the Dead, and the Hours of the Cross, though not all are complete; of the normal components it lacks only the calendar and the Suffrages. Third, the contents of Books of Hours, both texts and pictures, vary widely, since a book of this kind was used primarily by laymen and was not rigidly controlled by the church. And one final reason, the students of the volume were interested in the miniatures, whereas the text, which is of no historical importance, contains the only clear evidence of the volume's incompleteness.

Since the Arenberg-Guennol volume was thought to be the whole Book of Hours made for Catherine of Cleves, there was no reason, when another volume illustrated by the same artist was offered to the Morgan Library in 1963, to think that it was part of the same Book of Hours, except for the puzzling title, *Heures de Catherine de Clèves/Martyrologe*, stamped on the spine of its mid-nineteenth-century binding. Little is known about the history of the Morgan volume before it was acquired by the Library (with the generous assistance of the Library's Fellows) through a New York art dealer who had received it on consignment from a private owner in Europe.

But the title on its binding proves that its binder, Belz-Niedrée, or whoever specified the titling, knew of its connection with the Guennol volume, for the Morgan volume contains no conclusive evidence that the duchess was its original owner. Therefore, the division of the manuscript into its present two volumes probably took place in the 1850s, the approximate date of the Morgan binding and the decade in which the dealer Techener described the Guennol volume as *the* Hours of Catherine of Cleves and offered it for sale.

When the new volume arrived at the Library it was obviously not a complete Book of Hours—despite its title—since it lacked the one essential text, the Little Office. At first glance it was thought to be a book of miscellaneous offices and prayers; it only became clear some time later, after the texts of the book were identified, especially those on each of the chaotically disarranged leaves in the first part, that the Morgan book was incomplete, and that some of its texts were fragmentary. Its contents included a calendar, the Mass for the Dead, the Tuesday Hours of the Holy Ghost, part of the Wednesday Hours of All Saints, the Friday Hours of the Compassion of God (*Misericordia Dei*) and the Mass of the Cross, the Sabbath Hours and Mass of the Virgin, part of the Office of the Dead, and an uncommonly long series of Suffrages. The volume was obviously lacking the beginning of the Office of the Dead and large parts of an unusual and elaborate cycle of Hours and Masses arranged according to the days of the week, but there was no way of knowing what other texts, if any, were missing. Furthermore, since all of the manuscripts with miniatures attributed to the Master of Catherine of Cleves seemed to be intact, there was little reason to expect that the missing portions of the Morgan volume would ever be found.

At this point Mr. Alastair Bradley Martin, the owner of the Guennol volume, generously lent his book to the Library for comparison. It was immediately evident that not only were the two volumes illustrated by the same artist, but also that they were both products of the same scriptorium—the sizes of the leaves, the number of text lines per page, the script, the decoration of the text pages, all were the same. It was not then possible to prove that they were two portions of the same book, though this appeared to be a strong probability after it was discovered that the Guennol volume was also incomplete.

Over the next weeks and months the evidence accumulated. First, it was found that the texts of the volumes complemented each other in general to form a Book of Hours of rare, if not unique, complexity and rationality. Next, specific and irrefutable connections were discovered. Frequently the text from a page in one volume runs on directly, sometimes in the middle of a sentence, to a page now in the other volume. Occasionally the titles or rubrics for a text occur in one volume, but the text itself is found in the other (for example, the rubric for the Mass of the Holy Ghost is on page 71 in the Morgan volume, and the text begins on folio 109 of the Guennol volume). In at least two instances, Morgan page 178 and Guennol folio 192v, the devious mind that dismemberèd the book obliterated the rubrics to disguise the shift in the text from one volume to the other, although the erasure in the Guennol volume can still be read under a microscope. The same deviousness led the culprit—was it the dealer Techener?—to make almost all of the breaks in the middle of gatherings, so the catchwords at the end of one gathering would run on directly to the next gathering in the same volume. A different kind of evidence, crucial for restoring to their original positions some of the full-page miniatures without text on their obverse, consisted of matching spots or stains found on two once facing pages. From this evidence it is certain, for instance, that the Meeting at the Golden Gate in the Morgan volume (pl. 4) at one time faced the Birth of the Virgin in the Guennol volume (pl. 5). The final proof came when the Morgan volume was removed from its binding; the havoc of severed leaves, rearranged and pasted together, could be sorted out, and the original, highly regular, gatherings could be reconstructed. The text and gatherings of the manuscript, as it was presented to Catherine of Cleves, are reconstructed in Appendix B; the original order of the pictures has been followed here in the plates and accompanying descriptions, which also contain notes on a few miniatures presumed to be still missing.

This differs from most reconstructions, which rearrange existing materials and provide further examples of what is already known, for it incorporates the poorly known Guennol and the almost completely unknown Morgan volumes into a work whose art is truly extraordinary in its sustained originality and its consistently high

quality. Indeed, the most important result of this reconstruction is this recovery of a major illuminated manuscript. Beyond this, there are numerous historical consequences, for the "new" book alters our judgement of the artist, enlarges our knowledge of Catherine's milieu and of the potential of contemporary Dutch patronage, and revises our understanding of the development of Dutch art in the fifteenth century. The extent of these consequences will not be learned for years, but in the meantime the following observations, suggestions, and tentative conclusions will provide further information and serve as a point of departure for discussions to come.

Although the addition of the Morgan volume swells the Cleves Hours by almost one hundred miniatures, often with borders of un-exampled invention, and greatly extends thereby the recognized range and growth of the artist, it also makes clear the consistency of his decisions and of his taste. Underlying the whole program of illustration, a program which must have taken a number of years to execute, is a remarkable orderliness and rationality. The program must have been worked out from the beginning to avoid redundancy or conflict. The Adoration of the Magi (pl. 116) was omitted from the Infancy cycle illustrating the Hours of the Virgin and was re-served for the Suffrage of the Three Kings. Since the Passion cycle had been used for the Hours of the Cross, it was necessary to utilize a different series, taken from the Legend of the Cross, and even to invent new scenes to illustrate the Friday Hours of the Compassion of God and the Mass of the Cross. The same is true of the highly original illustrations for the Saturday Hours and Mass of the Virgin, most of the narrative scenes from the life of the Virgin having been employed to illustrate her Hours at the beginning of the manuscript. The same logicality is evident within the various cycles, as may be seen in the interplay of the here and hereafter in the Hours of the Dead or of the Mass and its interpretation in the Hours of the Holy Sacrament. The whole program may have been devised with the help of some scholar or cleric, but its execution reveals a mind that de-lights in systems and in organizing large numbers of things.

This rationality has its formal side. It is apparent in the control of details which never obtrude. One's first impression of the picture of Saint Christopher (pl. 133), for example, is limited to the giant figure

13

of the saint and the general landscape of rocks and water; a moment later one becomes aware of the first level of details, such as drapery, rocks, clouds, and sunset sky; but for some time one does not see, not until one uses a magnifying glass, such details as the fish jumping from the water, or the ducks, which measure about one thirty-second of an inch, floating among the reeds. Another aspect of rationality is to be found in the taste for constructed objects, particularly buildings, but also for altars, furniture, and the like. We find an interest in how stones are cut and joined together, in how vaults are made and sustained, and in how pieces of stained glass are leaded and supported on armatures. A similar sense of structure underlies the additive compositions of distinct shapes combined in clear patterns. In the Adoration of the Child (pl. 12), for example, the large triangle formed by the parents and the arc of heaven is repeated with variations in the silhouettes of the parents, the roof of the stable, the brick wall, and elsewhere. At the same time the directions of these lines determine the disposition of many things, such as the edge of the roof that is paralleled by the weathervane, a bracket, the candle of Joseph, various edges in his and the Virgin's drapery, and even in the drawing of one shepherd's legs. Similarly, the arc of the clouds above is repeated in the wings of the angel, the dormer window in the stable, the shapes of the hills behind, and the way in which the figures of the parents arch toward each other.

The same organizing impulse is revealed in the extended narrative sequences and in the anecdotal details. The desire to tell a story with maximum lucidity leads the artist to portray two successive moments in the scene of Adam Dispatching Seth to Paradise for a branch of the Tree of Mercy (pl. 79): Seth is shown twice, once receiving Adam's instructions and again, departing. Similarly, in the Deathbed Scene (pl. 41), the heartless and mercenary youth, presumably the son and heir of the dying man, stands aloof from the deathbed, and appears again in the border, where he takes money out of the man's money chest. Out of this scene the artist develops three additional stories: the suffering of the soul of the deceased in the Mouth of Hell and its final release; the care for the earthly remains of the deceased and the services for his departed spirit; and the subsequent sorrows of the widow, including her pilgrimage, which occur in later borders

(pls. 102, 107, 109). The search for elucidation appears in various other ways: in the banderoles and inscriptions to explain an action or to interpret a scene, in the minute pictures and letters in floor tiles to elaborate the iconography of a portrait, and in the border motifs to reinforce or to contrast with the meaning of a miniature.

Parallel to the craftsmanship of his own painting is the artist's appreciation of workmanship in various crafts. It is evident in the tools, utensils, stuffs, and other man-made objects that fill many of his paintings, but it is most purely presented in the later "still-life" borders of the manuscript. Products from diverse trades and crafts are included in these borders: wood sculptures, stone carvings, baked goods, fish nets, coins, bird traps and cages, bows and arrows, textiles, and jewelry. All of these objects are executed with a great care for the things themselves and the craftsmanship that produced them, but of them all the artist clearly prefers the more luxurious, particularly the jewelry. The finesse of execution and the enrichment of surfaces shown in the rosary, pins, and necklaces are strikingly like the qualities in the miniatures, as the luster of the silver, gold, and precious stones is like the luminous translucency of the artist's forms, which seem to glow from within. In fact, he often employs silver and gold in the miniatures, where they never seem foreign substances. He has, indeed, the taste and the instinct for workmanship of a jeweler.

This delight in luxury seems to contrast with, if not to contradict, a more plebeian concern with the familiar scenes and everyday objects also to be found in the second half of the manuscript, especially in the two miniatures of the Holy Family (pls. 92, 93), in the marginal scenes of wine drinking and baking (pls. 110, 111), and in the borders of mussels, fish, and butterflies (pls. 119, 128, 129). Although the domestic interiors of the Holy Family miniatures are certainly homely, they appear to be the moderately prosperous rooms of a tradesman class. These miniatures are quite different from the genre scenes in the margins of peasants or laborers, in which the figures are slightly grotesque, with dumpy proportions and sometimes with porcine faces; they and the beggars are rather like the unfeeling caricatures of Pieter Bruegel. Such things as mussels, fish, and butterflies may have been everyday objects, but they are coupled

with and counterbalanced by exotic objects like the intarsia panels of plate 96. Furthermore, these everyday things are transformed into objects of luxury by the way in which they are painted, a fact that is evident in the gold flesh of the mussels or in the stress on iridescence, a quality which all three have in common. Indeed, it is this transmutation of the ordinary into the precious that is characteristic of the artist, and links him with that later Dutch "alchemist," Jan Vermeer.

Although these traits may be typical of the manuscript as a whole, they are more purely embodied in the later than in the earlier miniatures. The artist shows a very marked development in his style and artistic ideas, moving rapidly toward a greater individuality and originality. One measure of this originality is the creation of the *trompe-l'oeil* and still-life borders, which are so novel and so precocious. However, important as these historic innovations are, of still greater importance is the insight gained from watching the creation take place before our eyes, with its alternation of plunging confidence and hesitant withdrawal to tradition.

The development in style can be seen in many details. In an early landscape, such as that in the Meeting at the Golden Gate (pl. 4), the ground plane is broken up into a series of sharply tilted and overlapping hills that climb toward a horizon high above the heads of the foreground figures. The scale of objects, such as trees, does not diminish regularly toward the horizon, and the most distant things are far too large and too clearly seen. The landscape formula of successive layers of hills ending at the horizon in one or more domical hills is a convention that goes back at least to the Boucicaut Master and to the first years of the fifteenth century. The artist rejected this convention soon—by the time he had completed the Hours of the Virgin—and replaced it with a landscape having a much deeper space, a continuous terrain, a more convincing gradation of scales, a gradient of clarity from the foreground to the background, and a much greater variety of landscape elements distributed through this greater depth (pl. 16, for example). Nevertheless, this development cannot be interpreted as a simple growth of realism or an increasing interest in the distance, for after the Hours of the Cross there are relatively few deep landscapes, and the usual outdoor scene has a very shallow foreground landscape with an extremely low horizon

line. Despite some striking exceptions, one can distinguish several stages in the artist's changing attitudes toward landscape: a first in which his interest in the distance is limited by a landscape formula; a second in which his interest is matched by a much greater skill in depicting depth; and a third in which the skill is still greater, but the interest is for the most part lacking. It is with the concentration on the foreground in this last stage that he developed the minutely detailed domestic interiors and the life-size still-life borders.

Corresponding to these changes in the landscapes are changes in the representation of the human figure. Perhaps the most obvious change is in the dramatis personae; there is a decided increase of human types through a growing discrimination of ages and social classes. In the earlier figures the limbs are differentiated by rather abrupt changes of direction, giving the body a somewhat wooden look, but in the later ones the artist is much more concerned with the ways in which the functional parts are joined together, a concern that gives the body a greater continuity and articulation. The figures are analogous to the paths in the backgrounds of their miniatures: the early paths are broken off at the edge of one hill only to begin again on a hill behind, whereas the later paths wind through the landscapes without breaks. The same correspondence appears in the draperies, whose patterns evolve from angular and broken lines to more flowing and continuous ones. Despite this general movement toward a more integrated and precisely rendered human figure, there is also a countermovement toward a greater idealization, which is quite evident from the Friday Hours of the Compassion of God onward. The bearing of the figures becomes more graceful and courtly. The modeling of the flesh is softened and diffused; the forms are rounder and fuller; the hair and complexion are usually golden or very blond. The figures increasingly resemble the precious objects of the later borders.

Thus far we have assumed that all the miniatures were painted by one artist, but considering the marked changes between the beginning and end of the book, we must examine the possibility of another artist. To establish the work of another hand, it is necessary not only to discover a substantial stylistic difference between any two parts of the book, but also to find one or more breaks at which the style

17

changes. Some people may feel, as they turn the pages of reproductions arranged here in the original sequence, that some miniatures seem unexpectedly different in details or general effect. Thus, in the Death of the Virgin (pl. 14), one is surprised by the shallow chamber, the crowded apostles, the disembodied frontal heads of some, the strange proportioning of figures, and the intense red of the canopy and bedspread; but those elements revealing the "habits" of the artist, such as the facial types, the drawing of ears, and the painting of flesh tones, are to be found in other miniatures. Or, in the Creation of Eve (pl. 88) and a few of the following miniatures, one is struck by the general lightening of color tones and by the simplifying of landscape forms; but again, many habitual details can be matched with those in other paintings in the manuscript. Do these or other deviations from the "normal" style of the miniatures require us to postulate another artist? Opinions may differ, but another hand does not seem necessary or warranted. The deviations can, instead, be explained by the growth of a single artist working over the several years required to execute such an elaborate project, by the expressive range of his art, and by the possible influence of different models upon his work. There are no basic or obvious breaks in the stylistic continuity of the miniatures, nor do they subdivide into two or more clear and coherent styles. Indeed, the deviations within the manuscript are far smaller than the differences between any of these miniatures and those in other manuscripts generally attributed to our master.

Nothing is known of the Master of Catherine of Cleves other than what can be inferred from this Book of Hours and from other works that can be assigned to him. The artist was originally known from the Guennol volume alone. Now the addition of the Morgan volume and the reconstruction of the original *Horae* have greatly increased the number and variety of paintings that must be his by definition, have prolonged the period of time during which we know his style with certainty, and have fixed beyond doubt the main directions and stages in the development of his art. Thus the requirements for attributing other works to this artist have become more exacting, for any attribution must be able to be interpolated into this development or extrapolated at either end as early or late works. It is impossible

in this brief introduction to discuss at any length these involved and complex questions, but some discussion is inevitable when considering what we know about the date of this Book of Hours and the conditions under which it was made.

Various dates have been proposed for the manuscript: 1428, 1430, about 1435, circa 1440, and 1443 to 1445 are the most germane. Each date is so supported by complex arguments, employing specialized evidence and subtle judgements, that they cannot all be adequately treated here. However, since it is desirable to fix the date of these miniatures and thus their relative position in the rapid development of painting at this time, it becomes necessary to consider the three precise dates—1428, 1430, 1443 to 1445—which associate the manuscript with events and persons in the life of Catherine of Cleves.

Of these precise dates, the first to be advanced was 1430. It was proposed by Dr. Friedrich Gorissen in 1958 for the Guennol volume alone, the Morgan part being then unknown, and was based upon the heraldic shields appearing in the margins of the first two miniatures. After identifying the eight smaller shields as those belonging to the great-great-grandfathers of Catherine—their names are given in the commentaries to plates 1 and 2—Gorissen turned to the ninth and larger shield, Catherine's own. It is divided *per pale* with the arms of her husband, Arnold of Guelders, and with the arms of her father, Adolph of Cleves, indicating thus a date for the manuscript after her marriage; but its crest is that of Cleves rather than that of Guelders, which would be customary after marriage. To solve this seeming contradiction between the husband's arms and the father's crest, Gorissen ingeniously proposed that the arms and therefore the manuscript must have been made between Catherine's marriage on January 26, 1430, and the date when Catherine actually left Cleves to join her husband in Guelders, February 4, 1431. After receiving photographs of the miniatures in the Morgan volume and the Library's preliminary publication reconstructing the original manuscript, Gorissen altered his argument slightly to account for the new evidence, especially for the new portrait of Catherine (pl. 96). He took this to be a portrait of her before marriage, because of her transparent gauze veil ("ein feiner, hauchzarter Schleier"), a type of veil which, he believed, was restricted to young maidens.

Therefore, he concluded that the manuscript was made earlier than 1430, probably in 1428, and that her arms and portrait with the opaque veil of a married woman (pl. 1) were added in 1430, after her marriage.

Impressive as Dr. Gorissen's arguments are, there are reasons for rejecting them. Although he is right to say that married ladies generally used the crests of their husbands, there are exceptions; two such exceptions adduced by Dr. Ottfried Neubecker, one earlier and one later, are cited by Dr. Paul Pieper. Thus, the arms of Catherine may also be an exception; if so, the manuscript would have to date from after 1430. But more inescapable evidence for a later date has been found by Dr. Peter Berghaus, also cited by Pieper, who has identified three coins in the upper border of plate 117 as ones minted between 1431 and 1455 for Rudolph von Diepholz, Bishop of Utrecht, and two coins in the side borders as minted between 1434 and 1447 for Philip the Good, Duke of Burgundy. There is no doubt, unless this evidence is wrong, or the coins were added later, that the manuscript, or at least the border with these coins, must have been made after 1434.

Nevertheless, Dr. Pieper has accepted the argument of Dr. Gorissen that the lady portrayed in plate 96 is unmarried; but, believing the manuscript to have been made in the early 1440s, he rejects Catherine of Cleves as the person depicted and proposes instead one of Catherine's daughters, probably Mary, the oldest, who was born in 1433, and who would have been about eleven years old between 1443 and 1445, when he thinks the miniature was painted. Leaving aside the improbability of a daughter, one of several, appearing so prominently in her mother's manuscript and also the question of whether the woman portrayed could be a girl of ten or twelve, the assertion that only a maiden could have worn such a transparent veil is doubtful. The thin gauze veils, usually over an opaque headdress, were commonly worn by married women at that time. Such transparent veils, both wired and unwired, appear frequently on married women in contemporary Flemish paintings: two women at the baptism in Roger van der Weyden's Altarpiece of the Seven Sacraments in Antwerp; the portrait by the same artist of *Isabella of Portugal as the Persian Sibyl,* formerly in the John D. Rockefeller,

Jr., collection; the *Portrait of a Young Lady,* also by Roger, in the National Gallery, Washington. It may be objected that these married women wear their transparent veils over opaque headdresses, but then so does the lady in the Cleves Hours, whose hair is concealed by templers and a thick gold cloth, covering the top and back of her head. There is thus no reason to search for an unmarried daughter or to date the manuscript before 1430; the lady is, in all probability, the married Catherine, and the manuscript was almost certainly made after 1434. It is likely, then, that a date of about 1440 cannot be wide of the mark by more than five years.

Some support for this date can be found in a Prayer Book now in The Hague (Meermanno-Westreenianum Museum, 10.E.1) that has twelve miniatures accepted by most students as the work of the Cleves Master. Several do resemble in a general way the miniatures in Catherine's *Horae,* and indeed the painting of Saint Michael is almost identical in individual forms and in composition to the miniature reproduced on plate 101; yet the loose manner of painting, the indistinctness of form, the neglect of details, and the awkwardness of articulation occur nowhere in the Cleves Hours. One might take the Prayer Book for an early pastiche by the master, even though such an opinion would contradict the meticulous craftsmanship that characterizes the Cleves Hours from beginning to end, except for the fact that some features are too advanced to be found in his early works. An example of this is the atmospheric, almost Chinese, representation of distant hills floating in the sky of the Saint Michael picture, an effect somewhat exaggerated by its damaged state; this manner of representation is not found in the Cleves *Horae* until after the Hours of the Virgin. Given this evidence, the miniatures in the Prayer Book must be products of the master's workshop or the work of a follower. That one of these is the case is further indicated by the technique of transferring a design from a model to the vellum leaf by means of pricking and then drawing between these points, a technique that can be most clearly seen in the Prayer Book's Last Judgement miniature, but was used in most, if not all, of the others. These miniatures are crucial for the date of Catherine's manuscript, since the Prayer Book is firmly dated 1438. They show, if they were done by a follower or co-worker, that the master's art existed

in 1438 and suggest that he may have already begun his major work, the Hours of Catherine of Cleves, by this date.

Two other manuscripts, which can be dated more or less precisely, bear less certainly on the date of our manuscript: a Dutch Bible in the Bayerische Staatsbibliothek, Munich (Germ. 1102), and the Hours of Kaetzaert de Zaers in the Bibliotheek der Rijksuniversiteit, Leyden (B.P.L. 224). According to an inscription in the Bible, it was made in 1439; it is illustrated by 116 pictures of which seven have been attributed to the Cleves Master by several scholars. These seven excellent wash drawings, whoever their artist, are comparable to the earlier, but not the later, miniatures in the Cleves Hours. Thus, like the Prayer Book in The Hague, the Munich Bible implies a date at the end of the 1430s for the beginning of our manuscript. Somewhat conflicting conclusions may be drawn from the other manuscript, the Hours of Kaetzaert de Zaers, whose calendar reveals that it was written after July 9, 1439, and before April 4, 1452. However, the eight full-page miniatures, universally accepted as works of the Cleves Master, are on separate leaves that might have been made and added later, or that might have been made before and adapted to the manuscript. The latter possibility seemed more likely when the arrangement of its leaves was examined several years ago. However this may be, the miniatures were perhaps done at a different date from the manuscript; thus this manuscript does not help us with dating our Book of Hours. At best, the uncertain evidence of these two books tends to support a date in the late 1430s or, better, about 1440 for the Hours of Catherine of Cleves.

Although all of the Cleves miniatures and probably their borders appear to be the work of one master, three different hands worked on the rather simple decoration that occurs on nearly all text pages. For the most part, these decorations consist of a vertical gold bar at the left of the text, which extends to the upper and lower margins and from each end of which a leaf grows horizontally across the top and bottom of the page. In two different sections (for example, Guennol ff. 91v–106v and Morgan pp. 102-112; see pls. 158, 160) human figures or animals or little scenes are added to the leaves by two distinct hands, one of which is very close to the master himself. It is possible that these hands can be connected with miniatures in

other manuscripts, and thus we may eventually be able to identify the Cleves Master's assistants in this project. We already know that he worked with other artists on at least two other manuscripts, the two vernacular Dutch Bibles in the British Museum (Add. 15410 and Add. 38122). A careful study of these associated artists and of the decorators and scribes involved should yield an accurate and fairly detailed picture of the circumstances under which the Cleves Master developed and practiced his art. In all probability he worked in Utrecht, and perhaps some further information may be drawn from the calendar of Catherine's *Horae*, now in the Morgan volume and here transcribed in Appendix C. It was composed for use in the diocese of Utrecht, although it differs in a number of entries from other available Utrecht calendars.

As a consequence of the new knowledge provided by the Morgan volume and the reconstruction of the whole manuscript, it will be necessary to reconsider all of the proposals that have been made about the sources of the Cleves Master's art and its influence. It has been said, for example, that the master was a pupil of the Dutch artist known as the Master of Zweder van Culemborg, in part because the Cleves Master has been thought to have contributed some miniatures at the end of one of the Zweder Master's major works, the Egmond Breviary in the Morgan Library (M. 87). If, however, one places the two books side by side, the differences are more striking than the similarities, and furthermore the earliest miniatures in the Cleves Hours are less like the Zweder Master's work than are some of the later ones. Thus, it seems impossible that he was the teacher of the Cleves Master.

The sources of some of the master's compositions, as has been pointed out by several writers, are to be found in Flemish panel painting. The example most often mentioned is the Descent from the Cross (pl. 28) which follows in general a composition by the Master of Flémalle preserved through a copy belonging to the Walker Art Gallery in Liverpool, though differing in many details. Nevertheless, the total number of such "quotations" is relatively small; many compositions are drawn from other sources, mostly manuscript sources; and the number of seemingly original compositions is very large. Among the other sources from outside the Netherlands are the works

of the Boucicaut Master and particularly the Master of the *Grandes Heures de la Famille de Rohan*. To the latter has been attributed a drawing in the Herzog Anton Ulrich Museum, Braunschweig, which has identical figures and the same general composition as the Pool of Bethesda (pl. 86). Occasionally single figures, such as the Saul in plate 131 or the seated beggar in plate 135, look like the very distinctive types of the Rohan Master. These are some of the paintings and painters drawn on by the Cleves Master; others will surely be recognized by scholars when the reproductions in this book become available.

Whatever we may learn in the future about the sources used by our artist, it is already clear that his interests were cosmopolitan, that he drew on a wide range of materials, as every intelligent artist of every age does, and that he transformed these borrowings to conform to his own taste and ideas, as any great artist must. While receptive to the advances being made by his illustrious contemporaries, he contributed his own innovations to the development of painting, by inventing new images, such as his Mouth of Hell (pl. 99), and new conceptions in his *trompe-l'oeil* and still-life borders. Many of his innovations were taken up, varied and elaborated by later artists. Thus the Master of Catherine of Cleves played a substantial role in the history of art, while enriching our artistic substance with this matchless manuscript from which he takes his name.

THE PLATES

with Commentaries

1. *Catherine of Cleves Kneeling before the Virgin and Child.*

The crowned Virgin stands on an inverted silver crescent moon, holding her Child and an ink bottle into which He dips His pen. Across His lap lies an illegible scroll, and an empty scroll case hangs over the arm of the Virgin. Both figures, encompassed by a gold mandorla, are placed within a shallow chapel, possibly Catherine's own, surmounted by flying buttresses, crenelations, two turrets with music-making angels and, in the central niche, a statue in a gesture of benediction, holding a gold object (a church?) in its other arm. The statue may represent Saint Nicholas who was patron saint of the castle chapel at Cleves. Beneath the statue hangs an heraldic shield *à bouche*, Barry of eight argent and sable. Catherine kneels at the Virgin's right with an open book and a banderole inscribed *O mater dei memento mei*. In the border are the arms of Catherine as Duchess of Guelders and those of four of her ancestors. These forebears have been identified by F. Gorissen as four of Catherine's great-great-grandfathers (Count Diderik of Cleves, Count Engelbert of Mark, Duke Ludwig of Bavaria, and Duke Ludwig of Liegnitz); by P. Pieper and D. H. Horstmann as four of her great-grandparents. The arms of other forebears occur on the facing page of the manuscript and are reproduced in the next plate. [G–f.1v]

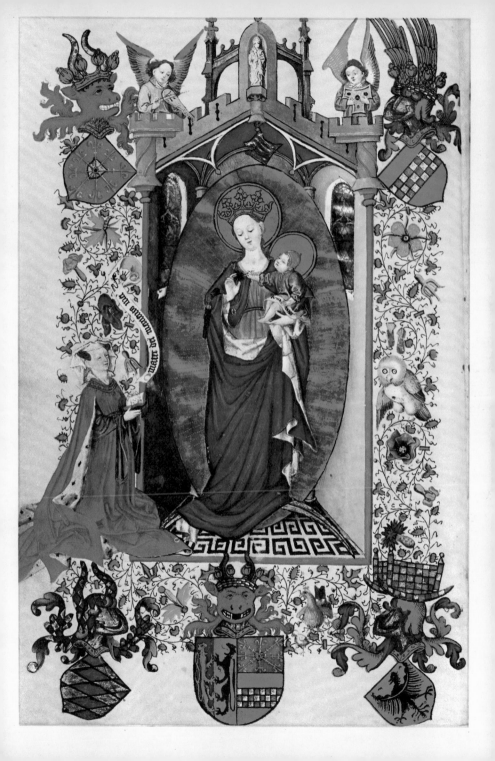

2. *Annunciation to Joachim.*

His hands in prayer, Joachim kneels before a small flying angel holding a blank scroll. In the field behind him and in the warren to the right the many rabbits are symbolic of the fecundity heretofore denied the old man. The border contains, among other things, a "wild man" stalking a hare, a stag, and the arms of four more of Catherine's forebears, completing those on the preceding page. They have been identified by F. Gorissen as her great-great-grandfathers (Jean le Bon, King of France, Count Lodewijk of Flanders, Duke Wilhelm of Jülich, and Duke Otto of Ravensberg); by P. Pieper and D. H. Horstmann as four of her great-grandparents. [G–f.2]

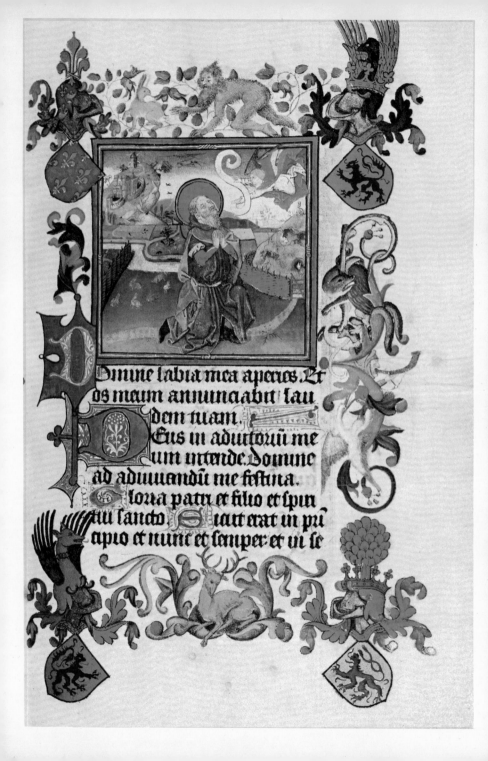

Dmine labia mea aperies. Et
os meum annunciabit lau
dem tuam.
Eus in adiutorium me
um intende. Domine
ad adiuuandum me festina.
loria patri et filio et spiri
tui sancto. Sicut erat in pri
apio et nunc et semper: et in se

3. *Singing Angels.*

Upon a tessellated floor, the three singing angels sit or kneel before a background decorated with gold vine patterns. This abstract setting is used elsewhere in the manuscript as a depiction of heaven. Across their laps is a banderole with the opening words of the hymn: *Te deum laudamus.* Originally their song was probably directed toward a facing full-page miniature, now missing, of the Annunciation to Saint Anne. Another reference to the same miniature may be seen in the unusual border composed of golden peas in open pods—symbols of fertility. The illusion that these are real peas and pods is heightened by the way in which the vines appear to pierce the vellum of the page. [G–f.11]

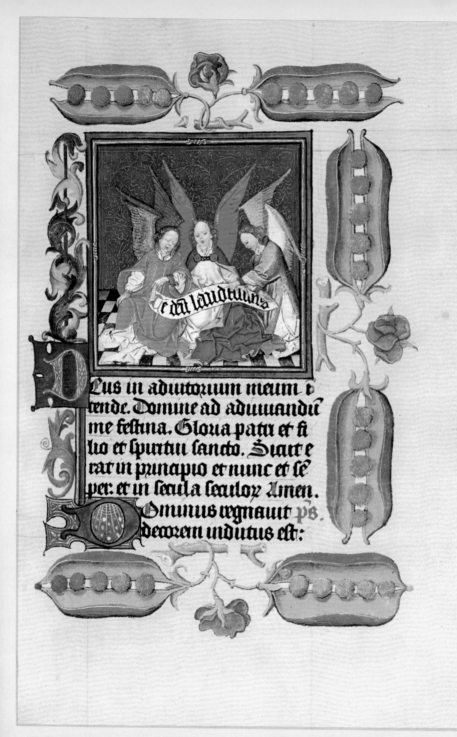

e dei laudabilis

Dus in adiutorium meum o
tende. Domine ad adiuuandū
me festina. Gloria patri et fi
lio et spiritui sancto. Sicut e
rat in principio et nunc et sem
per: et in secula seculoꝛ Amen.
Ominus regnauit ps
decorem indutus est:

4. *Meeting at the Golden Gate.*

Although now bound into the Morgan volume, this miniature clearly belongs stylistically among the earliest paintings of the manuscript. This subject should follow the Annunciation to Saint Anne and precede the Birth of the Virgin. That it originally faced the page of the Birth of the Virgin is proved by a number of small brown stains along the inner margins of both these pages which match perfectly. Joachim and Anne embrace with restraint before the Golden Gate of Jerusalem depicted as a small gold door, partly open, in the reddish walls of the city. Above the gate are two turrets topped by fanciful vase-like forms. [M–p.144]

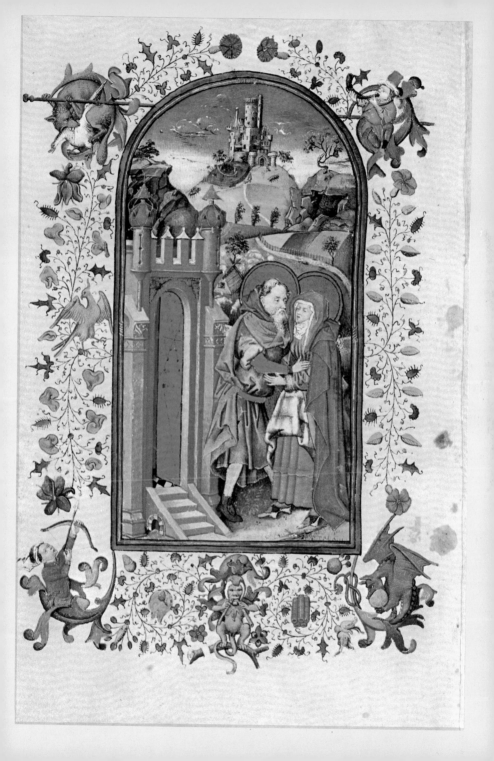

5. *Birth of the Virgin.*

In a red-covered bed, Saint Anne sits up to receive her swaddled infant from the midwife. The canopy of the bed is also red, with the exception of the center, which is blue with gold stars—the same "cosmological" canopy appears again in the Death of the Virgin (no. 14). On the floor at the left a cat washes and warms itself before a fire. A convex mirror hangs upon the far wall where a window opens upon a distant landscape. The two beehives in the lower border refer to the Immaculate Conception, since bees were thought to procreate without intercourse. [G–f.20]

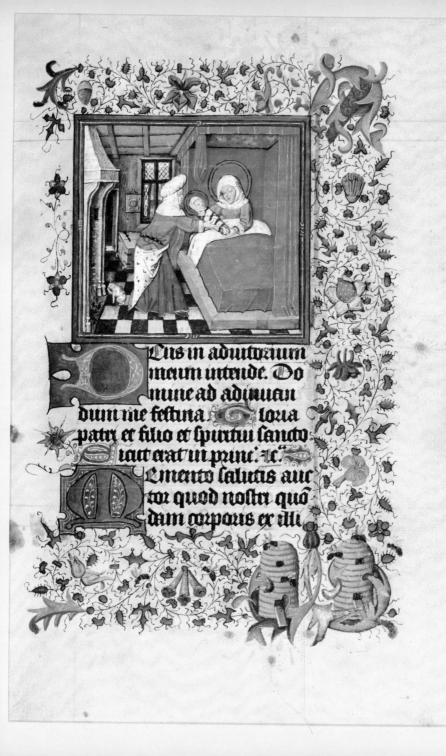

Dns in adiutozium
meum intende. Do
mine ad adiuuan
dum me festina. Gloria
patri et filio et spiritu sancto
sicut erat in princi. xc.

Memento salutis auc
tor quod nostri quon
dam corporis ex illi

6. *Presentation of the Virgin in the Temple.*

Lifting her skirt and grasping the stair rail, the young Virgin climbs unaccompanied the fifteen steps to the Temple where the priest Zacharias, seated, turns toward her with a gesture of surprise. Before him on the floor sit two small maidens weaving and spinning. The Virgin's parents stand in the Temple courtyard beside the stairs: Anne, her arms folded, watches her daughter, while Joachim fingers a string of amber-colored beads and looks somewhat anxiously into the Temple where his daughter will be reared. [G–f.23v]

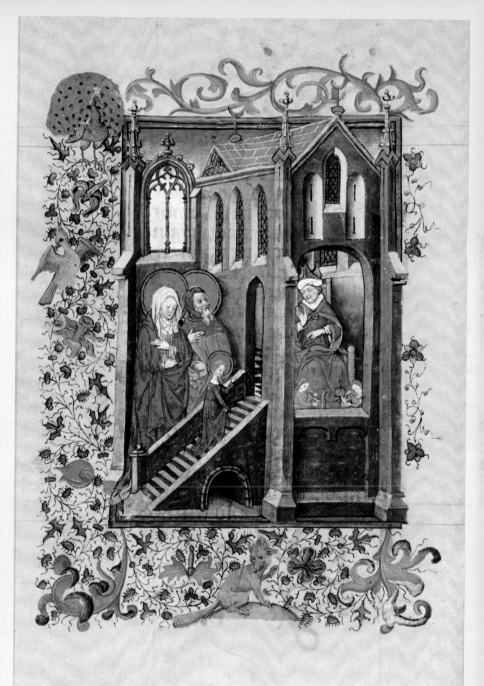

7. *Designation of Joseph.*

The seven suitors for the hand of the Virgin stand before the high priest at the altar, but the selection of Joseph has already taken place—the dove of the Holy Ghost hovers over his head while another suitor, holding Joseph's branched staff, points to him. Turned away from the altar and slumping forward, Joseph is supported by a fellow suitor. Another suitor has turned his back on the scene—apparently in disappointment. [G–f.24]

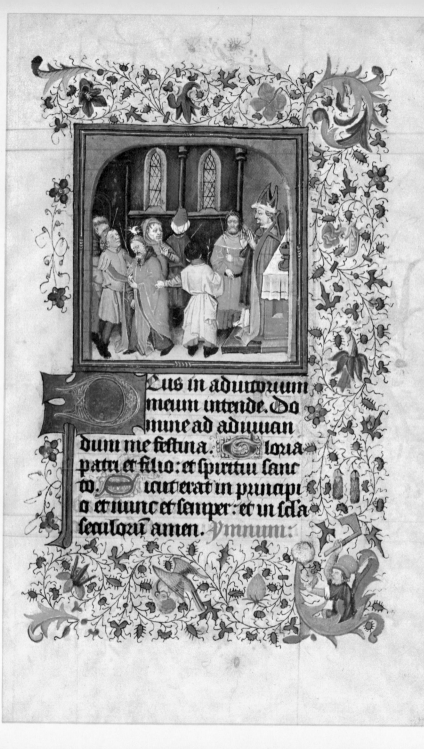

Eus in adiutorium
meum intende. Do
mine ad adiuuan
dum me festina. Gloria
patri et filio: et spiritui sanc
to. Sicut erat in principi
o et nunc et semper: et in secla
seculorum amen. Ymnum:

8. *Marriage of the Virgin.*

Facing front, Joseph stands in the center of the Temple, flanked by the high priest on the left and by the Virgin on the right. The priest blesses the marriage by placing his hand over the joined hands of the bride and groom. Among the attendants is a man with a dour greenish face who peers sullenly over the shoulder of Joseph at the joined hands. The scene takes place in a brick- and rib-vaulted temple. On the outside, two fanciful flying buttresses reach above the curve of the vault to a rectangular "cupola." [G–f.27v]

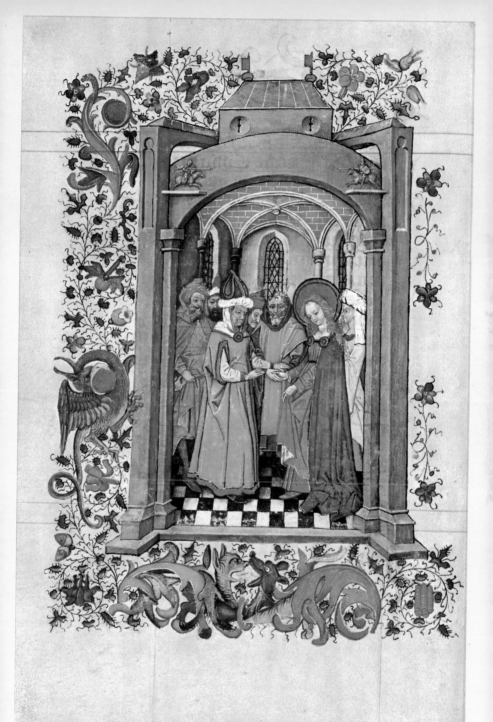

9. *God Dispatching the Angel of the Annunciation.*

Two angels stand before God, who wears a high conical hat and holds a golden orb on His lap. From His right hand unfurls a banderole with Isaiah's prophecy of the coming of the Saviour as quoted by Christ at His entry into Jerusalem: *Dicite filiae syon Ecce rex tuus venit* . . . (Tell ye the daughter of Sion, Behold, thy King cometh . . .). God gazes toward Gabriel, the angel on His right, who appears in the following scene of the Annunciation. [G–f.28]

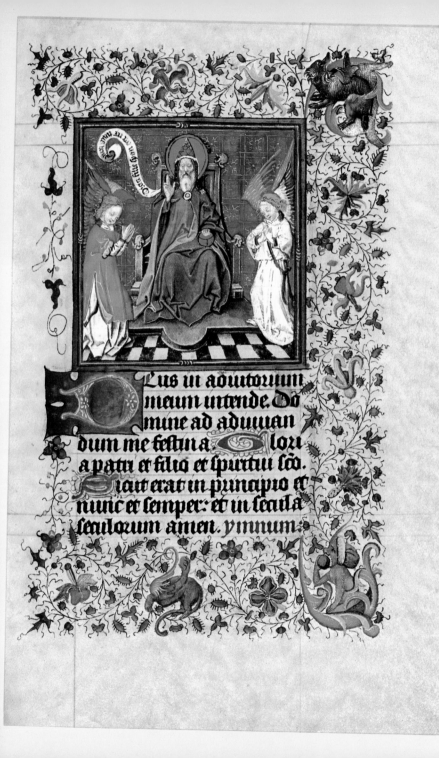

ꝑus in adiutorium
meum intende. Dō
mine ad adiuuan
dum me festina ✤ Glori
a patri et filio et spuritu sc̄o.
Sicut erat in principio et
nunc et semper: et in secula
seculorum amen. ymnum.

10. *Annunciation to the Virgin.*

Seated demurely, an open book upon her lap, the Virgin faces Gabriel, who kneels before her holding a staff and a scroll with the angelic salutation. At her side is a lectern and bookcase with a metal basin, which is symbolic of the Virgin's purity, as is the vase of lilies in the foreground. The scene takes place in a tall vaulted building, possibly the Temple, since the roof is topped by two golden crescents of the type often, but not exclusively, used in representations of the Temple. Inappropriate for the Temple, however, are the two Saint George shields—argent, a cross-couped gules—hanging from the tracery frame. [G–f.31v]

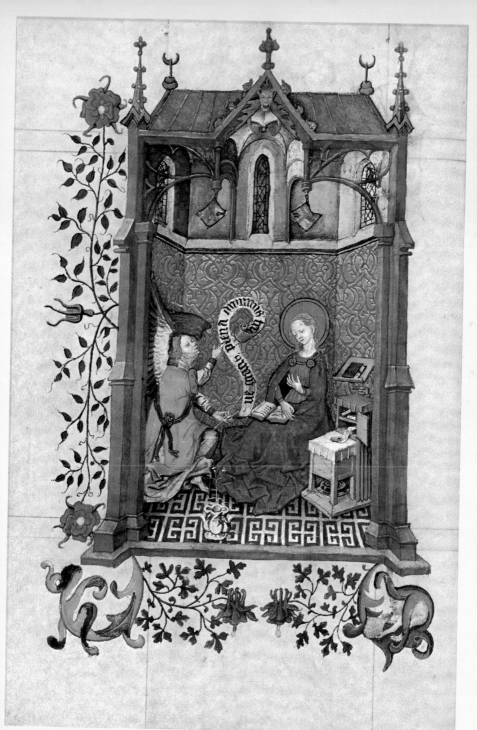

11. *Visitation.*

The meeting of the Virgin and Elizabeth takes place before the latter's house, a red stone building. Instead of embracing or examining the signs of each other's pregnancy, they clasp hands restrainedly as they do in some other Utrecht manuscripts. In the lower border are two naked infants: John the Baptist is trapping birds with nets, decoys, and bird cages, while Christ, blessing and holding a gold object in His hand, sits between two nets. This scene seems to refer to the Incarnation or to Christ as bait for the trapping of souls and thus as the lure for man's salvation. [G–f.32]

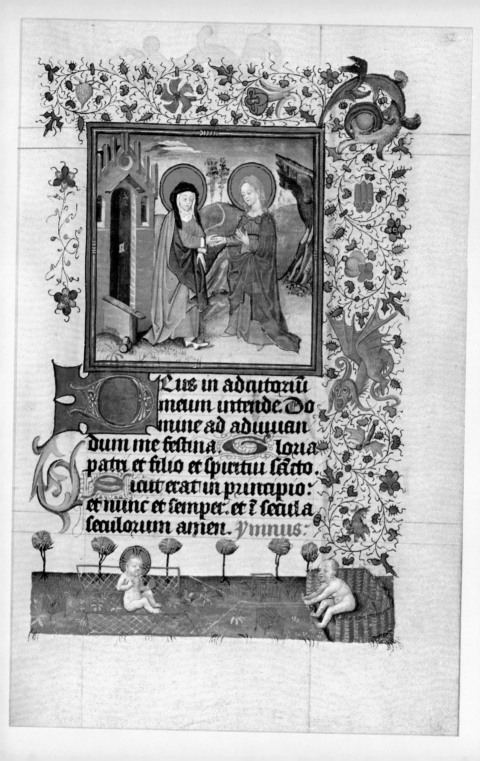

Eus in adiutoriū
meum intende. Do
mine ad adiuuan
dum me festina. Gloria
patri et filio et spiritui sancto.
Sicut erat in principio:
et nunc et semper. et in secula
seculorum amen. Ymnus:

12. *Adoration of the Child.*

Outside the stable kneel the parents of the Infant, who lies naked on a white cloth between them. Joseph holds a burning candle. The stone and timber stable is well thatched and in quite good repair. In the middle distance an angel in the luminous yellow sky announces the Nativity to two shepherds; and in the reddish haze of the far distance the buildings of Bethlehem are seen. [G–f.35v]

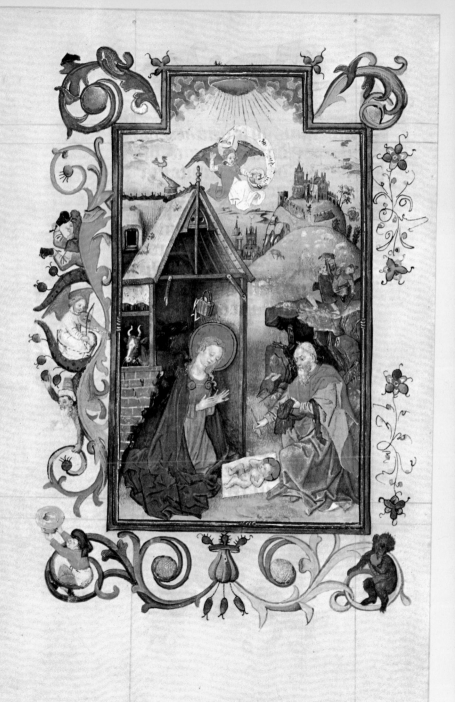

13. *Flight into Egypt.*

Leaving behind an idyllic landscape of fertile fields, grazing sheep, and a distant village, the Holy Family enters a rocky gorge symbolizing the dangers of their journey. Absent are their pursuers as well as the angel or young man who sometimes helps the family in their escape. None of the miracles often associated with the Flight is shown. The Virgin holds close her swaddled Child, while Joseph looks back anxiously, as he leads the way. In the lower border is a woman churning, but the reason for her presence is not clear. [G–f.36]

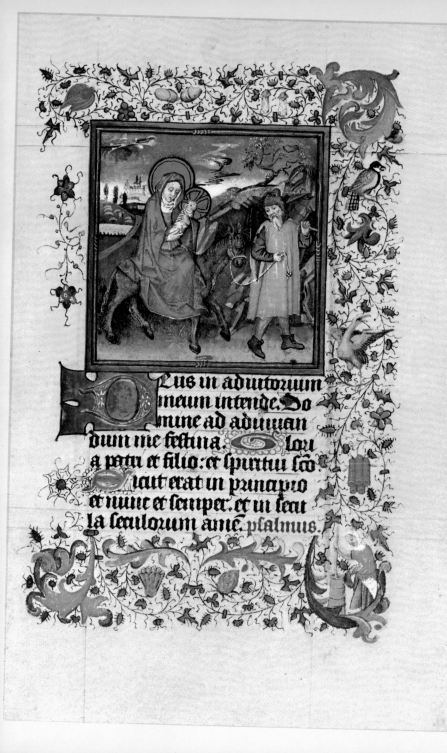

Eus in adiutorium
meum intende. Do
mine ad adiuuan
dum me festina. Glo
ria patri et filio: et spiritui sco.
sicut erat in principio
et nunc et semper. et in secu
la seculorum amen. psalmus.

14. *Death of the Virgin.*

The twelve Apostles crowd around the red-draped bed of the dying Virgin. She holds a burning candle together with Saint Peter, who has an aspergillum in his other hand. Saint Paul reads from an open book, and another apostle holds a censer. On the blue ceiling of the canopy are gold stars creating a "cosmological" bed like the one in which the Virgin was brought into the world (no. 5) and anticipating her Assumption depicted on the facing page. This miniature has been removed from its proper place and bound into the Morgan volume, but matching stains along the inner margins of this and the following page prove that this miniature originally belonged here.

[M–p.156]

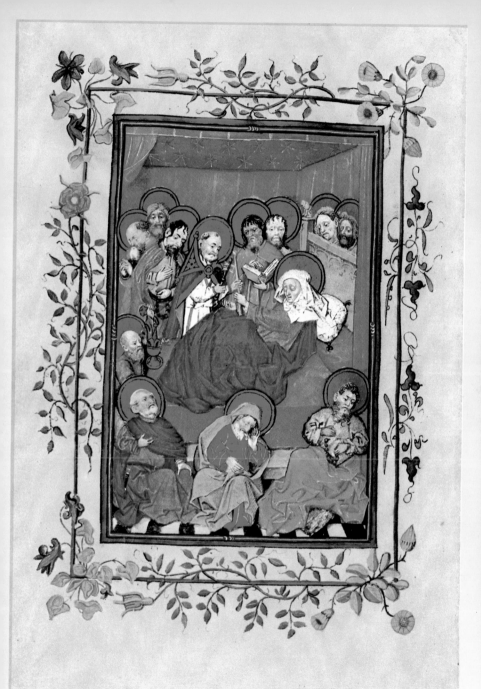

15. *Assumption of the Virgin.*

At the center the frontal Virgin, within a yellow mandorla and standing on a silver crescent moon, hovers between heaven and earth. Thus, this last illustration to the Hours of the Virgin echoes the first, and thereby creates an element of symmetry within the cycle of illustrations. The Virgin is crowned, and her hands are in an attitude of prayer. In the small arc of heaven above are God the Father, blessing and holding a globe, flanked by orange cherubim. [G–f.42]

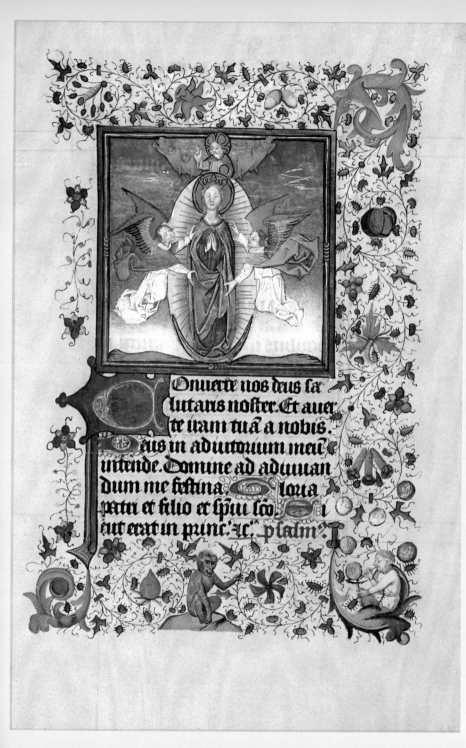

Onuerte nos deus sa
lutaris noster. Et auer
te iram tuā a nobis.
eus in adiutorium meū
itende. Domine ad adiuuan
dum me festina. Gloria
patri et filio et spū sčo
sicut erat in princ. &c. psalm.

16. *Agony in the Garden.*

Christ kneels in prayer before a natural altar, formed by a hillock with chalice and wafer. He looks up to the arc of heaven from which God the Father leans out, blessing and offering the cross to His Son. Three apostles sit or recline in the foreground, but only Peter seems to sleep. This scene is enclosed by a woven fence whose roofed gate stands open. Neither Jerusalem nor approaching soldiers are to be seen in the deep and detailed landscape background. Among the border figures is a pelican feeding her young with the blood from her breast— a common symbol of Christ's sacrifice. [M–p.120]

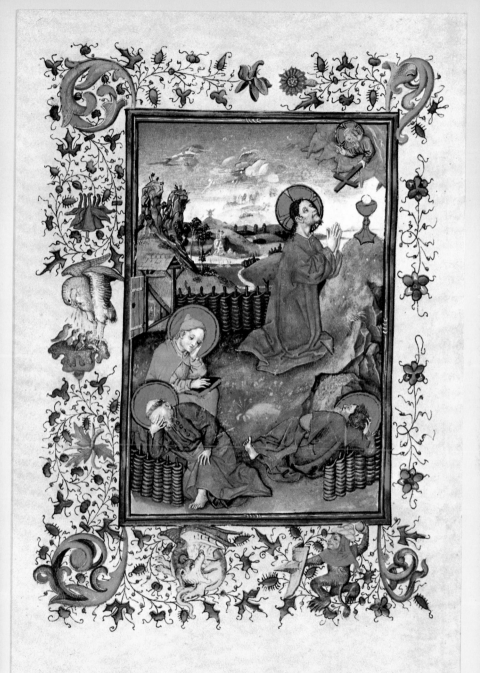

17. *Taking of Christ.*

With his hands on the head and neck of Christ, Judas does not fully embrace Him, nor does he kiss Him. Christ reaches down blindly to restore the ear of the bleeding soldier, above whom Peter still holds his raised sword. A row of soldiers blocks out the landscape; one sees only the yellow sky. Among the leaves of the border is a man holding out a lantern; such a figure often appears among the soldiers in scenes of Christ's arrest. [G–f.47]

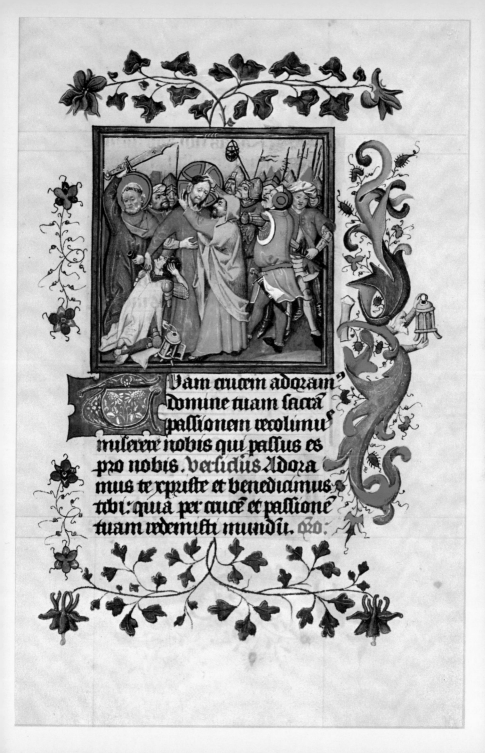

Vam crucem adoram°
domine tuam sacra
passionem recolimus
miserere nobis qui passus es
pro nobis. Versiculus Adora
mus te xpiste et benedicimus
tibi: quia per cruce et passione
tuam redemisti mundu. oro:

18. *Christ before Caiaphas.*

His long sleeves covering His hands and bound wrists, Christ stands before the enthroned Caiaphas who wears a hooded mantle. Before both kneels a "jester." Behind Christ are sol- diers, one of whom holds Him around the waist, and Peter who is denying Him. The room has a yellowish (probably wooden) barrel-vault. In the lower margin, a repentant Peter weeps at the mouth of a cave. [G–f.52v]

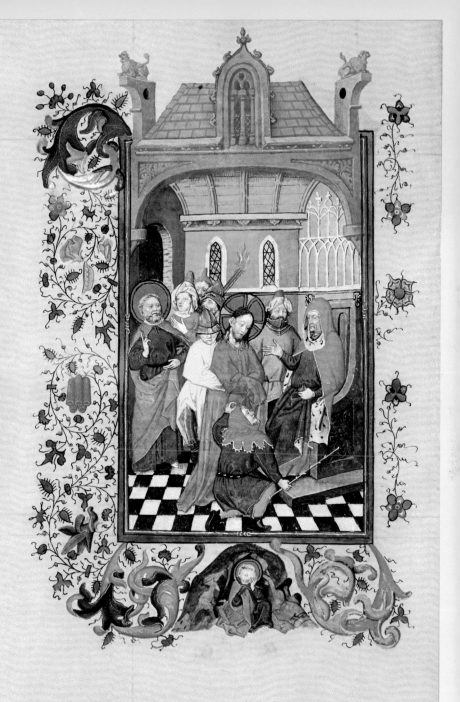

19. *Mocking of Christ.*

Despite the indignities inflicted upon Him, Christ sits in quiet majesty beneath the white cloth, His head held high. The stable symmetry of His large, frontal figure is echoed in the throne upon which He sits, in the tripart division of the walls, in the groin-vaulting of the gray ceiling, and in the central dome directly above Him. In contrast, the four tormenting figures around Him are aggressively active and correspondingly eccentric in position, asymmetrical in posture and irregular in outline and feature. A fifth tormentor in the outer margin beats a metal basin with a stick. Caiaphas stands in the background, his icy and cruel calm opposed to the dignity of Christ in His suffering. [G–f.53]

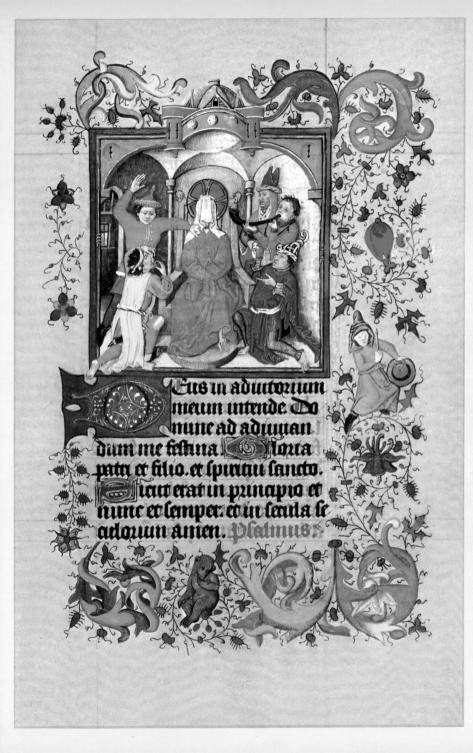

Eus in adintorium
meum intende. Do
mine ad adiuuan
dum me festina Gloria
patri et filio. et spiritu sancto.
Sicut erat in principio et
nunc et semper. et in secula se
culorum amen. Psalmus

20. *Christ before Pilate.*

Pilate, wearing a ballooned-crown hat, sits upon a throne in his barrel-vaulted audience hall. The barrel-vault may be an attempt to render Roman architecture, and the grass growing on the curved roof above may represent the actual appearance in the fifteenth century of Roman, or at least very old, buildings. Christ stands humbly facing Pilate, His hands hidden in long sleeves, His wrists bound. Pressing Him forward are a group of soldiers, whose pointed and knobby armor contrasts with the simple garb and vulnerability of Christ. Pilate washes his hands under the water poured by an attendant into a metal basin. It is apparently this water that a figure in the margin behind Pilate empties from a jar into the mouth of a dragon. The finality of Pilate's judgment is stressed by the inscription in Dutch on the rear wall, *Versinnet dat Ende* ("Think of the End"), and a visual parallel to the debate between Pilate and Christ may be seen in the two fighting cocks in the lower margin. [M–p.38]

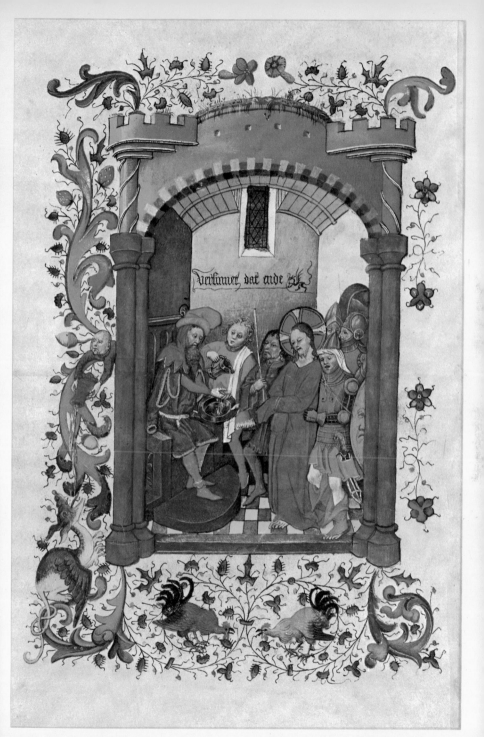

21. *Christ before Herod.*

The general composition repeats that of Christ before
Caiaphas (no. 18), but in a much simplified form. Here Christ
stands before Herod, His hands still covered and wrists tied.
He remains silent with downcast eyes, while Herod, sitting
upon a throne covered with a gold cloth, holding a sceptre, and
wearing a gold crown, interrogates Him. Only one soldier
remains from the previous composition. An attendant carries
on his shoulder what appears to be a bundle of cloth of the
same mauve-rose color as Christ's robe. This cloth is perhaps
the purple garment that, according to the Gospel of Mark, was
placed upon Christ by the soldiers before the crown of thorns.

[G–f.58]

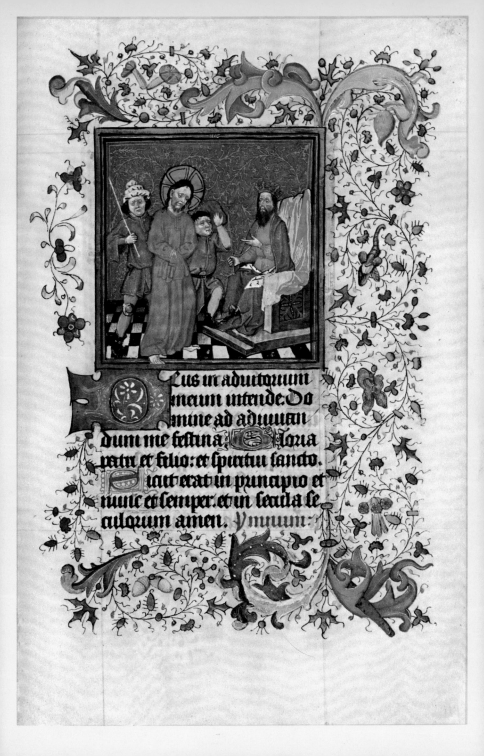

eus in adiutorium
meum intende. Do
mine ad adiuuan
dum me festina. Gloria
patri et filio: et spiritui sancto.
Sicut erat in principio et
nunc et semper. et in secula se
culorum amen. Uenite.

22. *Flagellation of Christ.*

While Pilate looks on from the background, two men pull tight the ropes around Christ's wrists and ankles, binding His slight body to the column. The form of the column's base and its color are unusual, but there are earlier examples of a broad base on which Christ stands and also of the reddish color, whose hue was apparently associated with the blood of Christ. In contrast to the stable vertical of the column and the strong horizontal lines of the room, the almost naked body of Christ slumps to one side; His flesh is scratched and bleeding. Unlike the other figures, Christ is drawn with a tremulous line that echoes His suffering. Flanking Him are two men who would traditionally be His flagellators, but only the one on the right, vigorously straining upward with his garment fluttering and hair flying, raises a bundle of branches over his head to strike Christ. The other flagellator, who holds Christ's head with his left hand, has "lost" his whip, perhaps because of the inter-ference of the border, but the straightness of his arm implies the stroke of whipping, rather than the punch of boxing. Along the lower edge of the painting is a carved molding with a horizontal rod held by leaves, echoing the column to which Christ is bound. Such a molding does not appear in any of the other miniatures, nor does it belong to the architecture of the room; it suggests instead some kind of picture frame, which may have been adapted from the model upon which this minia-ture was based. [G–f.60v]

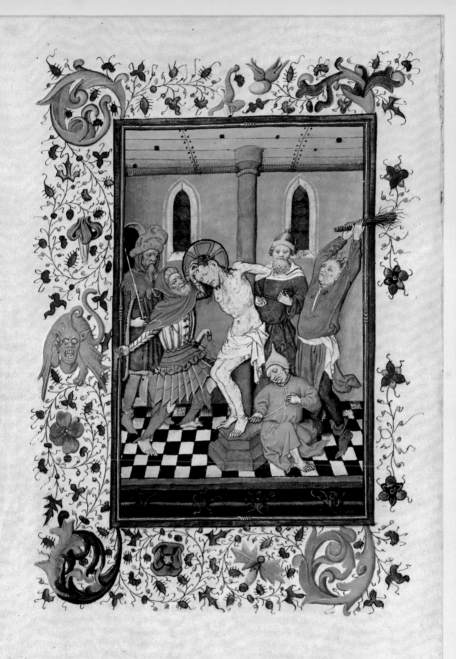

23. *Buffeting of Christ.*

Unlike the Mocking of Christ (no. 19), with which this sub-
ject is often confused, the Buffeting depicts the physical abuse
of Christ. Although Christ is again placed in the center, He
has lost the unperturbed majesty of the earlier picture. He is
no longer severely frontal and symmetrical; instead He sits
upon a small backless chair. His figure is lower and has been
brought closer to the foreground, where He is dominated by
His violent tormentors. Two of them hit or push His head with
long staves, while two others strike or are about to strike Him
with their hands, and a fifth tormentor kneels beside Him
looking up at His face. Christ is still robed, as He was before
the Flagellation, but He now wears a blindfold and His crown
of thorns. From the background a bearded man, apparently
Pilate, supervises the attack upon Christ. [G–f.61]

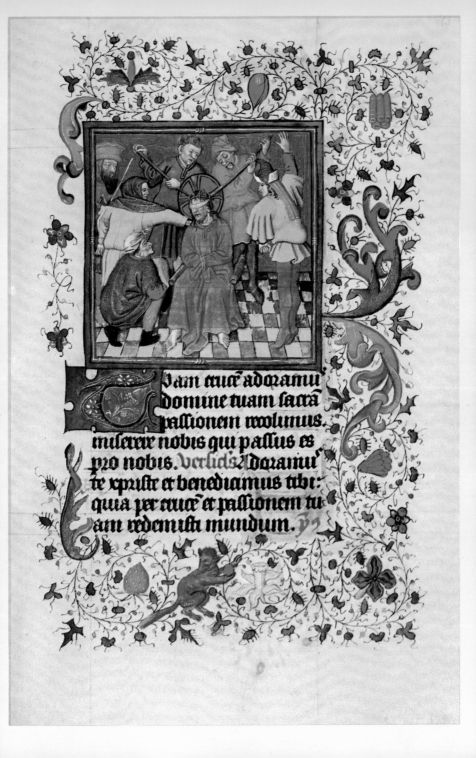

Iam cruce adoramus
domine tuam sacram
passionem recolimus.
miserere nobis qui passus es
pro nobis. Versicio. Adoramus
te xpriste et benedicimus tibi:
quia per cruce et passionem tu
am redemisti mundum.

24. *Christ Carrying the Cross.*

The bent figure of Christ and the T-shaped or *tau* cross that He carries over His shoulder dominate the scene. Their dominant lines are echoed by parallel lines in the other figures and in the landscape forms behind. The obviously larger scale of Christ, His measured gait, and His self-absorbed expression isolate Him from the other figures, giving Him an aloof dignity. Encumbered by two large metal clogs or spike-blocks hung apparently from His waist, He is pulled forward by one soldier as He is helped by Simon of Cyrene, who supports one arm of the cross on his shoulder. The sorrowing Virgin and Saint John follow behind in prayer. This small procession moves slowly into more rocky and hilly terrain toward Golgotha, which lies outside the painting. In the margin, Saint Veronica displays the sudarium with which, according to legend, Christ wiped His face, thereby imparting to it the image of His holy face. [G–f.63v]

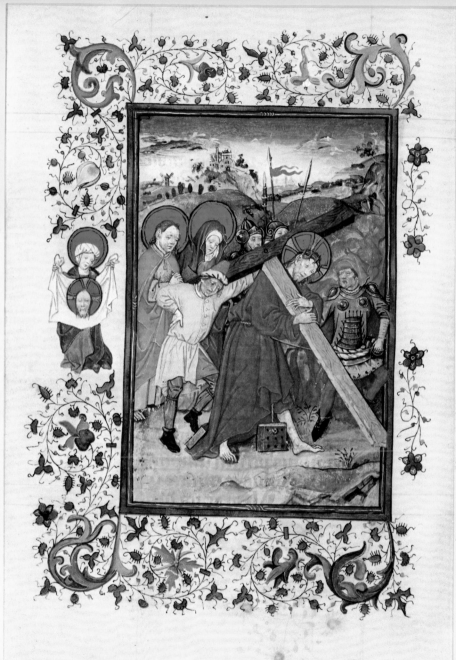

25. *Preparation of the Cross.*

The subject of this scene is far more unusual than that of Christ being nailed to the cross. Here Christ sits forlornly upon a hillock watching the preparation of the cross. His body is lacerated and, except for a loincloth, naked; His wrists are bound. One man drives nails or pegs into the joint of the arm and shaft of the cross, perhaps to strengthen it, since the cross was already assembled in the preceding scene. A second man drills a hole in the shaft, perhaps to facilitate nailing Christ's feet. From behind the hillock, the Virgin watches in grief. Behind her is another figure, haloed but otherwise hidden, who is probably Saint John. In the foreground are tools, an ax, a cup of nails, and the robe of Christ. [G–f.64]

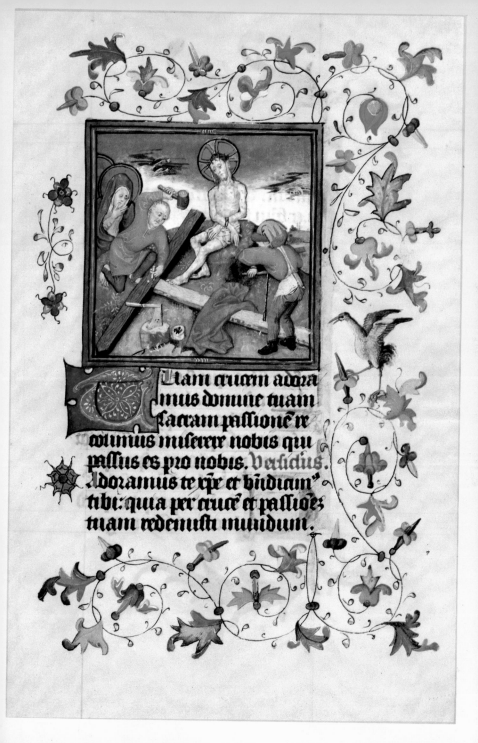

tiam cructem adora
mus dominie tuam
sacram passione re
colimus miserere nobis qui
passus es pro nobis. Versiculus.
Adoramus te xpe et bndicim
tibi: quia per crucé et passioez
tuam redemisti mundum.

26. *Crucifixion.*

The smooth frontal cross of the dead Christ stands between and slightly in front of the two rough foreshortened crosses of the thieves. The unusual symmetry of Christ's body confronts us directly, serving to identify Him with the stable form of His cross and to separate Him from the anguished figures of the thieves and the active figures below. Rather than hanging from their hands, the two thieves have their arms stretched over the tops of the horizontal arms of their crosses and tied behind. The flesh of the thief on Christ's right has a pinkish tone, and, although his face is turned upward, his eyes are covered by a cloth band, perhaps symbolizing the blindness of the unconverted thief. The body of the other thief is yellowish, like that of Christ; his wrists are bound to a short stick, and he averts his ugly face and uncovered eyes from Christ. Below, Saint John supports the swooning Virgin, while Mary Magdalene stands passively by. Opposite, three of the four spectators and soldiers look at Christ, and from the pointing hand of the centurion unrolls a scroll inscribed: *Vere filius dei erat iste* ("Truly this was the Son of God"). Above Christ, in the arc of heaven, is God the Father surrounded by angels; below Him, in the lower border, a kneeling angel weeps. [G–f.66v]

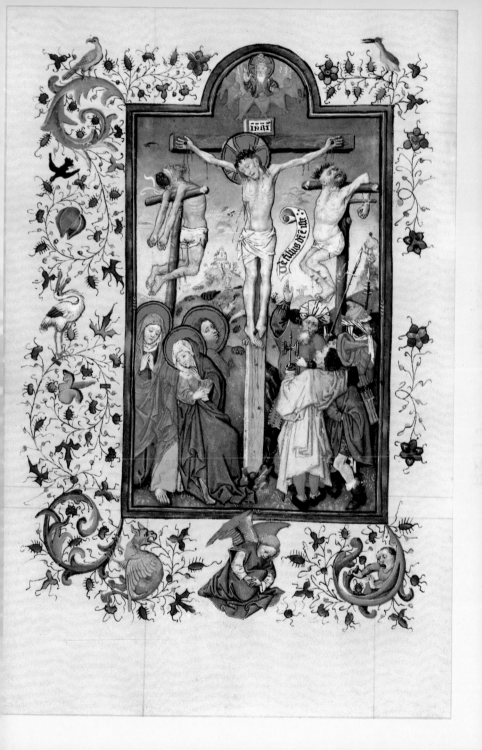

27. *Joseph of Arimathaea before Pilate.*

Joseph, the "rich man of Arimathaea" and secret disciple of Christ, bends forward humbly, his hat removed, as he approaches the enthroned Pilate to beg for the body of Jesus. Behind Joseph is Nicodemus, who is about to remove his hat. Two other figures stand beside Pilate's throne, one of whom must be the centurion who assured Pilate that Jesus was indeed dead. The room, unlike the previous audience hall (no. 20), is small, unvaulted, and windowless. In the lower margin, a hunter on foot sounds his horn, as he follows his hounds and the rabbit they chase. Although patently secular, this scene seems also to be an analogy for the Passion. [G–f.67]

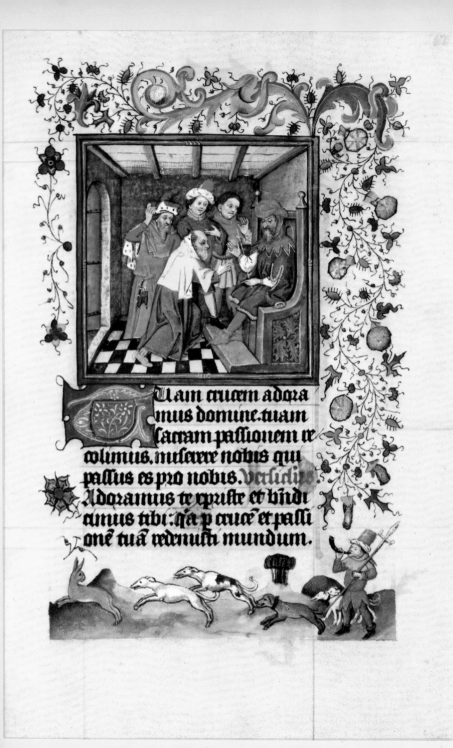

Uam crucem adora
mus domine. tuam
sacram passionem re
colimus. miserere nobis qui
passus es pro nobis. Versiculus.
Adoramus te xpiste et bndi
cimus tibi: qa p cruce et passi
one tua redemisti mundum.

28. *Descent from the Cross.*

Standing at the top of the ladder, the bareheaded Nicodemus holds the limp body of Christ under the arms and lowers it into the cloth-covered hands and upraised arms of an assistant. The Magdalene, her back turned to us, watches the deposition from below and raises her arms as though to help. At the left, Saint John supports the swooning Virgin, much as in the Crucifixion (no. 26). Her face is still averted, but her hands are in prayer. Behind this group, standing somewhat removed and aloof, is Joseph of Arimathaea, who holds a jar of ointment and watches the descent. Neither the thieves nor their crosses are present, and their places are taken by two adoring angels hovering in the distance. In the margin at the left a man, probably a doctor, holds up a flask containing, perhaps, a urine specimen, as does the doctor in the secular Deathbed Scene (no. 41). [G–f.69v]

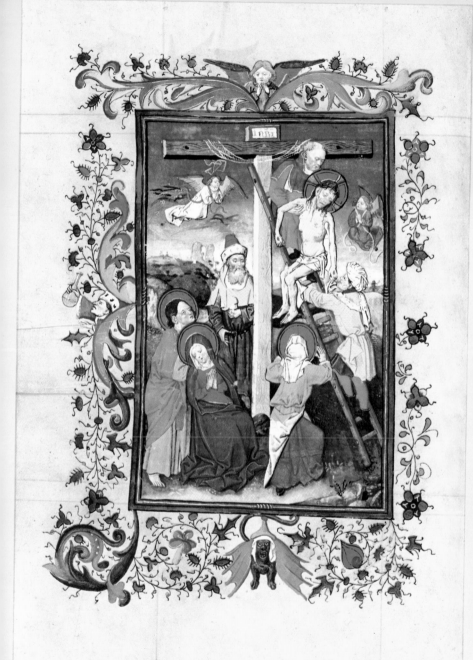

29. *Lamentation and Anointing.*

Seated below the cross, which has been made smaller to fit the composition, the Virgin holds the upper part of Christ's body on her lap, suggesting a Pietà. Holding Christ's feet and anointing them is Joseph of Arimathaea, his hands covered by a white cloth. Beside him kneels Nicodemus, who anoints Christ's left arm in the same way. Three jars of ointment, one with its lid removed, form a still-life in the foreground. At the Virgin's side, Saint John kneels in prayer. Behind stands the anguished Magdalene dramatically wringing her hands above her head. The simple border of small leaves and flowers differs from all others in this manuscript, but appears in other miniatures by the Cleves Master. [G–f.70]

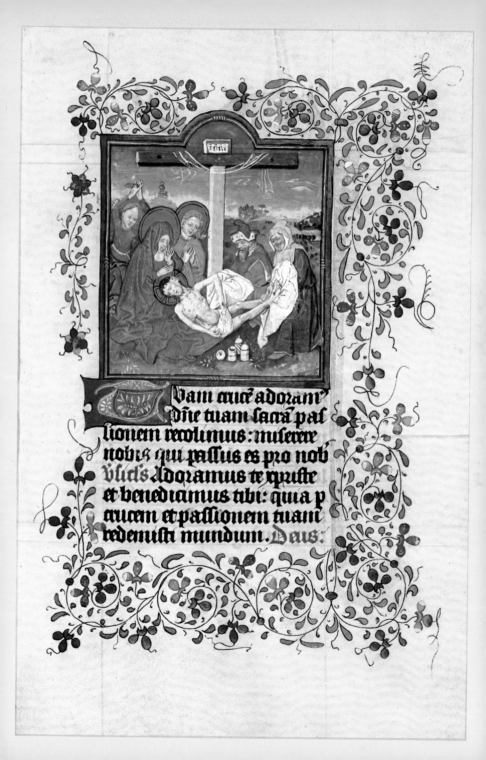

Uam cruce adoram'
dîie tuam sacra pas
sionem recolimus: miserere
nobis qui passus es pro nob'
v lic's Adoramus te xpriste
et benedicamus tibi: quia p
crucem et passionem tuam
redemisti mundum. Deus:

30. *Entombment.*

The body of Christ, wrapped in a white winding sheet, is held over the open sarcophagus by Nicodemus (at the head?) and Joseph (at the foot?). From behind the mauve-rose sarcophagus, the Virgin leans forward and raises Christ's left hand to her face. The Magdalene, holding a jar of ointment, and two other holy women stand behind the Virgin. In the foreground lies the stone of unction or lid of the sarcophagus with two ointment jars. The relevance, if any, of the small border figure drinking from a large tankard has not been explained.

[G–f.73v]

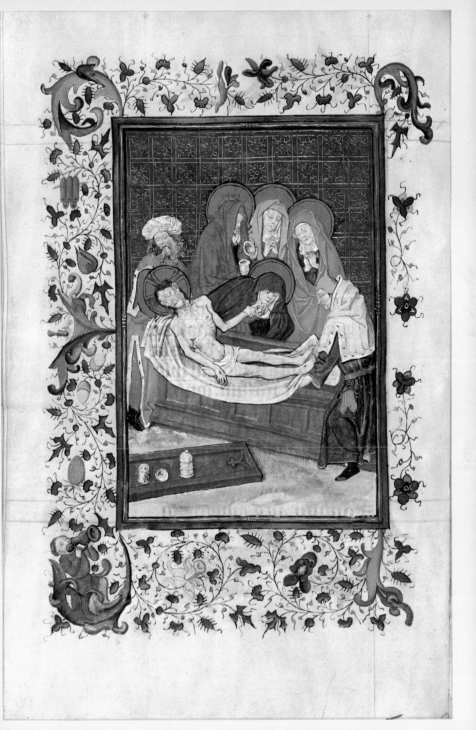

31. *Resurrection.*

This scene of the Resurrection is unusual in a number of its details, such as Christ stepping backward out of His tomb and the extremely awkward postures of the soldiers. Of the two soldiers in front of the sarcophagus, one sits upright, his head completely enclosed in a helmet, his arms and legs drawn in taut unnatural positions. The other kneels forward propping his head with one elbow on the ground and holding his back or hip with his other hand. A third soldier, behind the sarcophagus, throws his head back against the twisted lid while holding his battle ax and raising his other hand above his face. The fourth soldier, without armor but wearing iron gauntlets and holding a pike, leans drowsily on the edge of the sarcophagus. These postures do not suggest sleep, and two of the soldiers have their drowsy eyes at least partially open. In the lower border, a naked child or *putto* blows a long trumpet, an analogy perhaps to the trumpeting angels who will resurrect the dead at the Last Judgement. [G–f.74]

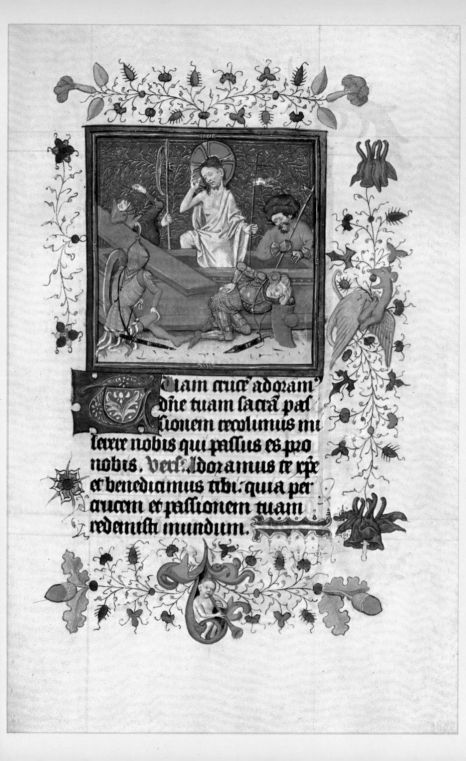

uam cruc' adoram'
dhe tuam sacra paf
fionem recolimus mi
ferere nobis qui paſſus es pro
nobis. Verſ. Adoramus te xpe
et benedicamus tibi: quia per
crucem et paſſionem tuam
redemiſti mundum.

32. Trinity in an Apse.

The three persons of the Trinity are seated upon a red throne in a rib-vaulted apse supported by flying buttresses and decorated with finials, gold banners, and a gold crescent. The Son, seated in the middle and facing directly forward, makes a gesture of benediction and holds a book on His knee; the Father, an old man crowned with a tiara and holding a gold globe on His knee, extends one arm behind His Son's back. The Holy Ghost, upon whose halo is perched a dove, is in appearance somewhat more youthful than Christ, whom He partially embraces and whose book He helps to hold. In the left and lower borders is an L-shaped band of orange angels surrounded by yellow clouds. The latter appear to have been repainted, but have in fact merely lost most of the blue pigment originally applied over much of the yellow. [G–f.77v]

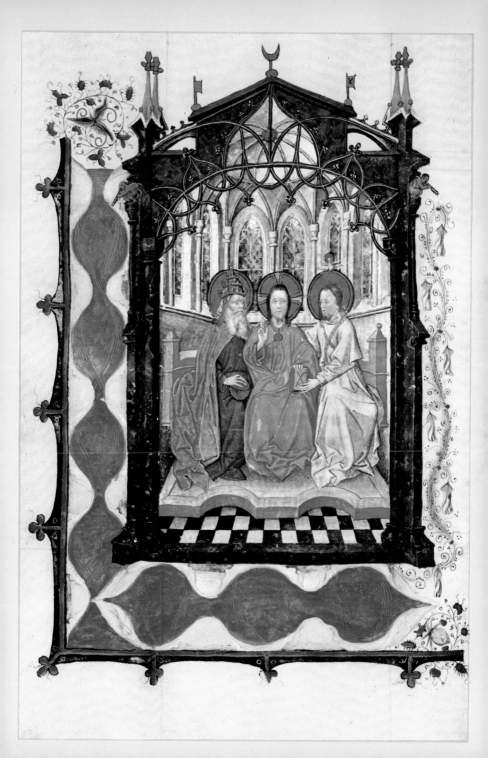

33. *God the Father.*

Seated frontally upon a large red throne, God the Father is dressed as before (no. 32) and wears the same conical tiara. One hand is raised in blessing; the other holds a globe on His knee. Two yellow angels appear behind in brown clouds which open to reveal gold stars in a blue sky. In the border, a goat reaches up to eat a cluster of grapes. [G–f.78]

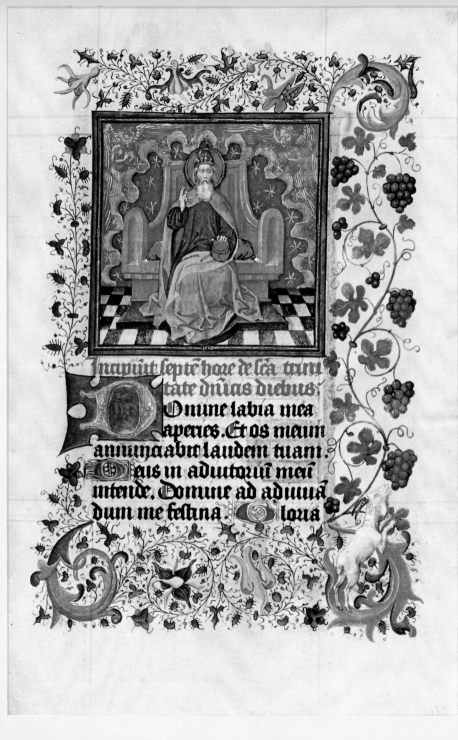

Inapiut septe hore de sca trini
tate dnias diebus.
Omine labia mea
aperies. Et os meum
annunciabit laudem tuam.
eis in adiutoriu mei
intende. Domine ad adiuua
dum me festina. Gloria

34. *God the Son.*

The figure of Christ is identical with the one in the previous miniature of the Trinity (no. 32), but He is here seated alone on a large red throne. In the border is a music-making angel.

[G–f.80v]

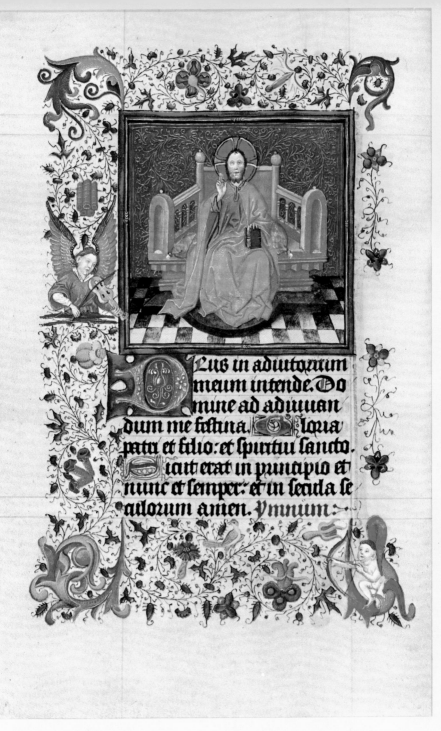

eus in adiutorium
meum intende. Do
mine ad adiuuan
dum me festina. Gloria
patri et filio: et spiritui sancto.
Sicut erat in principio et
nunc et semper: et in secula se
culorum amen. Ymnum

35. *Trinity Enthroned.*

Seated upon a red throne, the three persons of the Trinity
are depicted as before (no. 32), with the exception of the Holy
Ghost, who now holds His own book, but lacks His dove. The
blue sky behind them is scattered with gold stars, while pray-
ing angels in various colors hover around the edge of the nearly
elliptical frame. All three persons have scrolls with difficult-
to-read inscriptions concerning death and salvation.

[G–f.82]

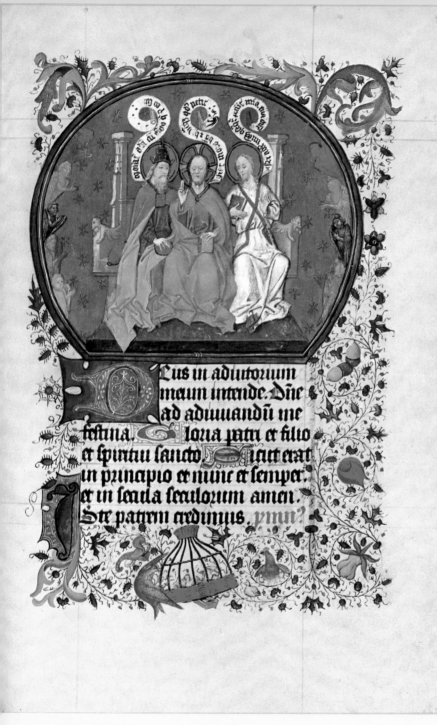

Eus in adiutorium
meum intende. Dñe
ad adiuuandū me
festina. Gloria patri et filio
et spiritui sancto. Sicut erat
in principio et nunc et semper
et in secula seculorum amen.
Ste patrem credimus. ymn?

36. *Trinity with the Son Kneeling.*

The Son is no longer seated upon the large red throne with God the Father and the Holy Ghost, but, instead, kneels on the step in front of His vacant seat. Christ is blessed by His Father as He receives from Him a golden cross, accepting thereby His Father's commission, His approaching Incarnation, and His suffering on the cross. In the lower left border a woman holds a rooster which she prepares to kill or pluck, an analogy to Christ's forthcoming Passion. The significance of the monkey to her right, who ladles some kind of liquid from a bowl, is, however, uncertain. [G–f.83v]

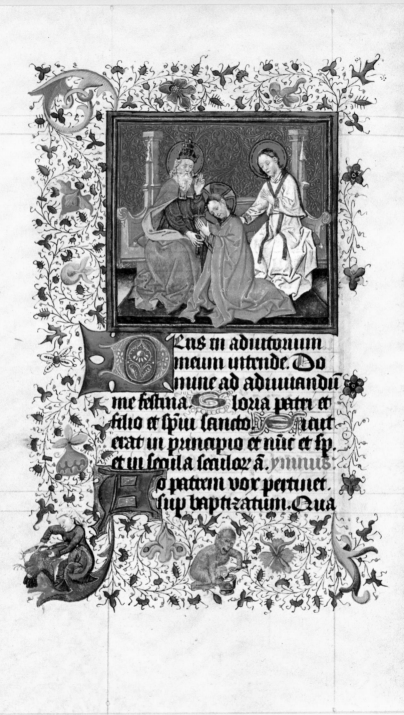

Eus in adiutorium
meum intende. Do
mine ad adiuuandū
me festina. Gloria patri et
filio et spiritu sancto. Sicut
erat in principio et nūc et sp.
et in secula seculor ā. ymnus:
o patrem vor pertinet
sup baptizatum. Qua

37. *Trinity with Dove and Infant Christ.*

From the tiara-crowned figure of God the Father, who blesses and holds a globe in the arc of heaven above, radiate golden rays along which descend, toward the landscape below, the dove of the Holy Ghost and the naked infant Christ holding a cross. This type of Trinity normally accompanies the Annunciation, the moment at which the Virgin conceived and the Son of God was made flesh. A further reference to the Incarnation occurs in the lower border where a fisherman kneels on the bank of a small pond in and around which are various kinds of nets, traps, and other equipment for fishing, symbolizing the corporeal prison of the soul. [G–f.85]

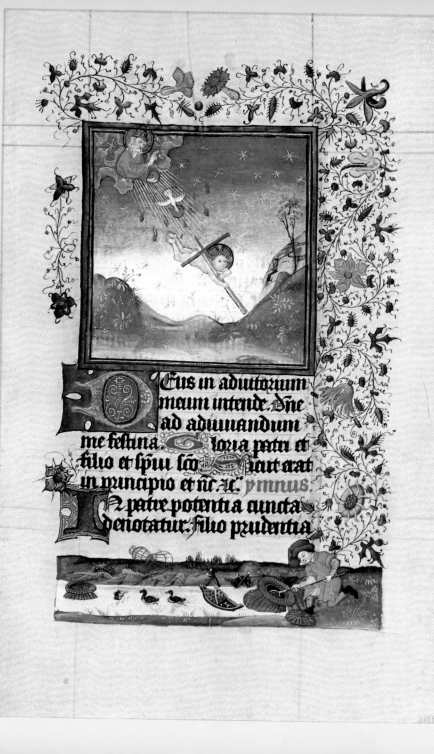

Eus in adiutorium
meum intende. Dñe
ad adiuuandum
me festina. Gloria patri et
filio et spū sco Sicut erat
in principio et nc. xc. ymnus.

Ex patre potentia cuncta
denotatur: filio prudentia

38. *Throne-of-Grace Trinity.*

Seated on a throne of gray stone a bareheaded God the Father holds a cross with His crucified Son, from whose feet blood flows onto a golden globe of the earth below. The dove of the Holy Ghost hovers between the heads of Father and Son. In the lower border are the two spies of Moses returning from Canaan carrying a gigantic cluster of grapes on a staff between them—in the Old Testament a testimony of the Covenant of the Lord and a common antetype for the Crucifixion. Their two unfurled scrolls are inscribed with part of their report to Moses on the land of milk and honey (Numbers 13:27). [G–f.86v]

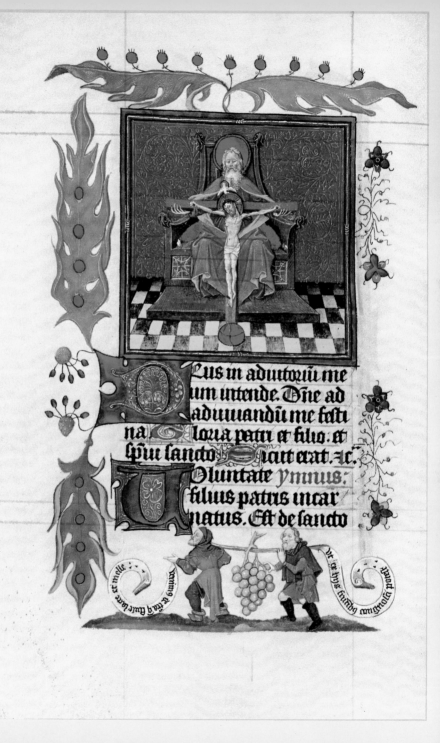

eus in adiutoriū me
um intende. Dñe ad
adiuuandū me festi
na Gloria patri et filio. et
spū sancto Sicut erat. ꝛc.
Uoluntate ymnus:
filius patris incar
natus. Et de sancto

ᵹᵉᵐᶦᵗᶜ... et melle et fauc dulcis erat Ut ex hijs fructibꝰ congrulla potest

39. *Trinity with Son Showing Wounds.*

As the two preceding miniatures show the Trinity at the
time of the Incarnation and Crucifixion, this represents the
Trinity after the Crucifixion. The Son in the center is supported
by the other two persons, who appear as before (*e.g.*, no. 32).
His feet resting on the gold globe of the earth, Christ displays
the wounds on His half-naked body, while the Holy Ghost
holds His cross before Him. [G–f.88]

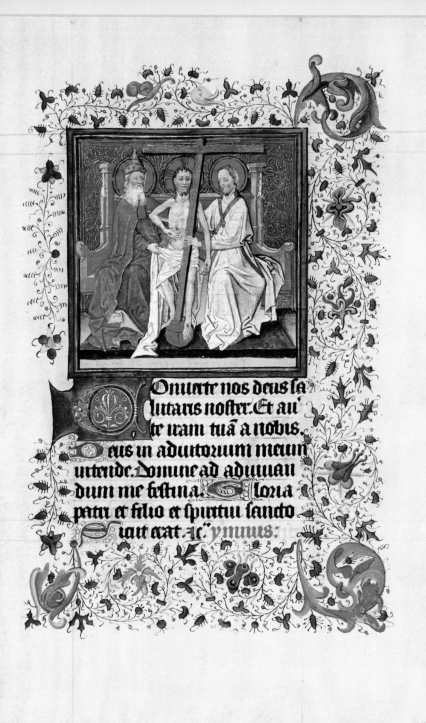

Onuate nos deus sa
lutaris noster. Et au'
te iram tuã a nobis.
Deus in adiutorium meum
utende. Domine ad adiuuan
dum me festina. Gloria
patri et filio et spiritu sancto
iait eat. ꝛc. Ymnus:

40. *Trinity Adored.*

Appearing in the arc of heaven is a Trinity of the throne-of-grace type, with the difference that the Father is shown only bust length. Adoring the Trinity from below are eight kneeling religious and lay figures, including a pope, two cardinals, a bishop, and three men in armor, of whom one is dressed in gold—his cape has a black doubleheaded eagle, and his helmet bears a crown and a cross. In the borders are an owl and a grazing stag. A full-page miniature, now missing, probably faced this page originally. [G—f.90]

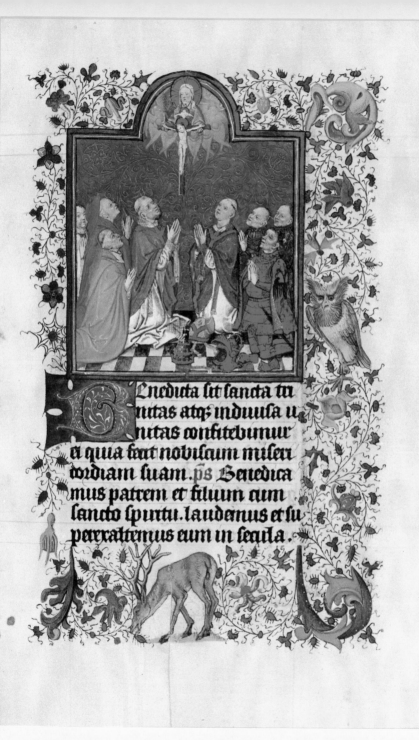

41. *Deathbed Scene.*

In a narrow room the bed of a dying man divides the background figures from the two seated in the foreground: a cowled priest (?) reads at a table upon which stand numerous vessels and other objects, presumably for use in the Viaticum or Extreme Unction, while a black-garbed woman, probably the widow, prays over an open book. Behind the bed are two women, one tending the dying man and the other helping him to hold a burning candle. A physician examines a urine specimen, and, somewhat apart, stand a foppish companion and the mercenary heir, who appears again in the lower border taking money bags out of a coffer. Dominating the rear wall of the room is a large window, shuttered except for one section, through which is seen a far distant landscape. The transfer of two brown stains from the originally facing folio 97 in the Guennol volume proves that this miniature introduces the Hours of the Dead. [M–p.180]

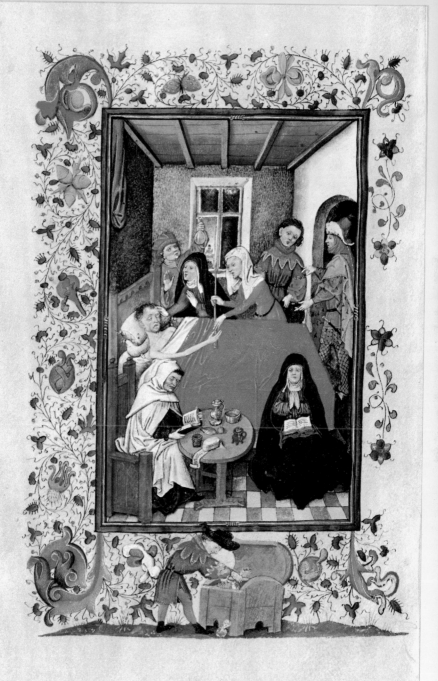

42. *The Mouth of Hell with Tormented Souls.*

Filling the miniature is a monstrous head personifying hell, almost black with yellow and orange flames or lights, and heightened with gold radiating from its eyes and ears. Its fanged and flaming crimson mouth holds seven naked and youthful souls, who pray as they writhe in anguish. [G–f.97]
the wounds on his half-naked body, while the Holy Ghost

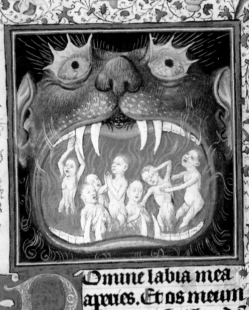

Omine labia mea
aperies. Et os meum
annunuabit laude
tuam. Deus in adiutoriu
meum intende. Domine ad
adiuuandum me festina.
Gloria pri et filio et spu
sco. Sicut erat. A. Ymnus

43. *Preparation of the Corpse of the Deceased.*

The naked corpse of the man shown dying in the earlier death-bed scene (no. 41), here held in a white winding sheet, is being lowered by two men onto some straw on the floor. The bare room appears to be that of no. 41, with a few alterations, the result, in part, of the different shape and size of this miniature. The shutters on the window have now all been thrown open, revealing more of the landscape in the distance. [G–f.99v]

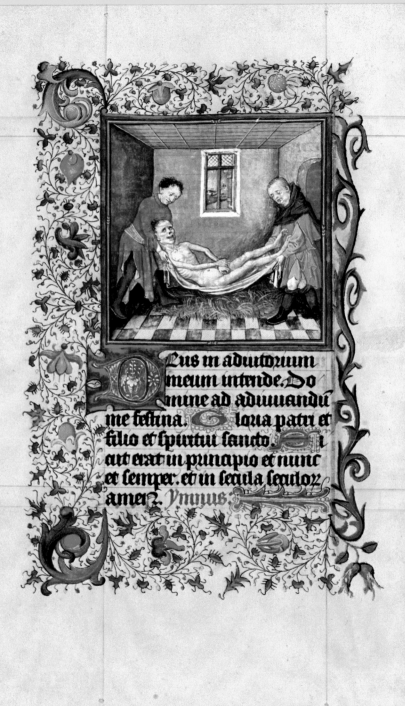

Eus in adiutorium
meum intende. Do
mine ad adiuuandu
me festina. Gloria patri et
filio et spiritui sancto. Si
cut erat in principio et nunc
et semper. et in secula seculor
amen. Ymnus.

44. *Office of the Dead.*

The coffin on the left, covered with a red cloth and supporting two candles, has been placed before the partially concealed altar on the far right, upon which one candle is visible. Behind the coffin are two kneeling mourners clothed in black, and just behind them in a choir stall are three singing clerics; each is wearing a surplice, and one a horned hood. [G–f.101]

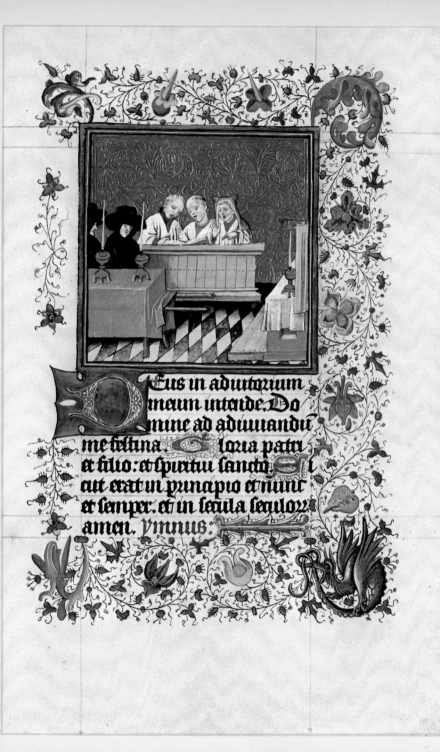

Eus in adiutozium
meum intende. Do
mine ad adiuuandu
me festina. Gloria patri
et filio: et spiritui sancto.
cut erat in principio et nunc
et semper. et in secula seculozu
amen. Ymnus.

45. *Interment of the Deceased.*

While two men lower the wooden coffin into the grave, the priest in white surplice sprinkles holy water from an aspergillum onto the coffin. Four black-robed mourners stand behind the grave. [G–f.102v]

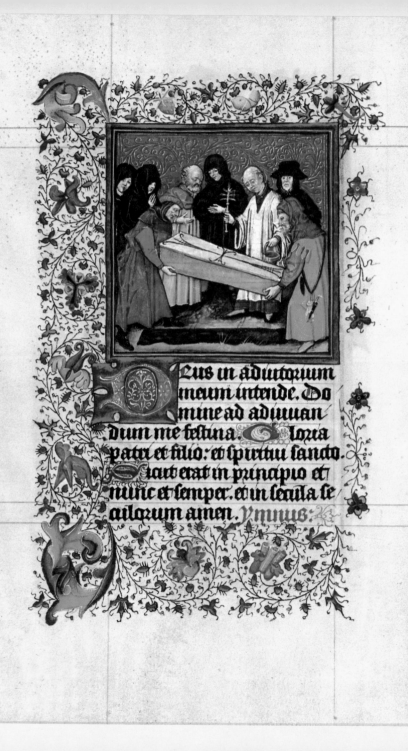

eus in adiutorium
meum intende. Do
mine ad adiuuan
dum me festina. Glozia
patri et filio: et spiritui sancto.
Sicut erat in principio et
nunc et semper. et in secula se
culozum amen. Ymnus:

46. *Requiem Mass for the Deceased.*

The priest prays facing the altar, which, as is usual in this manuscript, has side curtains and a gold retable, as well as an open missal and covered chalice. Besides the priest, there are three mourners in black, one of whom kneels at the side of the altar and offers a silver or pewter vessel to an attendant, who has already placed a gift of some kind of bread upon the altar.

[G–f.104]

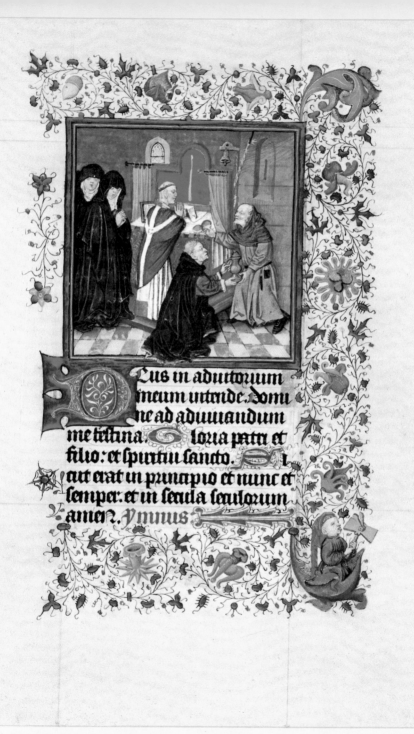

eus in adiutorium
meum intende. Domi
ne ad adiuuandum
me festina. Gloria patri et
filio: et spiritui sancto. Si
cut erat in principio et nunc et
semper. et in secula seculorum
amen. Ympnus

47. *The Mouth of Hell with*
 Three Souls at a Table.

Within the mouth of hell, as shown in no. 42, is a long bare table, at which three naked souls kneel, their hands in prayer. An angel flies down to the table with a cloth containing small brown objects that appear to be the bread placed on the altar in the preceding miniature. [G—f.105v]

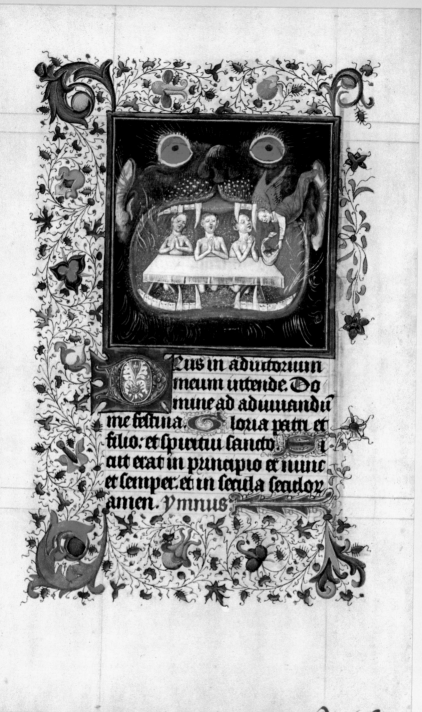

eus in adiutoriuin
meum intende. Do
mine ad adiuuandu
me festina. Gloria patri et
filio: et spiritui sancto. Si
cut erat in principio et nunc
et semper. et in secula seculor
amen. Ymnus.

48. *Release of Souls from the Mouth of Hell.*

An angel leads five naked souls out of the mouth of hell, here almost identical to nos. 42 and 47. Opposed to this scene of release, however, is the scene of capture in the lower border. A hunter is catching birds with a string trap; below the trap are two caged birds serving as decoys, and in the distance an open cage awaits the quarry. [G–f.107]

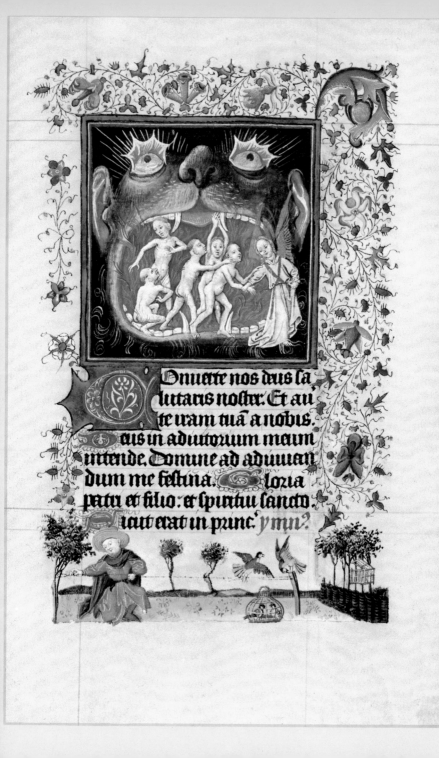

Onuerte nos deus sa
lutaris noster. Et au
te iram tuā a nobis.
eus in adiutorium meum
intende. Domine ad adiuuan
dum me festina. Gloria
patri et filio: et spiritui sancto
ſicut erat in princ. ymn?

49. *Last Judgement.*

The triangular composition is dominated by three main figures: at the apex is Christ seated upon the rainbow-like arc of heaven; on the ground below, the Virgin and John the Baptist kneel in adoration. Before the latter two the resurrected dead emerge as naked figures from the earth. From the distant waters, visible between the Virgin and Saint John, rises a rocky island, on which rests the golden globe of the earth surmounted by a cross. A red demon crouches in a fissure of the island. At opposite ends of the arc of heaven two groups of bust-length saints are shown flanking Christ. From the upper corners two orange angels descend, each blowing a long trumpet from which flutters the banner of Saint George (argent, a cross-couped gules). Lilies and the sword of the Apocalyptic vision extend from the mouth of Christ. In the four corners of the elaborate border are medallions with the symbols of the Evangelists, each identified by a scroll bearing his name. [M−p.28]

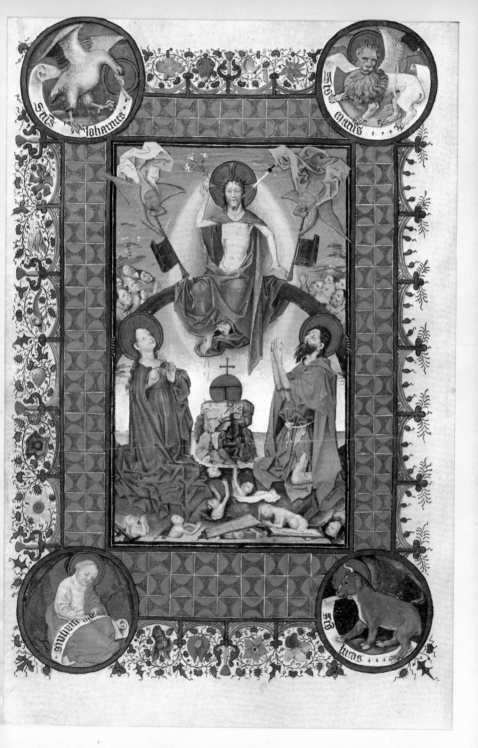

50. *Saint Michael Weighing Souls.*

Saint Michael, accoutered in golden armor, holds a long red staff topped by a gold cross in his left hand and the gold scales in his right. The left cup of the scales holds a naked soul in prayer, while a rose-colored demon tampers with the other cup. A music-making angel and a crane-like bird appear in the border. [M–p.29]

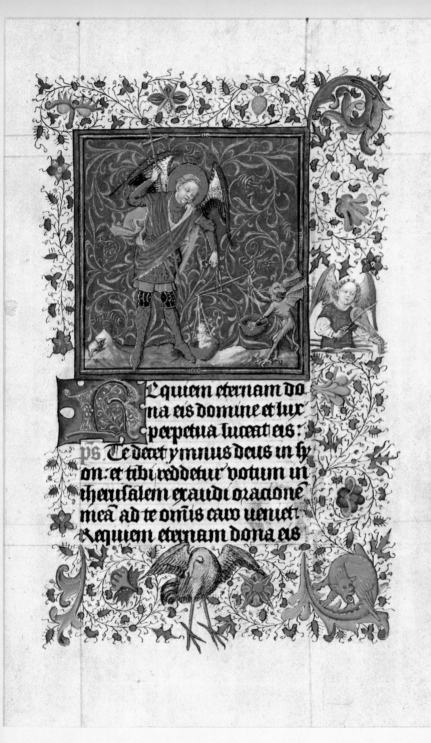

Equiem eternam do
na eis domine et lux
perpetua luceat eis:
Te decet ymnus deus in sy
on: et tibi reddetur votum in
therusalem exaudi oracionē
meā ad te omīs caro ueniet.
Requiem eternam dona eis

51. *Pentecost.*

The descent of the Holy Ghost to the Virgin and the twelve
Apostles takes place in the apse of a strangely vaulted church.
The ceiling is primarily a barrel-vault with liernes as well as
the customary transverse ribs; it rests on a horizontal molding
which, in turn, is supported by the apexes of painted wall
arches. Along the molding are small armorial shields. In con-
trast to the generally white interior, some of the vaulting ribs
are red and are so disposed as to echo the descent of the Holy
Ghost, represented as the white dove perched upon the Virgin's
head. A reddish glow radiates from the dove, contrasting with
the Virgin's halo, here white instead of the usual gold. The
pattern of gold rays toward the Apostles, also emanating from
the dove, is repeated in their halos of gold radiating lines. In
addition, the tongues of fire mentioned in Acts 2:3 burn upon
the Apostles' heads. Although surrounded by the Apostles, the
Virgin remains calmly aloof from their agitation, absorbed in
her reading. An architectural framework of roofs, finials, flags
and buttresses encloses the scene. [M—p.52]

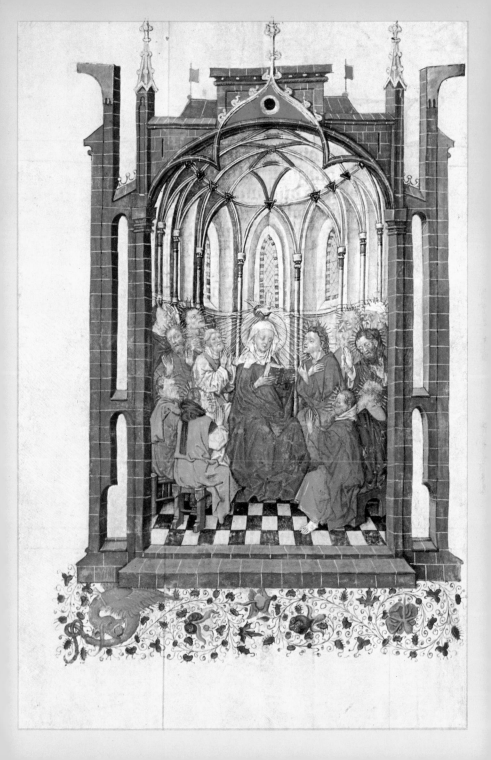

52. *Wisdom: Judgement of Solomon.*

Wisdom, the first gift of the Holy Ghost, is exemplified by
Solomon's sagacity in determining the true mother of a dis-
puted child by threatening to cut the child in two. King Solo-
mon, with the dove of the Holy Ghost perched on his head, sits
upon his throne, holding a sword over the infant's naked body.
Kneeling before him is the real mother, who pleads with the
king and offers to surrender her child to the other woman. The
false mother stands behind with two court attendants. In the
lower border is a sleeping infant in a cradle; in the upper mar-
gin is an inscription explaining that, through wisdom, the child
was restored to his mother. [M–p.53]

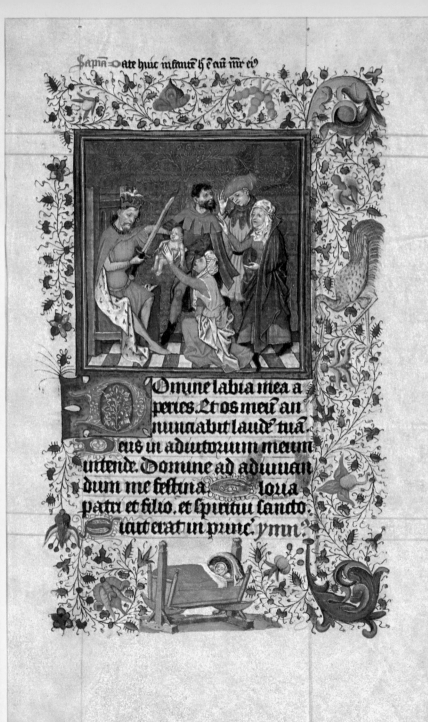

Omine labia mea a
peries. Et os meū an
nunciabit laudē tuā.
eus in adiutorium meum
intende. Domine ad adiuuan
dum me festina. Gloria
patri et filio. et spiritui sancto.
Sicut erat in princ. ymn.

53. *Understanding:*
David (?) Kneeling before an Altar.

The second gift, understanding or *intellectus,* is illustrated by
a gray-haired, gray-bearded man who kneels in prayer on the
step of an altar, asking the Lord, "Give me understanding that
I may learn your commandments." This petition, inscribed in
Latin on the banderole above, is an almost direct quotation
from Psalms 118:34 (Vulgate numeration); the man portrayed,
therefore, is probably David. Flying over the altar is the dove
of the Holy Ghost with a Latin scroll saying, "I shall give you
understanding." The top of the altar is bare except for an altar
cloth. At the back is a retable in three sections, each with a re-
flecting panel of gold and a candle before it. Behind the kneel-
ing figure is an open door through which a landscape may be
seen. [M–p.57]

Lus in adiutoriuu
neum intende. Do
mine ad adiuuandu
me festina. loria patri et
filio et spiritui sancto. t
att erat in principio et nunc et
semper. et in secula seculoru
amen. Ympnus.

54. *Counsel: King and Advisers Taking Counsel.*

A king, perhaps Solomon, stands in counsel with three advisers. As they confer, a haloed dove alights on the king's head indicating that counsel is a gift of the Holy Ghost. In his left hand the King holds a book representing, perhaps, the counsel of the past. The Latin legend in the upper margin explains there is soundness where there is counsel of many; but it is not clear how the large bird standing on burning logs in the lower border, possibly a phoenix, is related to the gift of counsel.

[M–p.60]

Eus in adiutorium meum intende. Domine ad adiuuandū me feſtina. Gloria patri et filio et ſpiritui ſancto. Sicut erat in principio et nunc et ſemper. et in ſecula ſeculorum amen. Ymnus.

55. *Fortitude: Jacob Struggling with the Angel.*

The fourth gift of the Holy Ghost is represented by Jacob's conquest of the angel. While Jacob holds the angel's wrist and garment, the latter struggles to escape, pointing toward the sky. The sense of the scene is explained by the quotation in the upper margin from Genesis 32:26, which, in the King James version, reads: "And he [the angel] said, Let me go, for the day breaketh. And he [Jacob] said, I will not let thee go. . . ." The action takes place in front of a red building; there is no sign of the river Jabbok. The angel, wearing a gold halo, amice, stole, and maniple, is dressed like the Holy Ghost and may therefore represent the deity, a common medieval explanation for this angel. Jacob has no halo, but above his head hovers the dove of the Holy Ghost. [M–p.73]

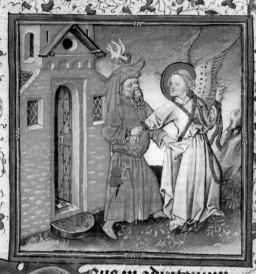

eus in adiutorium
meum intende. Do
mine ad adiuuandu
me festina. Gloria patri et
filio et spiritui sancto. Si
cut erat in principio et nunc et
semper: et in secula seculorum
amen. Ynuius.

56. *Knowledge: Teacher and Pupils.*

This schoolroom scene depicts the fifth gift of the Holy Ghost. The seated teacher holds a whip in one hand and in the other, an open book, which he extends for the recitation of the student kneeling before him. Above the student's head is the dove of the Holy Ghost and a banderole with a quotation in Latin from Psalms 2:12, saying in part, "Embrace discipline." Two other students studying their books are seated on the straw-strewn floor. The grotto-like room has two barred windows in its inward curving walls. [M–p.62]

Eus in adiutorium me
um intende. Domine
ad adiuuandum me
festina. Gloria patri et filio
et spiritui sancto. Sicut erat
in principio et nunc et semper.
et in secula seculorum amen.
Ymnus.

57. *Piety: Lady Distributing Alms.*

Piety, the sixth gift of the Holy Ghost, is here interpreted as
charity. Before the door of her house or palace, a fashionably
dressed lady distributes money to three beggars. The lady
would seem to be a conventionalized portrait of Catherine of
Cleves, since she strongly resembles Catherine's portrait re-
produced in no. 96, and even wears the same chatelaine. While
reaching into her purse with one hand, she puts a coin into the
bowl of one of the beggars with the other. The two remaining
beggars also hold out bowls; one beggar is crippled and leans
on a crutch, and all are tattered and patched. The dove of the
Holy Ghost hovers over the lady's head, and the banderole
above the beggars' heads carries a quotation from Luke 11:41,
which reads in translation, "Give alms, and all things are clean
unto you." In the lower border a parallel act of charity is repre-
sented: an unidentified woman offers a dish of food or water
to Christ through the bars of His prison window. [M–p.65]

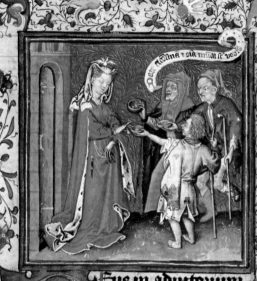

Eus in adiutorium
meum intende. Do
mine ad adiuuandu
me festina. Gloria patri et
filio et spiritui sancto. Si
cut erat in principio et nunc et
semper. et in secula seculorum
amen. Ymnus

58. *Fear of the Lord.*

Arranged in a triangular composition, like that of the Last
Judgement (no. 49), Christ, a kneeling man—possibly Arnold
of Guelders, the husband of Catherine of Cleves—and a
standing demon are shown. Christ has all of His attributes as
judge. lilies, sword, crown of thorns, wounds, rainbow, and
golden globe below. The man, his broad-brimmed fur hat on
the ground before him, prays to Christ, while the dove of the
Holy Ghost hovers over him. With bat wings on shoulders and
hips, hell-mouth head, and a strange yellow latticework on his
abdomen, the demon gesticulates in his role of prosecutor. All
three have banderoles with biblical quotations concerning
fear of the Lord: the man's from Psalms 118:120 (Vulgate),
the demon's from Psalms 35:2 (Vulgate), and Christ's from
Ecclesiastes 12:13. In the upper margin is a Latin legend which
states that fear of the Lord is the beginning of wisdom.

[M–p.68]

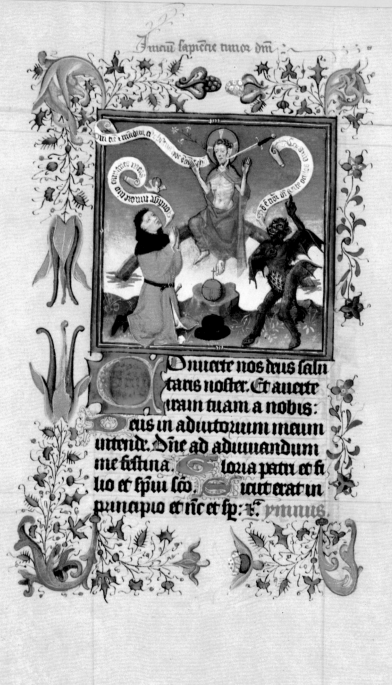

Jnittul sapiccie timor dm

Onuerte nos deus salu
taris noster. Et auerte
irain tuam a nobis:
eus in adiutorium meum
intende. Dne ad adiuuandum
me festina. loria patri et fi
lio et spu sco. icut erat in
principio et nc et sp: . ymnus.

59. *Saint Peter Bestowing the Holy Ghost.*

The meaning of this rare scene is given in the legend at the top of the page, a quotation from Acts 8:17. The biblical passage tells how Peter and John conveyed the Holy Ghost to the people of Samaria by placing their hands upon them; but the quotation is here changed to exclude John and stress Peter and, by implication, the Roman Church. In the center of the scene, Peter places his hand, with the dove of the Holy Ghost perched on it, upon the head of the first of four men kneeling before him. Standing behind Peter are three more men, two of whom are graybeards. The nearest of these seems skeptical and is probably Simon Magus, who appears in the next miniature. The scene takes place in an open octagonal tempietto whose rib-vaulted ceiling is supported by thin columns. Between these columns a deep landscape can be seen reaching to the distant sea where a sailing ship rides at anchor. Around the picture is a border of fleshy, squid-shaped plants. [M–p.72]

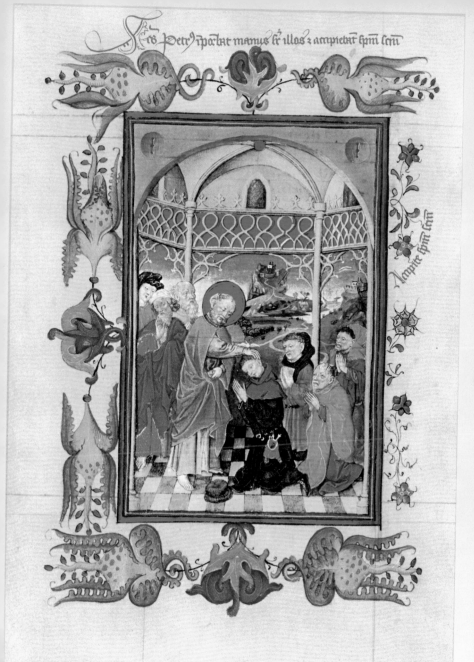

60. *Simon Seeking to Buy the Power of Peter.*

Impressed with Peter's apparent power to bestow the Holy
Ghost on men, Simon the Magician offers Peter money.
Dressed as in the preceding miniature, except for the long-
brimmed hat he now wears, Simon holds out the money to
Peter, who makes a gesture of refusal with one hand while he
holds a book in the other. The dove of the Holy Ghost hovers
between them. The scene is explained by the legend in the
upper border composed of quotations from Acts 8:19–20 (the
legend substitutes *gratiam* for *potestatem*). In the border, a boy
shears the lamb which he holds in his lap, but how these figures
are related to Simon and Peter is not known. [G–f.109]

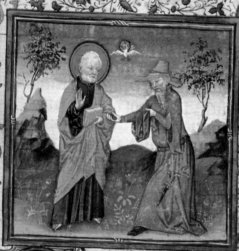

Virtus dominí repleuit
orbem terrarum allelu
ia. et hoc quod continet
omnia scientiam habet uocis
alleluia alleluia alleluya. ps.
Confirma hoc deus quod opera
tus es in nobis a templo sanc
to tuo quod est in therusalem.

61. *All Saints before God the Father.*

The throne of God the Father is suspended in the air above the standing assemblage of saints. Seated frontally, beneath a conical canopy and wearing a blue and gold tiara, He blesses with one hand, and holds a book with the other. The saints are divided into two groups: at the left are Saints Thomas Apostle, George, John the Baptist, a pope, and a cardinal; at the right, Saints Jerome, Agnes, Cecilia, and two other female saints. Three banderoles, one for each group of saints and one for God the Father, are adapted from Psalms 60:4–8, and speak of God's legacy to and support for the saints. Forming a border for the scene is a row of nine flaming angels appearing in blue clouds. [G–f.115v]

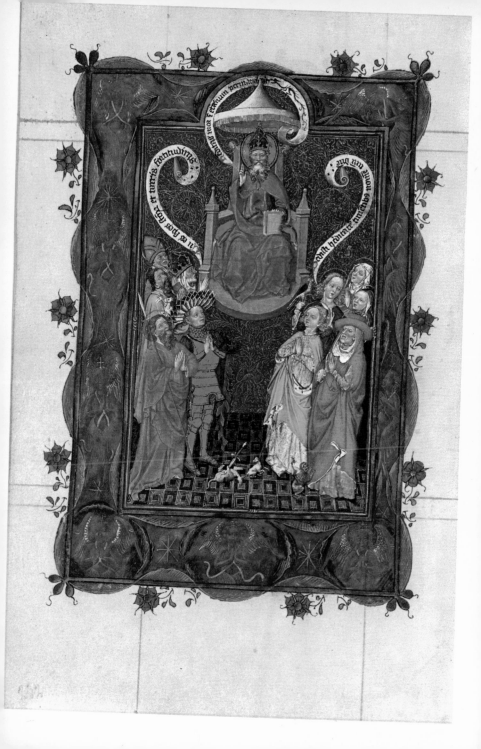

62. Virgin Kneeling before Christ.

This composition is customarily reserved for scenes of the Coronation of the Virgin, but here Christ blesses rather than crowns the Virgin. With gold crown and orb, He is seated at the right of a large double throne, while the Virgin kneels on the floor before her empty seat adoring Him. The throne is covered by a textile brightly patterned with gold crowns, each encircling three feathers, and with pairs of facing white swans or geese. [M–p.39]

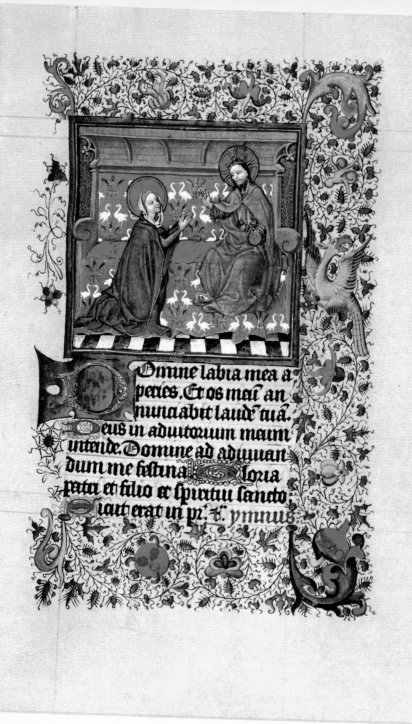

Omine labia mea a
peries. Et os meã an
nunciabit laudẽ tuã.
Deus in adiutorium meum
intende. Domine ad adiuuan
dum me festina. Gloria
patri et filio et spiritui sancto.
sicut erat in pꝛ. Hymnus

63. *Angels Adoring God the Father.*

Enthroned frontally and wearing a blue and gold tiara, God the Father raises one hand in blessing and holds a gold globe in the other. He is flanked by two groups of three standing angels. Each group has a banderole, whose legends combine to give the first two verses of the ancient hymn, *Te Deum.*

[G–f.116]

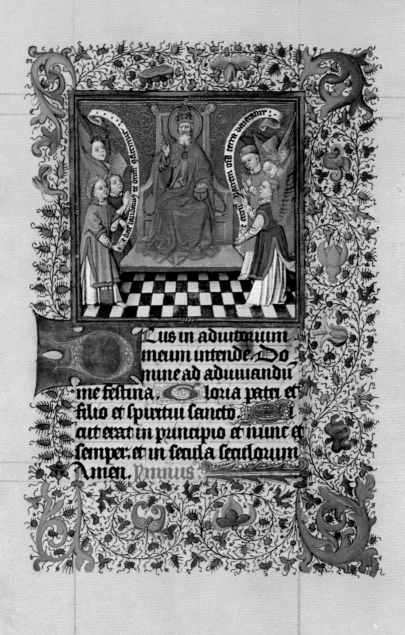

Eus in adiutorium
meum intende. Do
mine ad adiuuandu
me festina. Gloria patri et
filio et spiritui sancto. Si
cut erat in principio et nunc et
semper: et in secula seculorum
Amen. Annus.

64. *Apostles and Prophets Adoring God the Father.*

God the Father is in this miniature identical with the portrayal in the preceding no. 63; His throne, however, here floats above the floor. The Apostles and Prophets are separated by the throne, indistinguishable except for the Apostles' bare feet. The texts of their banderoles are also taken from the *Te Deum* (*Te gloriosus apostolorum chorus / Te prophetarum laudabilis numerus*), while the banderole of God the Father proclaims, "I am alpha and omega, God and man." [G–f.117v]

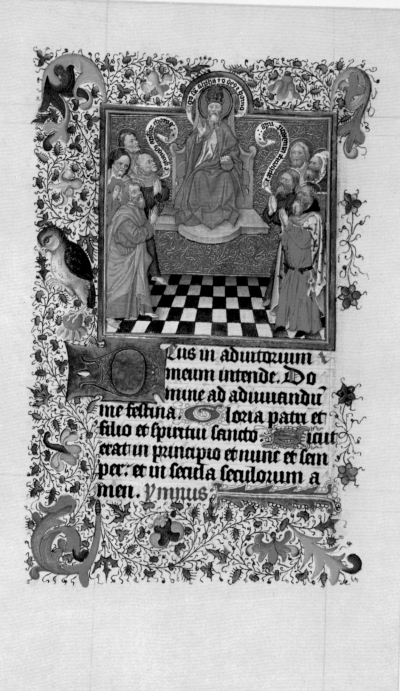

Eus in adiutorium
meum intende. Do
mine ad adiuuandu
me festina. Gloria patri et
filio et spiritui sancto. Sicut
erat in principio et nunc et sem
per: et in secula seculorum a
men. Ymnus.

65. *God the Father and the Four Evangelist Symbols.*

The enthroned God the Father, depicted as before, and the four medallions with the Evangelist symbols are placed against a green background decorated with gold motifs of stars and waves or clouds. Each of the symbols is encircled by a scroll identifying the evangelist represented.　　　[G–f.119]

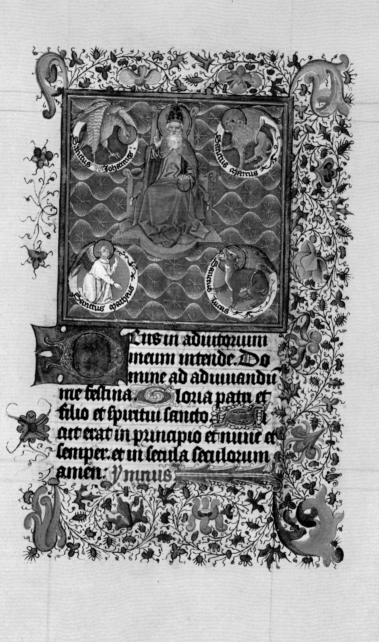

Sanctus Johannes · Sanctus Marcus · Sanctus Mattheus · Sanctus Lucas

...us in adiutorium
meum intende. Do
mine ad adiuuandu
me festina. Gloria patri et
filio et spiritui sancto. Si
cut erat in principio et nunc et
semper. et in secula seculorum
amen: Ymnus

66. *Ecclesiastical and Military Saints Adore God the Father.*

As in nos. 63 and 64, God the Father is enthroned between two groups: on the left are representatives of the religious orders (Dominican, Carthusian, Franciscan, Benedictine, and one other); on the right are five warrior saints in armor, of whom the foremost is distinguished by his gold armor, blue cape, and Saint George's shield. The banderole of God the Father identifies these groups as men who have battled worldliness, while their scrolls contain two more verses from the *Te Deum (Te per orbem terrarum . . .* and *Te martyrum . . .).* God's throne, with small clouds beneath, hovers slightly above the floor. [G–f.120v]

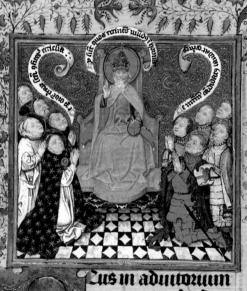

eus in adiutorium
meum intende. Do
mine ad adiuuandū
me festina. Gloria patri et
filio et spiritui sancto. Si
cut erat in principio et nunc et
semper: et in secula seculorum
amen. Ymnus.

67. *Virgins Adoring God the Father.*

Two groups of five virgins stand beside the throne of God, which floats upon clouds above the floor as in the preceding miniatures, nos. 63, 64, and 66. His banderole says, "Come to me all wisest virgins," while that of the secular virgins on the left expresses contempt for the world, and that of the nuns on the right speaks of love for Christ.　　　　　　[G–f.122]

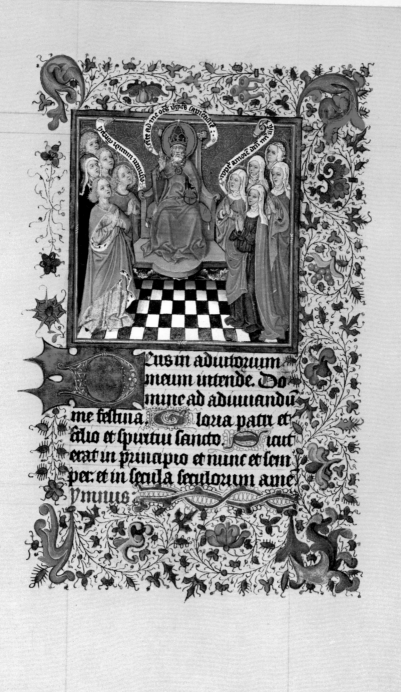

us in adiutorium
meum intende. Do
mine ad adiuuandū
me festina. ¶ loria patri et
filio et spiritu sancto ¶ icut
erat in principio et nunc et sem
per: et in secula seculorum ame
ymnus

68. *Saint Michael Battling a Demon.*

A resplendent Saint Michael is locked in combat with an
ochre demon, who claws at his armor as he is pierced by the
archangel-saint's long gold cross-staff. Although both Saint
Michael and the demon are winged, their struggle takes place
on the ground. [m–p.44]

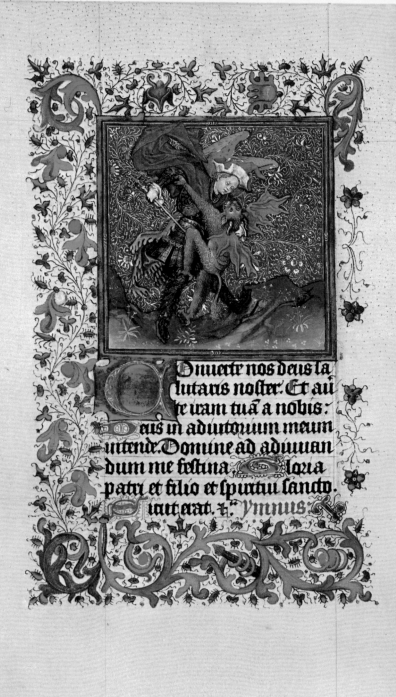

Onuerte nos deus la
lutaris noster. Et au
te iram tua a nobis:
eus in adiutorium meum
intende.Domine ad adiuuan
dum me festina. Gloria
patri et filio et spiritu sancto.
Sicut erat. ꝉ. Ymnus.

69. *Saints Peter, John the Baptist, and Martin.*

A full-page miniature probably preceded this scene. The three saints stand frontally, each with his customary attributes: Peter with keys, book, and tiara; John holding the Lamb of God on a book; and Martin in his bishop's vestments, giving his cloak to a diminutive crippled beggar.　　　[G–f.124]

Laudamus omnes in
domino diem festum ce
lebrantes in honore sanc
torum omnium de quorum sollep
nitate gaudent angeli et collau
dant filium dei. ps Exultate
iusti in domino. rectos decet col
laudatio. Gloria patri et filio

70. *Solomon Distributing Bread.*

The large miniature which introduced the Sacrament series is lacking, thus the series now begins with this picture. As the biblical quotation in the upper margin makes clear, the scene is based upon Proverbs 9:5, in which Wisdom invites everyone to share her bread and wine, an obvious antetype for the Eucharist. In this miniature, Solomon, as Wisdom, and a helper dispense bread from open sacks to three kneeling men. In the border another man walks away carrying a similar full sack over his shoulder. This sack and one other bear cryptic markings; these may have been used for identifying grain, possibly on Catherine's estates, or they could indeed be the artist's monogram. The banderole above Solomon bears a quotation from Genesis 47:13, which reads: "And there was no bread in all the land." The heads of the Apostles Andrew and Paul appear in the upper corners, and from them unroll two scrolls, one quoting John 6:9, on the multiplication of loaves and fishes, and the other from Paul's First Epistle to the Corinthians (10:16) identifying the communion bread with the body of Christic. [G–f.131]

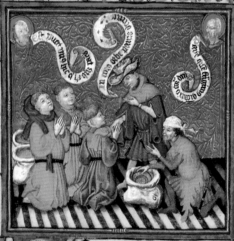

Omine labia mea ape
ries. Et os meum annū
ciabit laudem tuam.
eus in adiutorium meum
intende. Domine ad adiuuan
dum me festina. Gloria pa
tri et filio. et spū sco. Siait
erat in princ. ⁊c. Ymnus:

71. *Moses and John the Evangelist Kneel before a Monstrance.*

On either side of the central altar with a monstrance containing the host kneel Moses (with black horns) and John. Above each is a banderole: that of Moses has a quotation from Deuteronomy 8:3, on the gift of manna (an antetype for the bread of the Eucharist), while John's text is from Apocalypse 2:17, predicting a new gift of manna. Kneeling behind Moses is an unidentified old man in contemporary dress, possibly Catherine's father, Adolph of Cleves, or more likely the prophet Nehemiah who is quoted in the adjacent margin. The scrolls in the side margins bear text from II Esdras or Nehemiah 9:15, and John 6:35. The quotation from Nehemiah mentions God's gift of manna or "bread from the sky." In the opposite margin John quotes Jesus as saying, "I am the bread of life: he that cometh to me shall not hunger." [G–f.133]

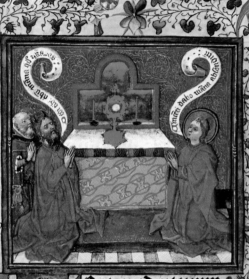

Panem de celo prestitisti eis in semie eos

Thesu Ego sum panis vite qui veniat ad me non esuriet

Cus in adiutorium
meum intende. Domi
ne ad adiuuandum
me festina. Gloria patri et fi
lio et spiritu sancto. Sicut e
rat in principio et nunc et semp
et in secula seculorum amen.
Ymnus

72. *Communion.*

His back to the altar, the celebrant holds a chalice in one hand and with the other places a portion of the host in the mouth of one of the two kneeling communicants. On the altar is a monstrance, standing in front of a gold retable and two burning candles. The heads of Elijah and Moses appear in the upper corners, each with a banderole referring to bread or "holy things." Elijah's text is taken from III Kings 19:6; that of Moses is from Leviticus 22:3. Two paraphrases written in the margins, both based on the Gospel of John, refer to Judas, perhaps to his acceptance from Jesus of the soaked bread or sop (13:26–27), and to John's identification of Jesus as the bread from heaven (6:33). [G–f.134v]

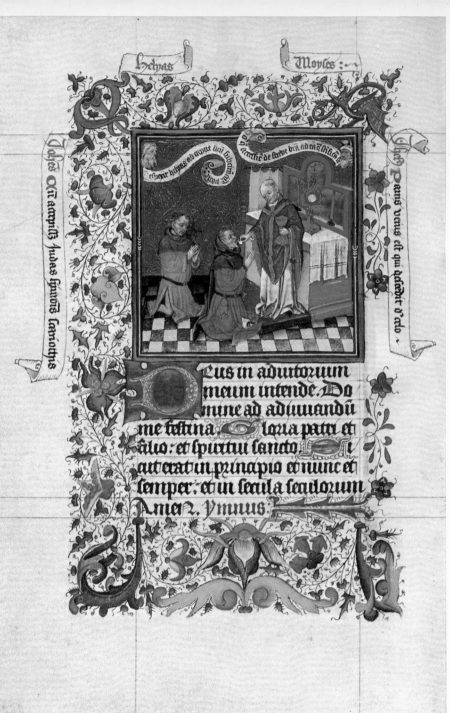

Deus in adiutorium
meum intende. Do
mine ad adiuuandū
me festina. Gloria patri et
filio: et spiritui sancto. Si
aut erat in principio et nunc et
semper: et in secula seculorum
Amen. Ymnus.

73. *Isaiah, Aaron, Paul, and Luke Adoring a Monstrance.*

The Old Testament figures, without halos, kneel to the left of the altar; those of the New Testament to the right. On the floor before Aaron is his mitre, identifying Aaron as a bishop; above his head is a banderole with a text drawn from Exodus 12:48, requiring that no uncircumcised person shall eat of the passover. The text of a second banderole, above Paul's head, has a parallel meaning in its quotation from his First Epistle to the Corinthians (11:28), demanding that a man be worthy before partaking of the eucharistic bread and wine. Two further scrolls are unrolled in the margins with complementary texts from Isaiah (45:15, on the left) and Luke (8:17, on the right). While the Old Testament quotation says, "Verily thou art a God that hidest thyself," that from the New Testament affirms, "Nothing is secret, that shall not be made manifest."

[G–f.136]

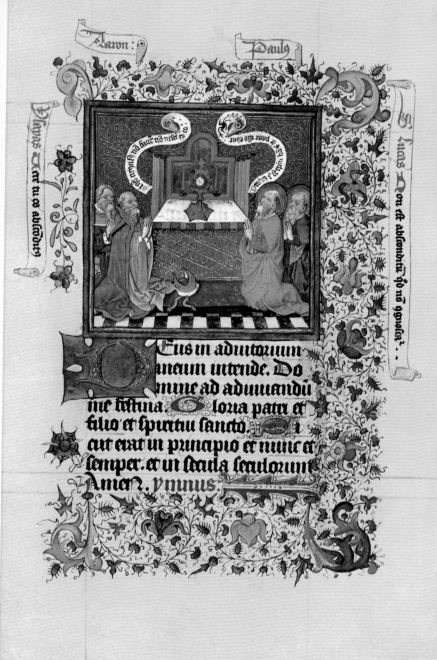

Eus in adiutorium
meum intende. Do
mine ad adiuuandū
me festina. Gloria patri et
filio et spiritui sancto. Si
cut erat in principio et nunc et
semper. et in secula seculorum
Amen. ymnus.

74. *Gathering of Manna.*

Manna, looking much like large hailstones, rains from
heaven, while Aaron and five Israelites gather it into their
robes, hats, and baskets. Moses, identified by his black horns
and holding a staff, stands at the side watching. Before him
is Aaron wearing a bishop's mitre over a turban. Among
the biblical texts in the margin are two drawn from Exodus
(16:4 and 15) that describe the event. Two other texts drawn
from the New Testament, one from John 6:11, and the other
from Paul's First Epistle to the Corinthians 11:24, relate the
falling manna to Christ's distribution of loaves among the five
thousand and of the bread of His body among His disciples
at the Last Supper. [G–f.137v]

Monstos ex pluia vobis panes de celo ·

Aly ista · Cū vidissent viri ista pacts dicebāt maxhu · i · p2 thor

Eus in adiutorium
meum intende. Do
mine ad adiuuandū
me festina Gloria patri et fi
lio et spiritui sancto. Sicut
erat in principio et nunc et sem
per. et in secla seculorum amē.
Ad nonam:

75. *Supper at Emmaus.*

Christ, in pilgrim's garb with shell badges, is seated behind
the table; facing Him are, on the left, Luke (?) with a halo, and,
on the right, Cleopas without. Christ breaks the bread, while
Luke reaches for some meat and Cleopas drinks from a glass.
In the margins are four texts drawn from the Bible: Exodus
16:35; Lamentation of Jeremiah 4:4; Matthew 28:20; and
Luke 24:35. While the text from Luke narrates the revelation
of Christ at Emmaus through His breaking of the bread, the
other texts interpret the event. In the passage from Matthew,
Christ reassures His disciples that He will be with them al-
ways; the two Old Testament quotations speak of bread and
manna. [G–f.139]

139

Jheremias Perunli petienit pane? & nō erat q̄ frāgret eis ·

Apostolus · Filij ideo inuedetit mā xō anis ·

Eus in adiutorium
meum intende. Do
mine ad adiuuandū
me festina. Gloria patri et
filio et spiritui sancto. Si
aut erat in principio et nunc et
semper. et in secula seculorum
amen. Ymnus.

76. *Israelites Eating the Passover Lamb and Unleavened Bread.*

Four Children of Israel stand around a circular table eating
lamb and unleavened bread. In the upper left-hand corner is
the head of Isaiah with a banderole text from his book (52:11)
which enjoins cleanliness on those bearing the vessels of the
Lord. In the opposite corner are another head and text which
have not been identified; the text says that "the multitude of
the Children of Israel shall sacrifice a young goat." Two
quotations from Paul's First Epistle to the Corinthians (5:7
and 11:27) give a Christian meaning to the food of the Pass-
over, while another Latin quotation in the upper margin,
attributed to Isaiah, reads, "the Children of Israel with a lamb,"
and provides a title for the miniature. [G–f.140v]

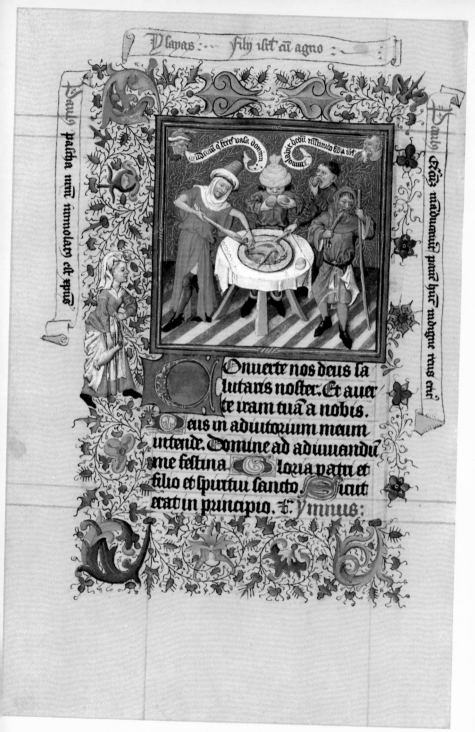

77. *Last Supper.*

Christ is seated at the center of a rectangular table, and the apostles, divided into two equal groups, are arranged around the ends. John rests his head on Christ's breast, while Christ gives Judas the sop by which He identified His betrayer. At the moment of betrayal, Satan, represented here as a small black demon, entered Judas. The other apostles are shown eating and drinking. On the tiled floor in the foreground, two dogs snarl over a bone; a maid enters through the door at the right. The rather plain rectangular room is given a more formal, even liturgical, appearance by two concave niches in the side walls flanking Christ, and by a tall window in the end wall behind Christ's head. The significance of the scene is interpreted by two scrolls in the margins with biblical quotations: one from Psalms (77:25) that speaks of eating the bread of angels, and one from Luke (14:15) saying, "Blessed is he that shall eat bread in the kingdom of God." [G–f.142v]

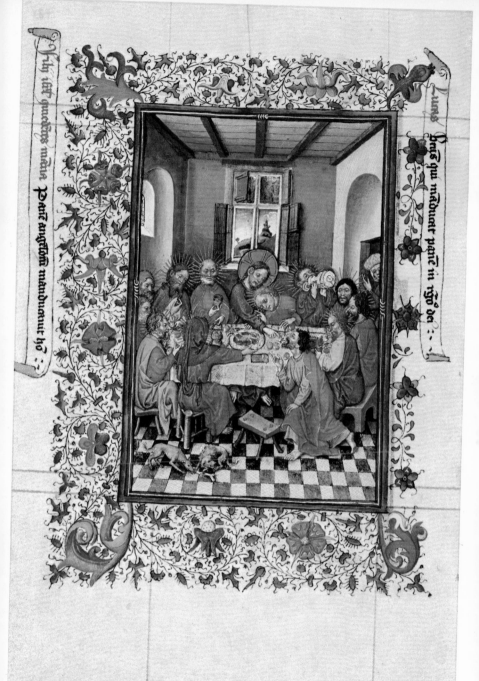

78. *Moses and Paul Observing the Celebration of Mass.*

A priest kneels before an altar upon which stand a monstrance, a covered chalice, a book, a lectern, and two candles burning before a retable. Behind him stand Moses and Paul, each with a banderole. That of Moses bears a quotation from Exodus (19:22) in which the Lord demands the sanctification of the priests; the quotation of Paul's scroll is taken from his First Epistle to the Corinthians (11:31) where he speaks of judging the worthiness of those who eat the bread or drink the wine of the Eucharist. Largely hidden by Moses is another, as yet unidentified, saint. [G–f.143]

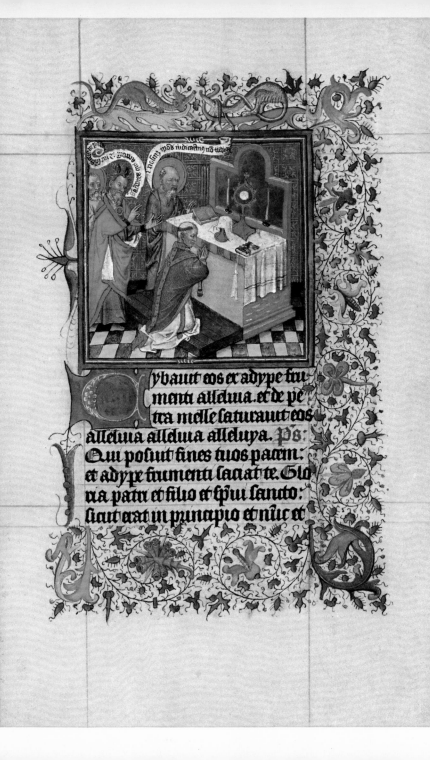

ybauit eos ex adype fru
menti alleluia. et de pe
tra melle saturauit eos
alleluia alleluia alleluya. Ps:
Qui posuit fines tuos pacem:
et adype frumenti saciat te. Glo
ria patri et filio et spu sancto:
sicut erat in principio et nüc et

79. *The Dying Adam Dispatching Seth to Paradise.*

This unusual cycle, illustrating the legend of the cross, was originally introduced by a large miniature, now missing, perhaps depicting the Tree of Knowledge or the Fall of Man. Here, however, it begins abruptly with Adam commanding Seth to fetch a branch of the Tree of Mercy. The cadaverous Adam lies on his deathbed, speaking to his third son, Seth, who stands beside the bed and respectfully removes his straw hat. Seth appears a second time, as he leaves the bedside, with his hat on and a staff over his shoulder—an unusual example in this manuscript of "continuous narrative." In addition to the imposing bed, the furnishings of the shallow barrel-vaulted room include a chair beside the bed and a candle resting on a small scroll in a niche above the headboard. A small landscape with a tree (symbolic of the Tree of Mercy?) may be seen through the window in the rear wall separating the two Seths. In the lower border are a dragon and lion counter-passant, each with one front leg raised. [M–p.75]

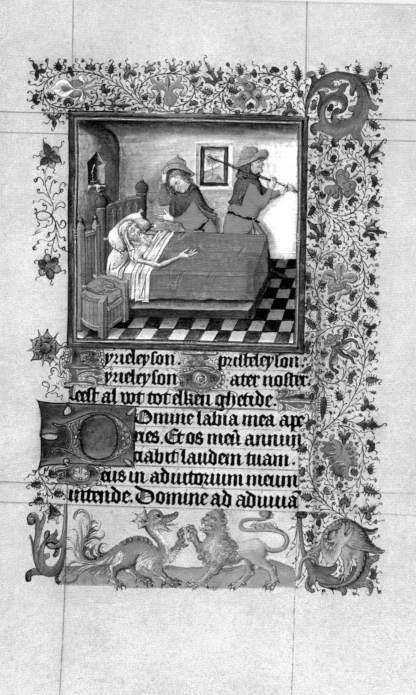

yrieleyson. xpeleleyson.
yrieleyson ater noster.
leest al wt tot elken ghetide.
Omine labia mea ape
ries. Et os men annun
tiabit lauden tuam.
eus in adiutorium meum
intende. Domine ad adiuua

80. *The Archangel Michael Giving Seth a Branch of the Tree of Mercy.*

The archangel Michael, having just emerged from the golden gate of Paradise, gives a branch to Seth. The two stand in front of the mauve-rose wall and a gothic gatehouse to Paradise. Little can be seen of Paradise itself: two trees project above the wall, and through a sluice gate in the wall runs the water from one of the rivers of Paradise. The arched sluice gate, barred by a gold grating, resembles a water wheel turned by a small treading animal on the keystone. In the lower border, Seth's older brothers, Abel and Cain, place their offerings to God upon an altar. [M–p.85]

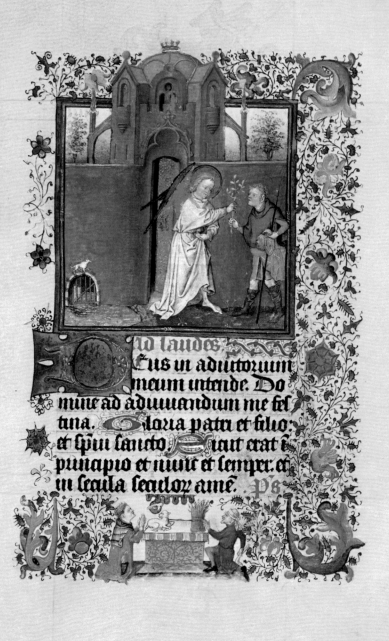

ad laudes
Eus in adiutozium
meum intende. Do
mine ad adiuuandum me fel
tina. Gloria patri et filio:
et spui sancto, Sicut erat i
principio et nunc et semper. et
in secula seculoz amen. Ps

81. *Seth Planting the Branch in the Mouth of the Dead Adam.*

The corpse of Adam, wrapped in a white shroud, has been laid out on a hillside in a cool green landscape. Seth bends over the body and places the branch from Paradise in Adam's mouth. In the lower border a seated woman with a straw hat milks a cow.

[M–p.91]

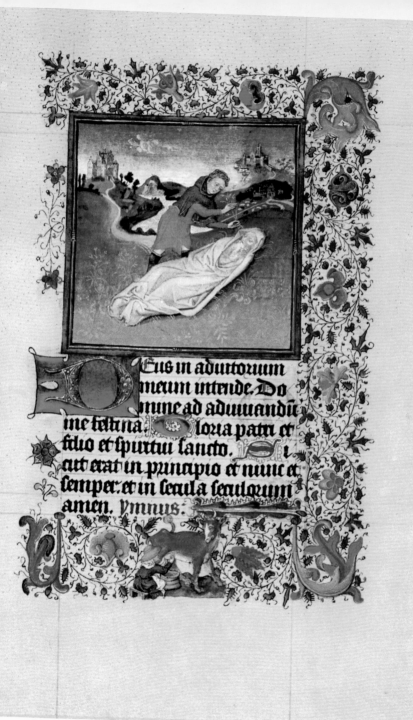

Eus in adiutoríum
meum íntende. Do
mine ad adiuuandu
me festina. Gloria patrí et
filío et spírítuí sancto. Si
cut erat in prínapío et nunc et
semper: et in secula seculorum
amen. Ymnus.

82. *Tree Growing from Adam's Grave.*

The tree has grown through a crack in the mauve-rose grave slab decorated with a horizontal pilaster. At the base of the tree lies a skull, presumably Adam's, part of whose skeleton can be seen beneath the slab. The small green animal, no doubt a mouse, a frequent symbol of death and the destruction of time, is about to enter the grave. Behind, in his lair, a wolf-like animal gnaws upon a bone. The striking contrast of the green foreground and the vivid orange sunset sky is harmonized through the yellowish tones predominating in each. This scene is a rare early example of "pure" landscape. In the lower border the hand of God stays the sacrificial sword of Abraham raised to kill his son Isaac before a flaming altar. [M–p.97]

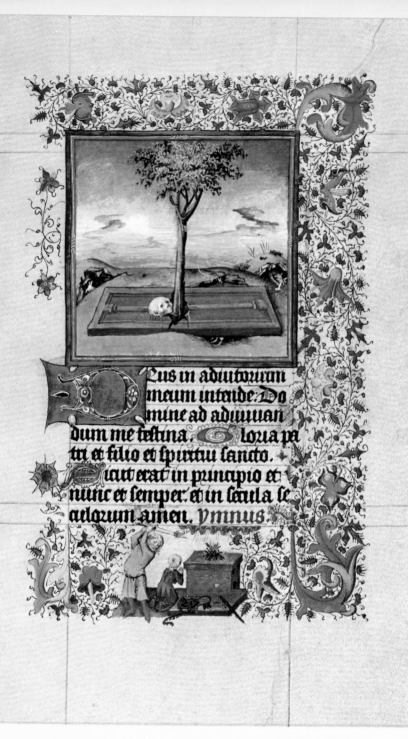

eus in adiutorium
meum intende. Do
mine ad adiuuan
dum me festina. Gloria pa
tri et filio et spiritui sancto.
Sicut erat in principio et
nunc et semper. et in secula se
culorum amen. Ymnus.

83. *Solomon Ordering the Tree Cut Down.*

Planning to use the tree for building his temple, Solomon commands that it be chopped down. The king and three members of his retinue stand at the right; Solomon touches the tree with his sceptre, while a carpenter at the left begins to fell it with his ax. The scene takes place in a space enclosed by a woven fence. In the lower border a round-faced boy turns two animals, probably lambs or chickens, on an open-air spit with a fire behind and dripping-pan and ladle beneath. [M–p.101]

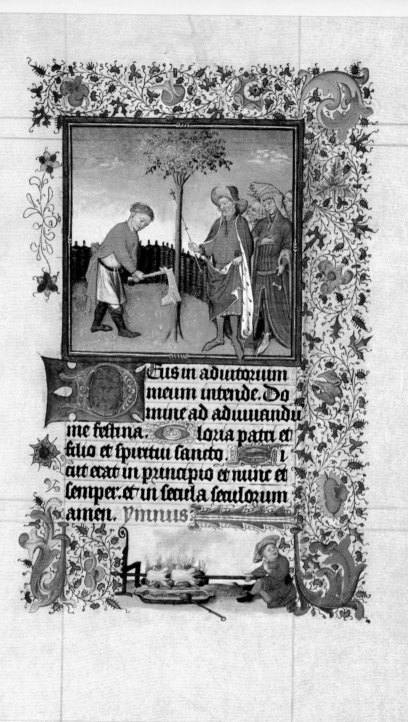

Gis in adiutorium
meum intende. Do
mine ad adiuuandu
me festina. Gloria patri et
filio et spiritui sancto. Si
cut erat in principio et nunc et
semper: et in secula seculorum
amen. Ymnus.

84. *Measuring the Timber.*

Having cut the tree and shaped the timber, the carpenter is measuring it with a piece of string, supervised by Solomon and two members of his retinue. The ax blade has been buried in the stump of a tree in the foreground; the enclosing woven fence has disappeared. In the lower border a harp-playing dwarf (?) rides a yellow and green "dragon." [M–p.105]

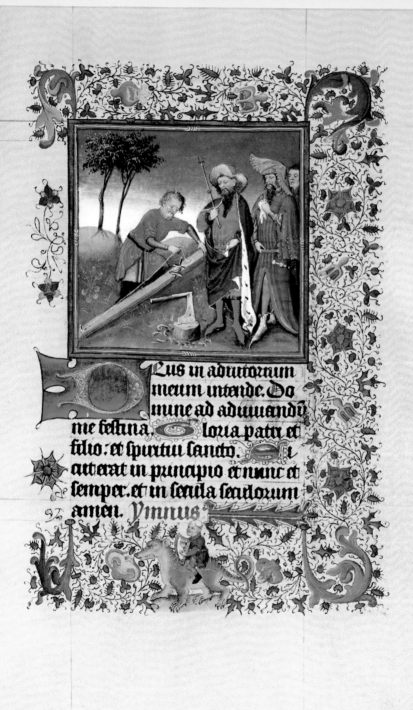

Ius in adiutorium
meum intende. Do
mine ad adiuuandū
me festina. Gloria patri et
filio: et spiritui sancto. Si
aderat in principio et nunc et
semper. et in secula seculorum
amen. Ymnus

85. *Queen of Sheba Fording a Stream (the Kedron?).*

When Solomon's carpenters found that they could not use the wood, which was always too long or too short for the Temple, they used it instead for a footbridge. The Queen of Sheba, recognizing it as the wood upon which Christ would be crucified, refused to step on it and, according to one of the many versions of the story, waded through the stream. She is shown here holding up her long dress and fording the stream, while Solomon and one of his courtiers watch from the right bank. F. Gorissen has identified this courtier as Duke Adolph of Cleves, father of Catherine, from the necklace worn by the Knights of Saint Anthony and from his likeness to Adolph's other portraits. On the left bank, a Negro attendant of the queen, dressed in an exotic gold and purple costume, shows a piece of jewelry to a lady, presumably a member of the Queen of Sheba's entourage or the court of Solomon. The footbridge, made of the single timber and a rough log railing, is visible behind the queen. This scene, especially in the light of the following miniature, probably represents the curing of the queen's legendary malformation, duck-feet, through the power of the Tree of Mercy. The border contains a woman spinning and displaying her garden produce before a conically tented market booth. [M–p.109]

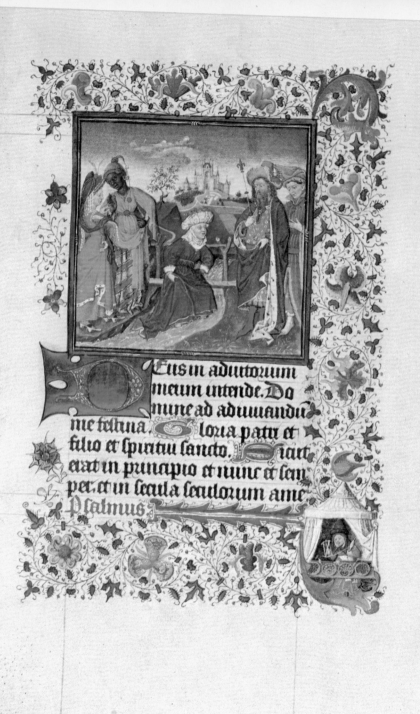

Eus in adiutozium
meum intende. Do
mine ad adiuuandu
me festina. Gloria patri et
filio et spiritui sancto. Sicut
erat in principio et nunc et sem
per. et in secula seculozum amen.
Psalmus.

86. *Miracles of the Pool of Bethesda.*

The healing powers of this pool, mentioned in the fifth chapter of Saint John's Gospel, are attributed to an angel who occasionally stirs its waters. In the Middle Ages these powers were also explained by the presence in the pool of the wood of the Tree of Mercy, upon which, according to an ancient prophecy, the Kingdom of the Jews would come to its end. Fearing this prediction, Solomon had the wood buried, and the miraculous pool was formed by water welling up over the burial spot. In this scene the angel stirs the water, and the log (not the timber) floats in the pool. One lame man sits by the pool holding a staff; another lies beside the pool, while a third is being lowered into the water by an attendant. In the lower border, Christ, kneeling on the ground, washes the feet of Peter. [M–p.114]

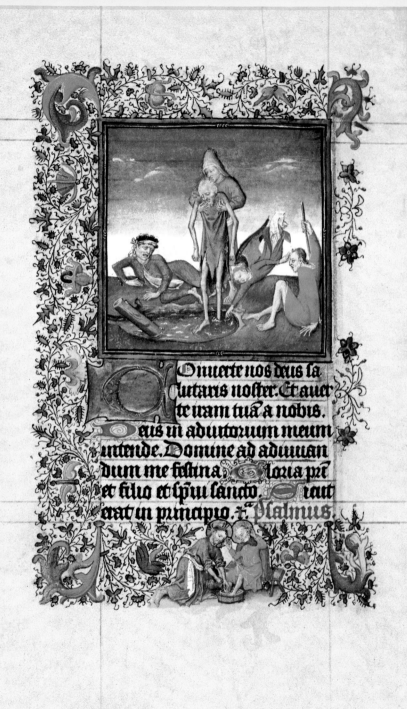

Onuerte nos deus sa
lutaris noster. Et auer
te iram tua a nobis.
eus in adiutorium meum
intende. Domine ad adiuuan
dium me festina loria pri
et filio et spu sancto. sicut
erat in principio. ꝯ Psalmus.

87. *Christ Standing on the Lowered Cross.*

A second full-page miniature missing from this series on the legend of the cross must have faced this scene. Here Christ, bleeding from the wounds of His flagellation and crucifixion, stands in triumph with one foot on the reclining cross. He is dressed only in a loincloth and wears His crown of thorns. No other figures appear; indeed, there is no sign whatever of any human habitation in the barren landscape. Rather than historical, the scene is symbolic or allegorical. In "Christ in the Winepress," another allegorical scene which appears in the lower border, Christ holds two whips from the flagellation under His arms, and the blood from His wounds runs through a trough into a golden chalice below. [m–p.121]

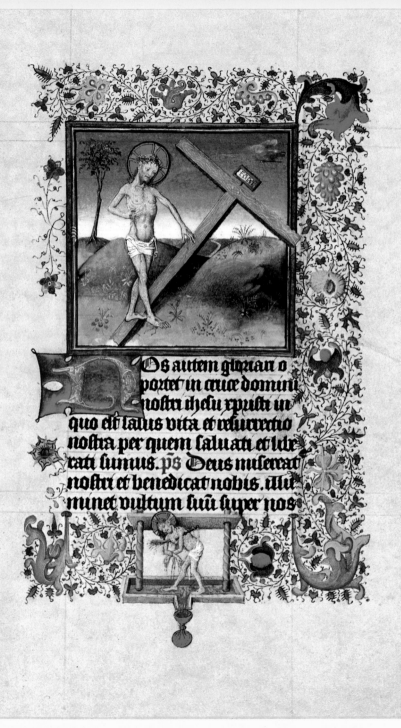

Os autem gloriari o
portet in cruce domini
nostri ihesu xpristi in
quo est salus vita et resurrectio
nostra per quem salvati et libe
rati sumus. ps Deus misereat
nostri et benedicat nobis. illu
minet vultum suũ super nos

88. *Creation of Eve.*

A luminously blond Creator, dressed in lavender and rose robes, blesses Eve and touches her hands, as she emerges half-length from behind Adam, rather than from his side. Though turning his body away from God, Adam looks up at Him, while awkwardly propping his head on his hand. The three figures, all of very fair complexion, are silhouetted against a dark blue-green hillock on which grow five trees; two of these are orange trees, and one appears to be a palm. The border, composed of spreading leaves and fleshy buds, parallels the fullness of Eve's figure and the fertility of Eden. [M–p.138]

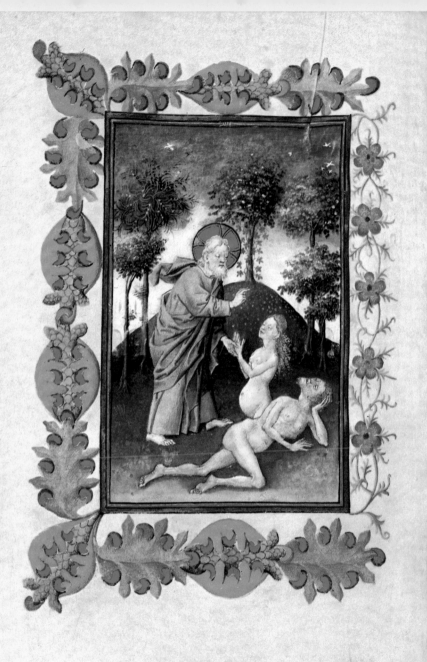

89. *Eve and the Virgin.*

The two mothers of mankind, the original Eve and the "New Eve," the Virgin Mary, stand on opposite sides of the Tree of Knowledge. The serpent hands a piece of fruit to the first Eve, who is naked except for the leaf with which she covers herself. In contrast, the Virgin is heavily clothed, as is the Infant Jesus whom she holds. The opposition of the two Eves is made explicit by the banderole held above the tree by an angel: "Eve authoress of sin; Mary authoress of merit." The rigid symmetry of the miniature is echoed in the paired motifs of the border which create a bower of delicately colored leaves and flowers. [m–p.139]

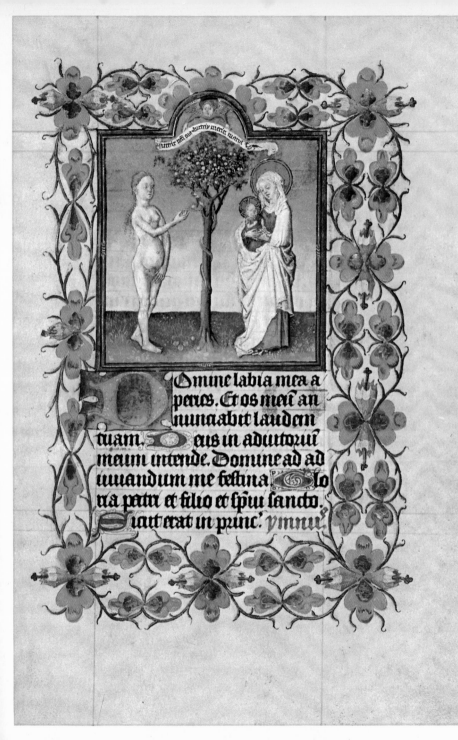

Omine labia mea a
peris. Et os meū an
nunciabit lauden
tuam. Deus in adiutoriū
meum intende. Domine ad ad
iuuandum me festina. Glo
ria patri et filio et sp̄u sancto.
sicut erat in princ. ymnū.

90. *Tree of Jesse.*

From Isaiah's mention of Jesse's root, branch (*virga*), and flower, and from the genealogies of Christ given in the Gospels, the Middle Ages created a family tree arising in Jesse, continuing through Christ's ancestors, and concluding with the Virgin and her Son. Here the tree grows from the breast of Jesse who lies upon a pallet on the ground. Among the leaves are distributed twelve unidentifiable "portrait" busts of the royal ancestors, arranged without regard for generations, and seated at the top is the Virgin, an open book on her lap. In the lower left corner, David plays his harp under the tree; Christ, however, is not depicted in this scene. The border is composed of large, fanciful leaves in various colors. [M–p.148]

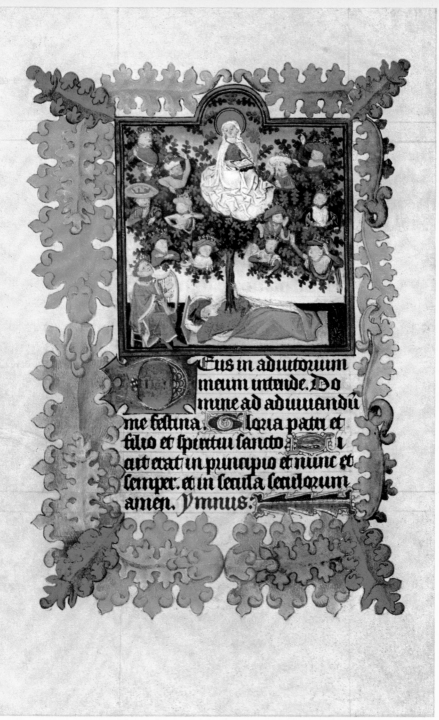

Eus in adiutorium
meum intende. Do
mine ad adiuuandu
me festina. Gloria patri et
filio et spiritui sancto. Si
cut erat in principio et nunc et
semper. et in secula seculorum
amen. Ymnus.

91. *Joachim and Anne:*
The Immaculate Conception.

That appears to be only a double portrait of the Virgin's parents is in fact also a rare version of the Immaculate Conception. Joachim and Anne, silhouetted against a burnished gold background, stand upon a floor decorated with tiles of the sun and moon. Joachim holds a scroll with a Latin legend. saying that Anne will give birth to the mother of the Saviour; Anne holds a book and gestures in demure surprise, as does her daughter in the Annunciation. Above, in the blue arc of heaven, God the Father appears, holding a gold globe and blessing Anne; golden rays radiate from Him toward the womb of Anne. The border weaves a fantasy of similar forms, a gold bar entwined by leaves of uterine shape. [M–p.145]

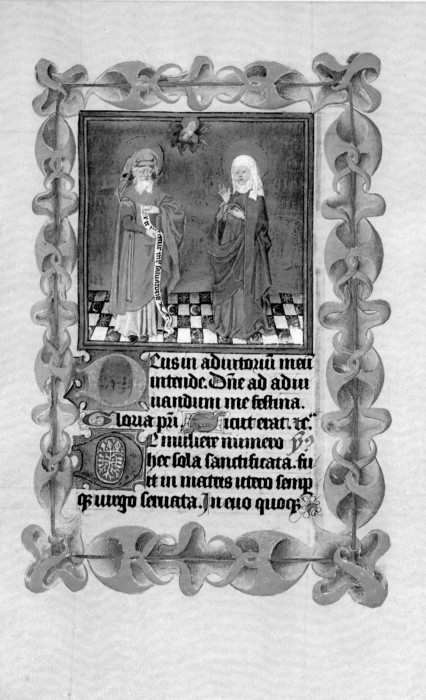

Eus in adiutoriū meū
untende. Dñe ad adiu
uandum me festina.
Gloria pri. Sicut erat. xc.
E muliere numero
hec sola sanctificata. fu
it in matris utero semp
q̃ uirgo seruata. In euo quoq̃

92. *Holy Family at Work.*

Within a domestic interior, the Virgin is seated weaving at a loom; Joseph stands planing a board, while the Infant takes His first steps in a walker. Many homely furnishings and utensils are distributed throughout the room: a shelf of silver or pewter plate, a cabinet of weaving materials, a fireplace with an adjustable hook for holding pots, a carpenter's bench and various tools, etc. Two windows open onto the landscape beyond. The infant Jesus holds a banderole that floats up toward His mother; its Latin legend says, "I am your solace." The border is composed of small delicate leaves and flowers. [M–p.149]

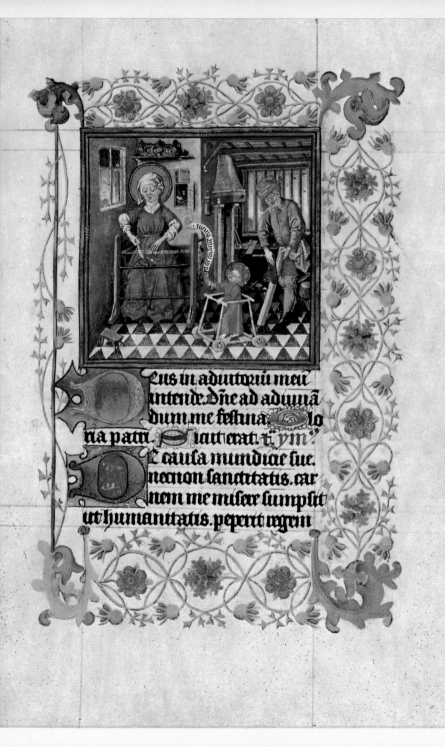

eus in adiutoriu meu
intende. Dne ad adiuuan
dum me festina Glo
ria patri Sicut erat. ÿm̄
C causa mundicie sue.
necnon sanctitatis. car
nem me misere sumpsit
ut humanitatis. peperit uirgin

93. *Holy Family at Supper.*

The Virgin, seated upon a yellow mat on the floor, nurses the infant Jesus, while Joseph rests in a barrel chair, spooning his soup. The room is not the same as that of the preceding miniature, but it has a similar abundance of furnishings and utensils. Two pots cook in the tall cylindrical fireplace, one in the fire and one hanging over the flames from an adjustable hook. Tongs lean against the side of the fireplace and a hand grill hangs above; also visible are a hook, ledge, and warming niche. Beside the fireplace are a shelf of silver or pewter plate, a pair of shears, a bellows, a wooden cabinet with food and various dishes, and a basket with herbs (?). On the side wall a rack holds still other utensils. The leaves and flowers of the border are unusually delicate. [M–p.151]

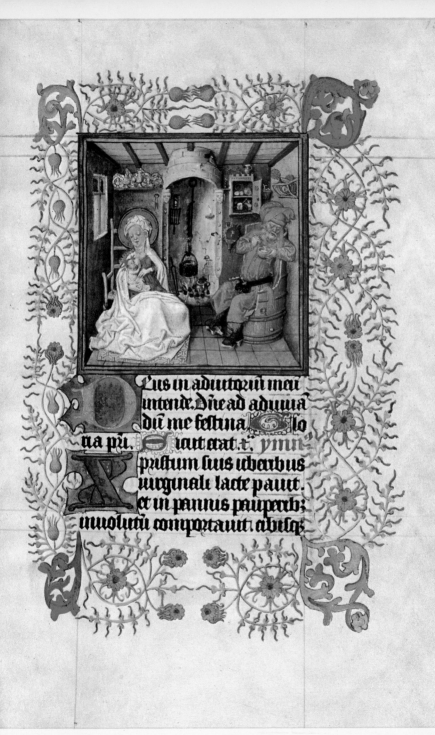

eus in adiutoriu meu
intende. Dne ad adiuua
du me festina. Glo
ria pri. Sicut erat. Ymnu

priftum fuis vbcrbus
uirginali lacte pauit.
et in pannis pauperib;
inuolutu coportauit. abifcp

94. *The Ascension.*

Unlike the usual Ascension crowded with apostles, this scene is limited to a devoutly kneeling Virgin who looks up at her Son disappearing into the clouds, only His feet and the bottom of His garment still visible. This scene of their private parting takes place by the door of a small church-like building. The border is comprised of small leaves and flowers.

[M–p.153]

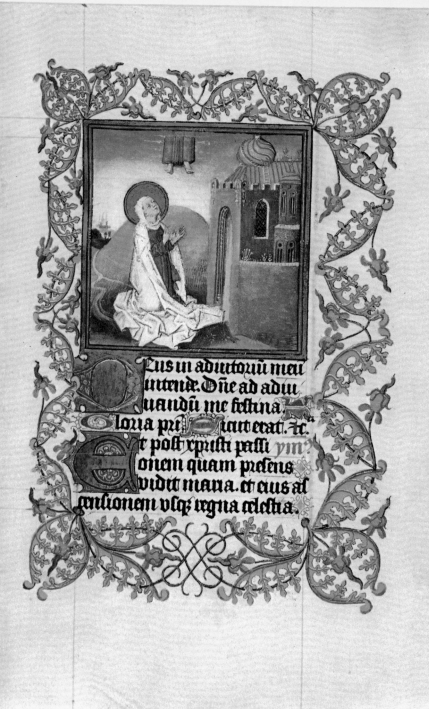

Eus in adiutoriu meu
intende. One ad adiu
uandu me festina.
loria pri . atr erat. ꝛc.
t post cristi passi ꝰ ym
onem quam presens
vidit maria. et eius as
censionem vsqꝫ regna celestia.

95. *The Funeral Procession of the Virgin.*

The funeral cortege consists of the twelve apostles: John, carrying a palm, leads the way; behind him is the coffin covered with gold cloth and carried by four of the apostles; beside the coffin are Peter, who sprinkles holy water on it, and Paul, who censes it; the remaining five apostles follow behind. Beyond a small hillock stands the priest Jephonias with a group of soldiers; two other soldiers, in an attempt to turn back the procession, have tried to seize the coffin, but their hands stick miraculously to it—indeed, the hand of one soldier is torn off at the wrist. Small leaves and flowers compose the border.

[M–p.157]

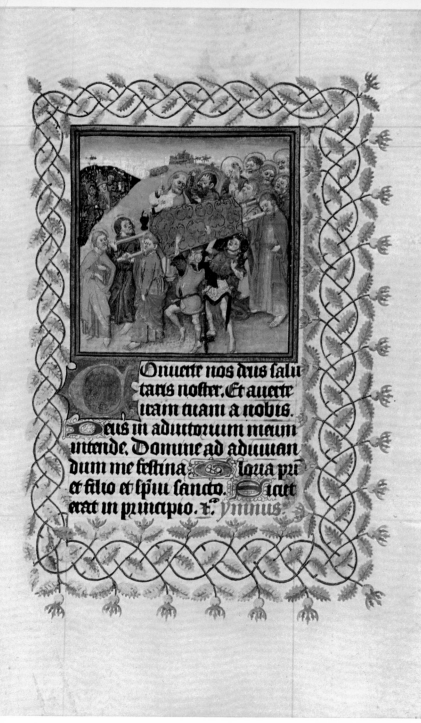

Onuerte nos dñs salu
taris noster. Et auerte
iram tuam a nobis.
Deus in adiutorium meum
intende. Domine ad adiuuan
dum me festina. Gloria pri
et filio et spui sancto. Sicut
erat in principio. ꝯ Ymnus.

96. *Crucifixion with God the Father, the Virgin, a Patron-Saint, and Catherine of Cleves.*

The significance of this devotional scene is explained by the banderoles: Catherine pleads with the Holy Mother of God to pray for her; the Virgin intercedes with her Son to be gracious to Catherine for His mother's sake, whose breasts nursed Him; Christ crucified asks, in the name of His wounds, for His Father to spare Catherine; and the Father tells His Son, "Your prayer has been heard with favor." On the tiled floor, at either side of the cross, kneel the Virgin (on a red carpet) to the left, and Catherine (on a blue carpet) to the right. The Virgin, one of her breasts bare and spurting milk, gazes up at her Son; Catherine looks down at her praying hands and carries over her arm the rosary that is shown again almost actual size in the border of no. 116. She wears a mauve-rose, ermine-lined houppelande, and her hair is worn in pointed templers under a goffered veil, identical with that of the personification of piety in no. 57 and similar to that of her portrait in no. 1. On the floor in front of her are a tiny poodle-like dog and a beautifully painted stool with a half-open book on it. Behind her stands an unidentified saint with a crozier, presumably a bishop and her patron saint, who gently touches her shoulder with his gloved hand. The Christ is not dead, but rather looks up beseechingly to His Father, who appears in the corner surrounded by angels, wearing a tiara, holding a globe, and blessing his Son. The miniature is surrounded by an elaborate pattern of orange interlace knots upon which are hung panels of geometrical intarsia work, Italian or Spanish in style.

[M–p.160]

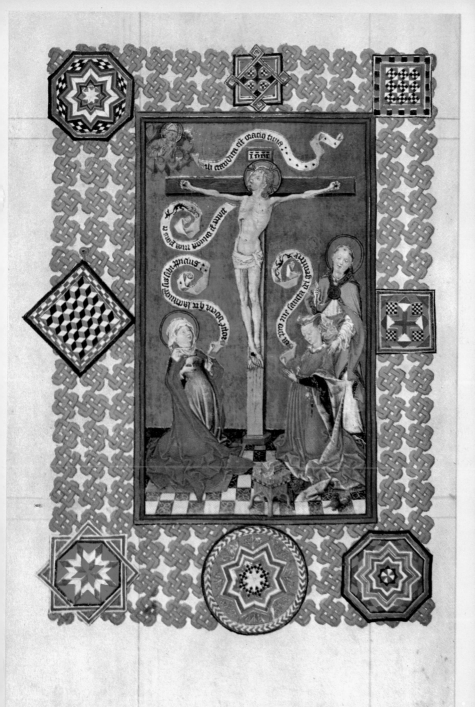

97. *Virgin and Child in a Grape Arbor.*

The Virgin, wearing a gold crown, is seated reading on the grass, surrounded by a low brick wall which supports a gold trellis with grapevines. The infant Jesus and two angels collect bunches of grapes from the arbor, a clear reference to the Crucifixion and the Eucharist. Above the Virgin's head, a third angel holds a banderole with the introit of the Mass below: *Salve sancta parens enixa puerpera regem.* Most of the border is composed of textile and lacework motifs, but at the bottom are six singing angels crowding around a lectern enclosed by a large throne whose cushions bear an armorial design resembling the Cleves device. [M–p.161]

Salue sancta parens e
nixa puerpera regem q
celum terramq; regit
in secula seculor. Ps. Sentiant
omnes tuu leuamen quiaiq; ce
lebrant tuam commemoratio
nem. Gloria patri et filio et spi
ritui sancto. sicut erat in princi

98. *Man of Sorrows with Kneeling Franciscans.*

The Penitential Psalms may have opened originally with a full-page miniature, now missing. His wounds visible, Christ, wearing the crown of thorns and holding the two whips of the Flagellation, stands half-length in His tomb before an orange and green cloth hung from the arms of the cross above. At the sides of the tomb are two groups of four kneeling Franciscans; each group has a banderole, and though both legends are only partly legible, they ask the forgiveness of sins. In the lower border is the reclining Lamb of God, holding the staff and banner of the Resurrection, blood spurting from His chest into a nearby chalice. [G–f.151]

Omine ne in furore tuo arguas
me: neꝗ in ira tua corripias me.
Miserere mei domine quoni
am infirmus sum: sana me
domine quoniā conturbata
sunt ossa mea. Et anima
mea turbata est ualde: sed tu
domine usꝗ quo Conuer
tere domine et eripe animam

99. *Mouth of Hell.*

Not one, but three mouths are incorporated into this awe-some vision of the castellated gate of Hell. At the top of the structure is a blue-green head, its mouth forming an ogive arch enclosing a rectangular window that opens into the fiery interior, its lower jaw forming a crenelated parapet from which two demons throw stones on the sinners below. The skull-decorated façade is flanked by two towers that are actually furnaces whose fires heat caldrons into which demons cast the mutilated bodies of sinners. The entrance to Hell is formed by two additional mouths, one inside the other. The outer head, with gold eyes and flames shooting from its nostrils, has its lips pulled wide apart, and a crab-like claw attached to each point of the scalloped edge. Within the circular opening of the outer mouth is the crimson inner head with its gold eyes and gaping toothless mouth, in which souls are being boiled in a vat by demons. Outside the mouth, many more souls are being tormented: one group is chained to a wheelbarrow pushed by a demon; another chained group is being dragged into the flames; still another group, caught in a flaming cavern below the ground, is being prodded with a spear; and many separate souls are dragged, clawed, hammered, speared, and devoured. The kinds of demons are as varied as their tortures—they are black, red, green and blue; some are hairy; some have claws, some quills; some look like frogs, some like pigs, some like insects, and some bear no resemblance to any beast of this world. From the mouth of a green demon in the lower border emerge scrolls listing the seven deadly sins. [G–f.168v]

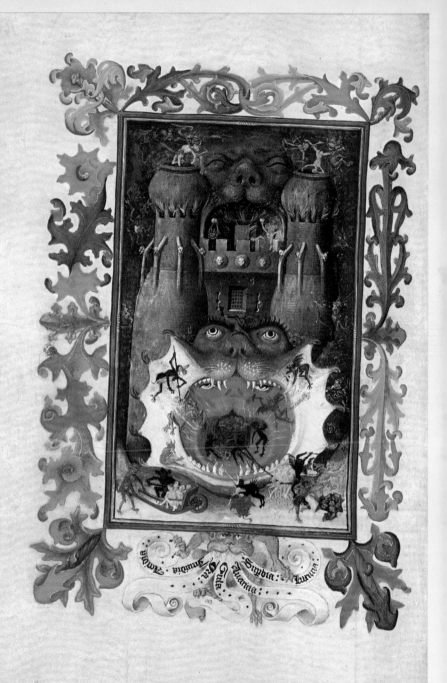

100. *Funeral.*

In a vaulted chapel or church, the Office or Mass for the Dead has just concluded. The mourners, entirely in black but for their white pattens, enter another room and approach the coffin, which is covered by a black cloth with two long strips of gold forming a cross on the top. Three gold candlesticks with burning tapers have been placed upon the coffin, behind which stand three clerics, one holding a cross-staff, another sprinkling holy water and reading, and a third filling his censer. They are garbed in surplices; each has a black amice and a black maniple; the central figure wears a black stole. In the border, two dragons hold a golden basket of apples between them. [G–f.169]

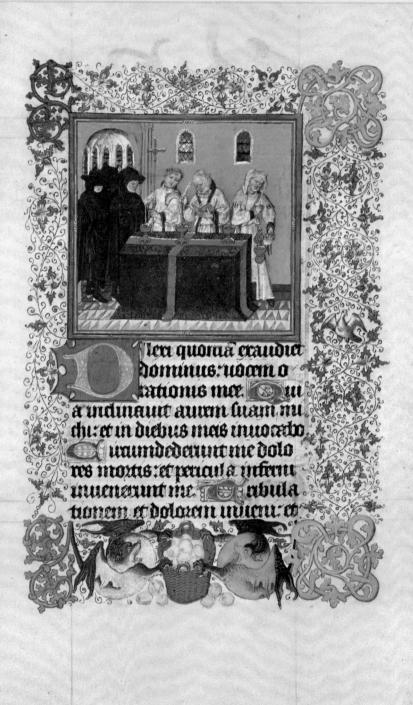

101. *Saint Michael Battling Demons.*

The manuscript's remaining miniatures, mostly "portraits" of individual saints, illustrate an unusually long series of suffrages, brief devotions usually dedicated to a single saint. They begin with Saint Michael standing triumphantly on the bodies of two demons and raising his sword over a cowering third demon. The saint, a green crown on his head, wears a pale purple cassock, a green stole, and a long red mantle that has slipped from his shoulders. The battle takes place among rocks with flaming fissures, in one of which another demon can be seen. [M–p.204]

et regnas aim deo patre in u
nitate spiritus sancti deus: p
omnia secula seculor. Amen.
Domine exaudi oracione
meam. Et clamor meus ad
te veniat. Requiescant i
pace. Amen. Sequitur suffragi
a primo ad sanctum michaelem.

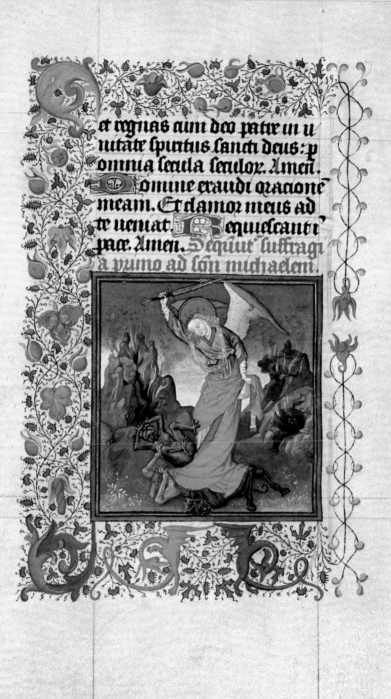

102. *Guardian Angel and Demon Battling over a Corpse.*

The corpse, its winding sheet partly unwound, is laid out in a coffin of which one side and the top have been removed. Its guardian angel, richly dressed and brandishing a sword, struggles with a brown, winged demon for possession of a large, blank-paged, gilt-edged book. The coffin rests on a wooden rack beside the grave, which is being dug by a man with a long-handled shovel. A pick and spade are in the grave. Below, in the border, a seated female mourner wrings her hands; apparently she is the widow of the dying man in no. 41, and would also appear to be the figure shown in the borders of nos. 107 and 109.　　　　　　　　　　　　　[M–p.206]

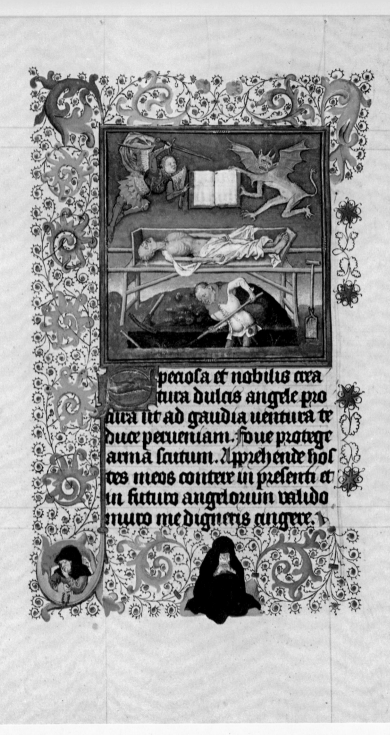

peaofa et nobilis crea
tura dulas angele pro
dua iri ad gaudia uentura te
duce perueniam. foue protege
arma fautum. Apprehende hof
tes meos contere in prefenti et
in futuro angelorum ualido
muro me digneris augere.

103. *Saint John the Baptist.*

In a wilderness landscape of rocks and caves, Saint John
stands against an orange sunset sky, holding the bannered
staff of the Resurrection and pointing to the wounded Lamb
of God cradled in his arm. His body and face are gaunt, his
hands red and raw. He wears a mauve-rose cloak over a robe
of golden animal skin. [M–p.208]

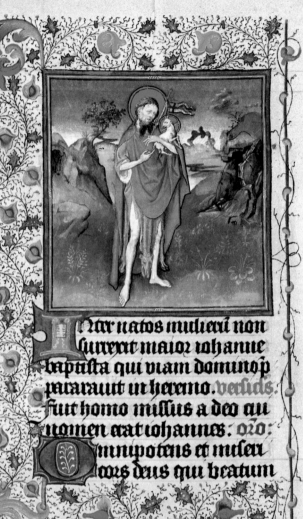

Inter natos mulieri non
surrexit maior iohanne
baptista qui viam domino p
pararauit in heremo. versus.
Fuit homo missus a deo cui
nomen erat iohannes. oro:
Omnipotens et miser
cors deus qui beatum

104. *Saint Peter Apostle.*

For most of the miniatures illustrating the suffrages a standard format is used, consisting of a standing "portrait" of the saint and a simple stage set of a tiled floor with a textile backdrop, but within this format there is a ceaseless variation of color and pattern. Important as these variations are, the setting will only be described when it is exceptional in some way or interesting for its iconography. Here Saint Peter carries his attributes, keys and a book, and wears priestly vestments, a plain mauve-rose cope over a surplice, dalmatic, and green stole. In the border are three entwined fish painted with silver; they are, of course, attributes of the fisherman Peter, fisher of fish and of men. [M–p.210]

teram manu misericordie tue:
et auriliare michi in omnibus
necessitatibus meis et esto pui
intercessor apud altissimu ut
dias dementia ut me a peccox
tenebris eripiat. et ad lucem
celestis glorie perducat. O vi.
De sancto petro aplo oracio:

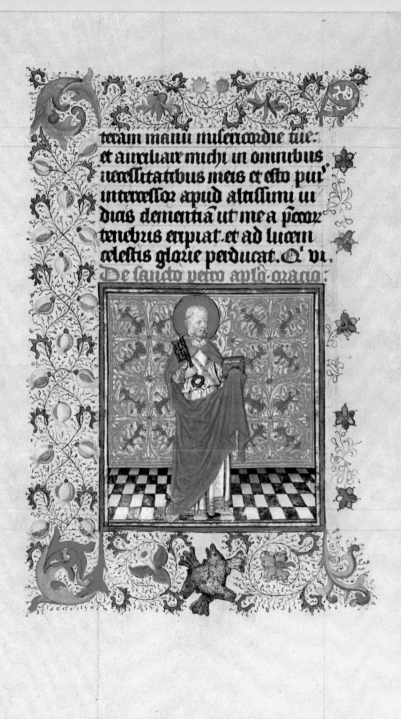

105. *Saint Paul Apostle.*

Unlike the priestly Peter, Saint Paul is dressed in a long blue gown under a long crimson cape. He holds his own attributes, a sword and a book. A small King David wrestles with a lion in the lower border. The exact reason for juxtaposing David and Paul is not clear, although there are obvious parallels between the two, and Paul is sometimes depicted with lions.

[M–p.213]

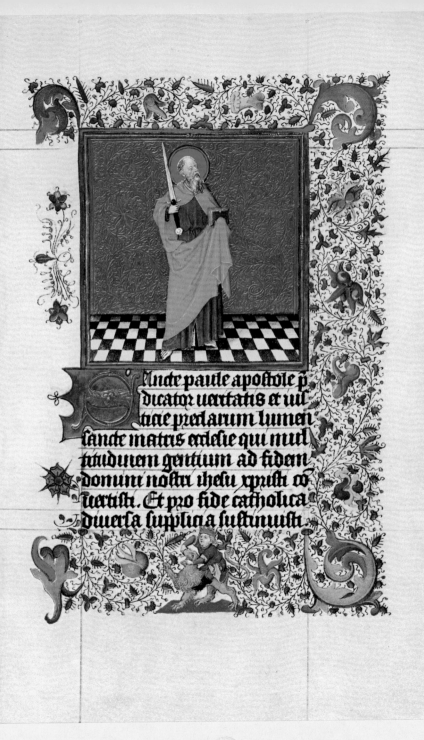

ande paule apostole p̄
dicator uertatis et uit
tute prelarum lumen
sancte matris ecclesie qui mul
tuudinem gentium ad fidem
donini nostri ihesu xp̄isti cō
uertisti. Et pro fide catholica
diuersa supplia sustinuisti.

106. *Saint Andrew Apostle.*

Wearing the traditional apostle's garb of long cape and gown, Andrew stands holding his X-shaped cross. Contained in the border is a small scene of a hairy wild man slitting the throat of a white goose or swan, a theme which has no discernible connection with Andrew, although it is not clearly antithetical to him. [M–p.214]

et tandem decollatus paradysi
gaudia gaudenter adysti. Te
humiliter imploramus: ut ob
scure mentis nostre oculis tuus
doctrinis verissimus digneris il
luminare. ut vana mudi gau
dia possimus euitare. et tecum
xpm drim pre cunctis adamare.
et sibi ut aipimꝰ perpetue cohereg
nare. Amē. de scō Andrea aplō:

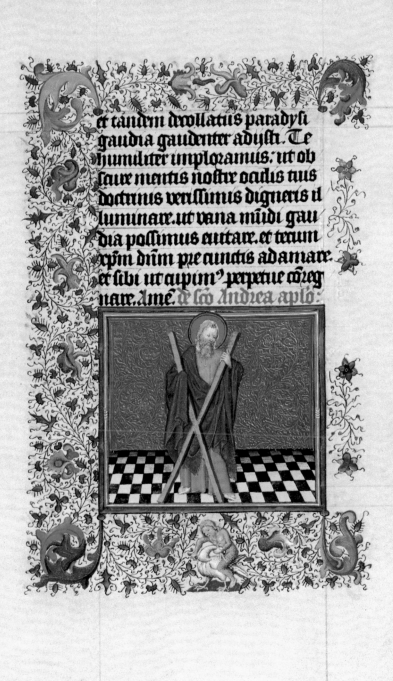

107. *Saint James Major.*

The saint stands in a landscape between two hills crowned by castles. He wears the apostle's cape and gown and a broad-brimmed pilgrim's hat decorated with a shell. With pilgrim's pouch at his side, he carries a large pilgrim's staff and a book bound in a loose envelope-binding (*Hülleneinband*). At the bottom of the page, a weeping woman dressed in black is comforted by a cleric (?), caped and hooded in white, to whom she gives something, probably money. These figures appear to be the same two seen in front of the deathbed in no. 41, and the woman also appears in the border of no. 102. It seems likely that the grieving widow is about to leave on a pilgrimage, possibly to Compostela, for she appears on the road in the border of no. 109. [M–p.216]

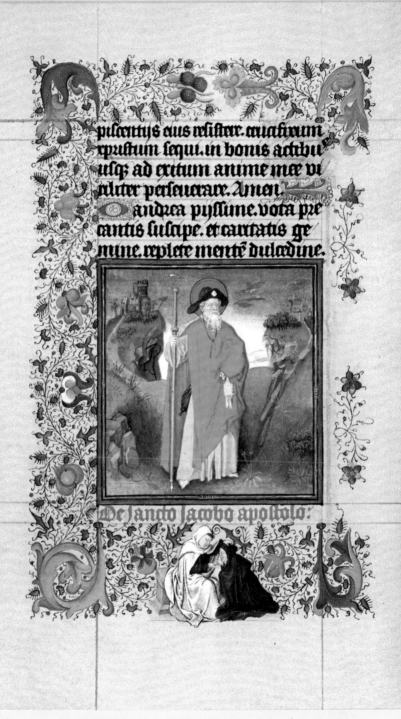

piscentijs eius resistere. cruafixum
rpistum sequi. in bonis actibu
usqz ad exitum anime meæ vi
saliter perseuerare. Amen.
andrea pijssime. vota pre
cantis suscipe. et caritatis ge
mine. replete mente dulcedine.

De sancto Jacobo apostolo:

108. *Saint John the Evangelist.*

The young saint holds in his left hand the poison cup, shaped like a chalice with a black demon in its bowl, and blesses with his other hand. His torture is shown in the lower border: with his hands in prayer, he squats in a caldron of boiling oil over a log fire. [M–p.218]

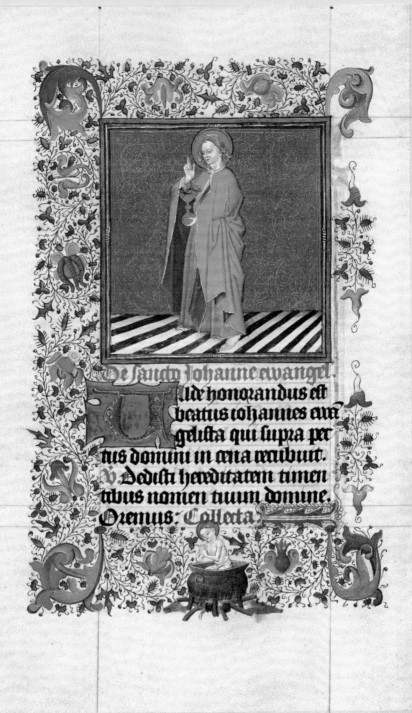

De sancto Johanne evangel.
Ualde honorandus est
beatus iohannes eua
gelista qui supra pec
tus domini in cena recubuit.
V. Dedisti hereditatem timen
tibus nomen tuum domine.
Oremus. Collecta

109. *Saint Thomas Apostle.*

Thomas holds a lance and a book in an envelope-binding.
Below, in the border, a female pilgrim walks along with two
rectangular packs strapped over her shoulders, and wearing
a white drum-shaped "crown" bearing an illegible inscription.
She appears to be the woman of nos. 41, 102, and 107, who is
probably joined here with Saint Thomas because of his far-
reaching travels. [M–p.221]

bonum et malum quo me inter
aduersa egrediente dominus con
seruet docte me tuis sanctis meri
tis cuncta odio habere nocentia
et amare quecp celestia. Amen

De scõ thoma aplo. oz
Ancte thoma apostole
dei qui propriis manib?

110. *Saint James Minor.*

The saint holds a pedum staff and a short string of beads. At the open-air wine-stand below, one man fills a pitcher from a cask, while another approaches carrying a branch with grape (?) leaves and an empty tankard. The drinking scene provides the antithesis to Saint James, who was famous for his abstinence. [M–p.224]

ti. concede nobis peccatoribus ut
eius exemplo resurrectionem tu
am credere et uenerari. et ad celes
tem gloriam precibus ipsius
beati apostoli tui thome peruc
nire mereamur. Qui uiuis et
regnas deus. per oia. f.f. Amé.

Scus Iacobus aplus. minor.

111. *Saint Philip Apostle.*

Selected from his various attributes are the book and cross-staff borne here by the saint; he stands before an unusually rich textile of yellow-green and gold patterns painted over a blue-green background. Three figures in the margin are baking: a woman measures the ingredients, one man kneads the dough and forms the small round cakes, and a second man puts the cakes into a fiery stone or brick oven. Philip was often considered the patron of pastry-cooks. [M–p.226]

Ancte philippe apostole
dei qui ab unigenito
omnipotentis patris
filio eundem patrem t̃ et sociis tu
is ostendi petisti. Te ego miser
peccator et multis sordibus ob
uolutus deprecor ut me ab oĩ
districto iudicio quod digne

112. *Saint Bartholomew Apostle.*

The saint, a large knife in his hand, is shown against a gold-patterned blue-green textile. Around the page is a border of pretzels and biscuits; these seem to have no eucharistic significance, although pretzels are sometimes found on the table of the Last Supper. The biscuits look somewhat like hosts, but lack the cross marking used in this manuscript to designate the eucharistic wafer. Instead, they relate either to the preceding scene of secular baking, or to some special patronage of Saint Bartholomew. [M–p.228]

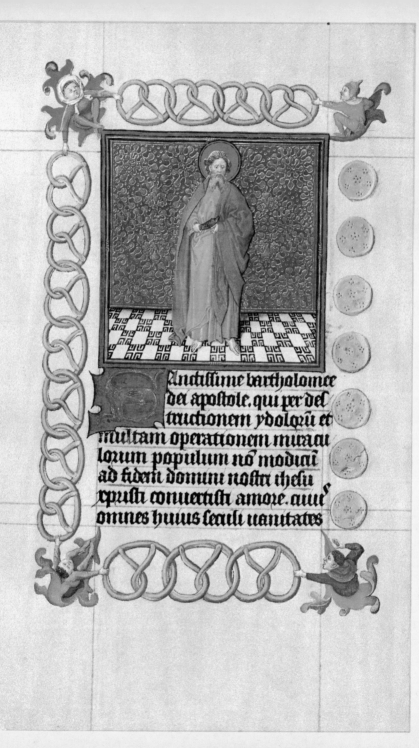

Anctissime bartholomee
dei apostole. qui per des
truccionem ydoloru̅ et
multam operacionem miracu
lorum populum no̅ modicu̅
ad fidem domini nostri thesu
xp̄isti convertisti amore. amu̅s
omnes huius seculi vanitates

113. *Saint Matthew Apostle.*

The saint is shown carrying a book and a carpenter's square; the square attribute is unusual and as yet unexplained. It relates Matthew to woodworking, as does the border, a simulated wooden frame of carved rosettes, vines, and leaves. Around the four corners is a gold inscription telling why Matthew, as one of the Evangelists, was assigned the form of a man for his symbol; it begins: *Formam viri datam matheo.* . . . [M–p.231]

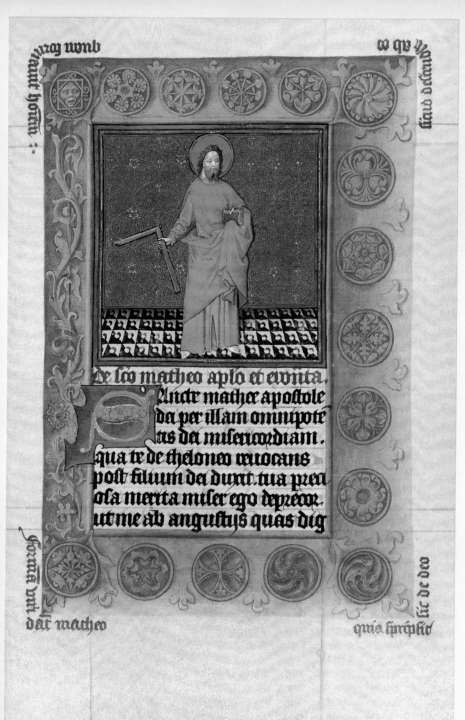

De sco matheo aplo et euūta.

Sancte mathee apostole
dei per illam omnipote
tas dei misericordiam .
qua te de theloneo reuocans
post filium dei dixit. tua preti
osa merita miser ego deprecor.
ut me ab angustijs quas dig

114. *Saint Simon Apostle.*

In a setting of unusual refinement, the saint stands holding his attributes, a book from which he reads and a long-bladed saw. The border is composed of fish nets, one of which is being repaired by a man leaning out from behind the miniature. Simon is rarely connected with fishing; this depiction would seem to indicate a confusion with Simon Peter, the great fisherman. [M–p.233]

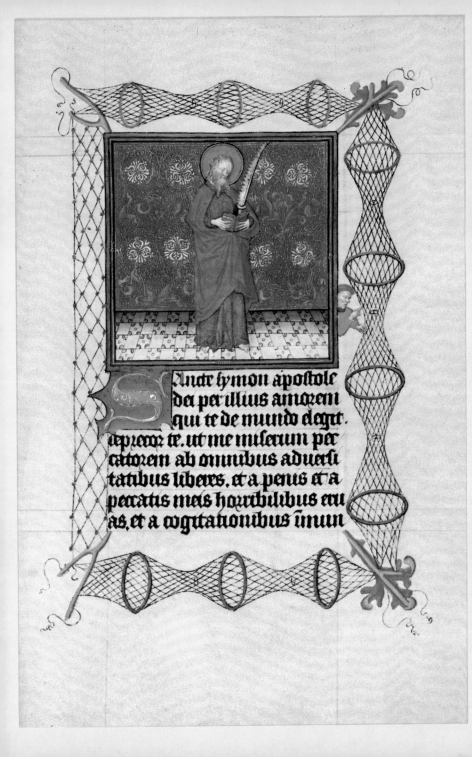

Andr lymon apostole
dei per illius amorem
qui te de mundo elegit.
depzecoz te. ut me miserum pec
catozem ab omnibus aduersi
tatibus liberes. et a penis et a
pecatis meis horribilibus eru
as. et a cogitationibus immun

115. *Saint Matthias Apostle.*

The saint, holding his attributes, a book and a short-handled ax, wears a white turban, yellow tunic, and crimson mantle. In the border are three swastikas, each composed of four Matthias axes. [M–p.235]

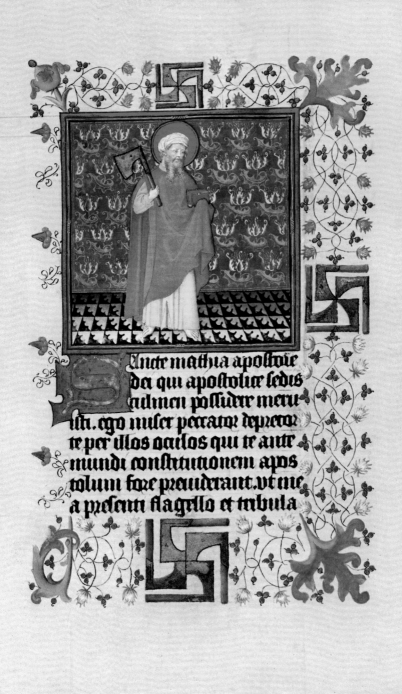

Ancte mathia apostole
dei qui apostolice sedis
adimen possidere meru
isti. ego miser peccator deprecor
te per illos oculos qui te ante
mundi constitutionem apos
tolum fore preuiderant. ut me
a presenti flagello et tribula

116. *Adoration of the Magi.*

This narrative scene, which interrupts the series of hagiological portraits, precedes the suffrage for the Three Kings. With no sign of their entourage, the kings approach from the right; they are expensively and fashionably dressed, and each carries a gold ciborium-like vessel. The first king, his tall-crowned hat on the ground before him, kneels in front of the Child, offering Him gold; the second king points to the distant star; and the third and youngest stands waiting his turn. The plainly dressed Virgin sits at the entry to the stable holding her Infant on her knees; behind her, inside the stable, sits a stolid and rather plebeian Joseph, his hands upon his staff. Beside him are the unruly ass and an ox eating from the manger. In the distance is a cool green landscape with a village, a windmill, and castles. Disposed around the page is Catherine of Cleves' red-beaded rosary, terminated by tassels with gold and pearls. Attached to the rosary are a seven-pointed star of pearls and gold, a small cross of the same materials, and a blue purse with drawstrings, a gold mouth, and three red tassels drawn through pearls. The purse bears the letters CD, or possibly ED, in gold encrusted with pearls (*Catherina Duxissa?*). [M–p.237]

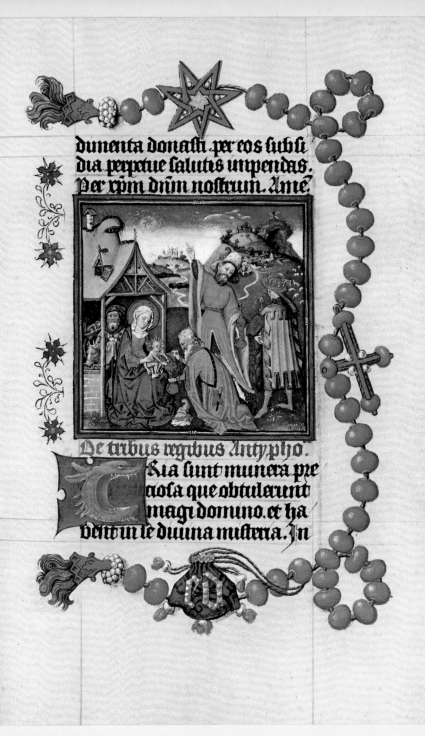

dumenta donasti. per eos subsi
dia perpetue salutis inpendas.
Per xpm dnm nostrum. Ame.

De tribus regibus Antypho.
Ria sunt munera pre
ciosa que obtulerunt
magi domino. et ha
bent in se diuina misteria. In

117. *Saint Gregory the Great.*

Holding a cross-staff and book, and wearing his papal tiara, the saint stands before a crimson textile. A single row of twenty-five gold and silver coins forms the border. Painted with remarkable care, these coins seem to reproduce contemporary money. Although the coins are represented as somewhat worn, their designs are clear, and a few of their inscriptions can be read. Two or three have DUX: ARNOLD': GLE, presumably the husband of Catherine of Cleves, but some of the silver coins seem to be Burgundian. Although these coins do not seem part of the iconography of Saint Gregory, he was one of the great administrators of the church. [M–p.240]

Ancte gregori comes in
clite. angelorum gloria ro
manorum specialis a
postole. per thesum xpistum et
per uirtutes quibus mirabilis
papa sedis apostolice fuisti:
et uenerandus patriarcha uni
uersalis ecclesie. Adiuua me ueľ

118. *Saint Jerome.*

Dressed in his crimson cardinal's robes and hat, Jerome holds a book, while he reaches down to remove a thorn from the paw of the lion beside him. The page is a *trompe-l'oeil* in which the text and miniature appear to form part of a large processional banner of patterned mauve-rose silk, which hangs from a crossarm terminated by two human hands holding little bells. The crossarm was probably supported on a staff of which only the gold-cross head is visible. [M–p.242]

Gricolarum dux lux vas
abstinentie. o scriptura
rum vigor rigor peni
tentie. heremitarum forma. nor
ma continentie. sacerdos felicis
sime lucens ardensq[ue] lucerna.
Iheronime clarissime nos tuere
nos guberna. Aue gloriose

119. *Saint Ambrose.*

Wearing a surplice, cope, and miter, Ambrose holds his bishop's crozier and a book. The border is composed of eleven mussels, open, with their inner tissues painted gold. They are represented with great precision and are arranged like a necklace for which the crab in the lower border forms the clasp. These animals are not normally part of Saint Ambrose's iconography. [M–p.244]

ntis adiuuemur. Per xpm do. n̄.
Ambrosij episcopi et conf. a.

...erdos et pontifex et
uirtutu̅ artifex bonus
pastor in populo sic
placuisti d̄no. V. Ora pro nob
beate pater ambrosi. ut digni
efficiamur promissione xpe.

120. *Saint Augustine.*

Except for the heart pierced by two arrows that Augustine holds, he is depicted in much the same manner as Saint Ambrose. The border consists of four pieces of chain held at the corners by two angels and two golden-eyed demons; the chains run through or are attached to four hearts resembling, but larger than, the one held by the saint. Blank banderoles, some gold, others white and brown, spiral around the chains between the hearts. [M–p.245]

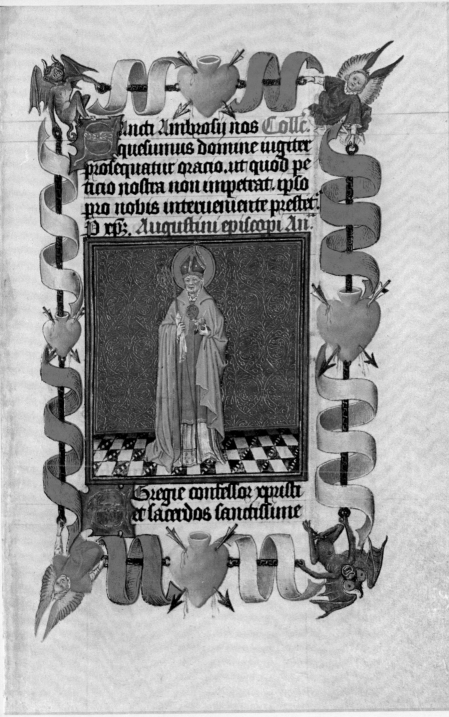

121. *Saints Cornelius and Cyprian.*

Associated in the liturgy, these two saints stand side by side in a double portrait, each with his appropriate attributes: Cornelius has a curved golden horn, the papal cross-staff, and tiara; Cyprian holds a sword and crozier and wears his bishop's miter. A collection of bird cages and training cages comprise the border. There are five cages of differing shapes and decoration, one bird perch, and two training devices, one a long spiraling cage to discourage flight and the other a revolving drum, perhaps for the same purpose. On one of the elaborate cloth cage covers are the letters C and D plus a third letter that may possibly be a G or an R. These letters are read by F. Gorissen as e, d, and r, but the first letter cannot be an e, though it might be read as a t. (See nos. 116 and 151.) While these bird cages may only reflect a personal interest of Catherine of Cleves, they may also indicate the role of Cornelius as a patron saint of domestic animals. [M–p.247]

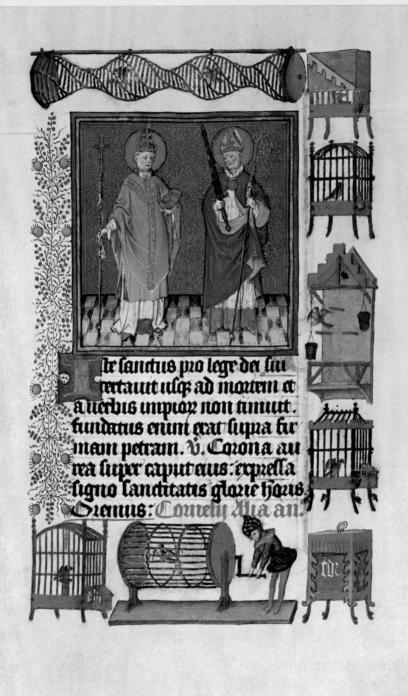

te ſanctus pro lege dei ſui
tertauit uſqʒ ad mortem et
a uerbis impior non timuit.
fundatus enim erat ſupra fir
mam petram. ℣. Corona au
rea ſuper caput eius: expreſſa
ſigno ſanctitatis glorie horis.
Oremus: Cornelij Alia an.

122. *Saint Anthony.*

With a pig at his feet, Saint Anthony stands beside a small salmon-colored building in a verdant landscape. He is dressed in a white surplice, pale lavender dalmatic (?), and black hooded cape. He holds an open book in one hand, from which he reads, and a cane and bell in the other. Additional bells hang from the pig's collar and in the belfry behind. In the middle distance is an enclosure surrounded by a woven fence and a gate with posts formed of two living trees, whose stripped branches form a perfect arch above. The border simulates stone, and its carved leaves are painted various colors.

[M–p.249]

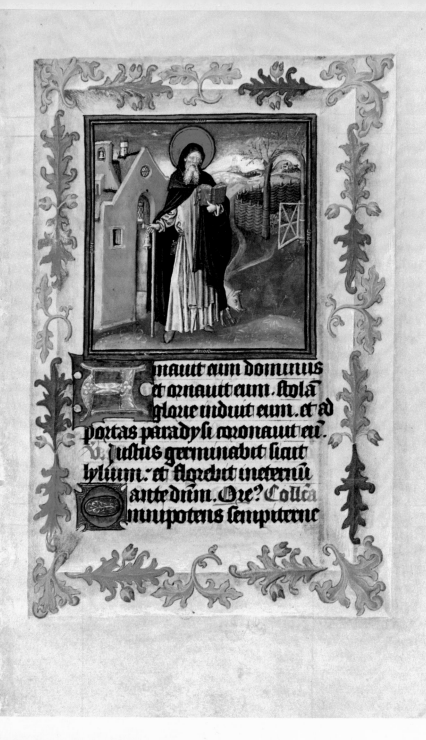

mauit eum dominus
et ornauit eum. ſtola
glorie induit eum. et ad
portas paradyſi coronauit eũ.
V. Iuſtus germinabit ſicut
lilium: et florebit ineternũ
ante dñm. Oꝛe? Collc̄a
Omnipotens ſempiterne

123. *Saints Fabian and Sebastian.*

This double portrait is placed in the usual setting of tiled floor and textile backdrop. Pope Fabian is dressed as other pontiffs in this manuscript, but holds a sword as well as the papal staff. The upper part of Saint Sebastian's body is naked and pierced by many arrows; the lower part is covered by a loincloth and long red hose; his wrists are bound to a mauve-rose column, similar to the one in Christ's Flagellation (no. 22). Distributed in the borders surrounding the text are different kinds of archery equipment: crossbows, long bows with both one and two strings, arrows and bolts, quivers and bolt pouches—all related to Sebastian's martyrdom. [M–p.253]

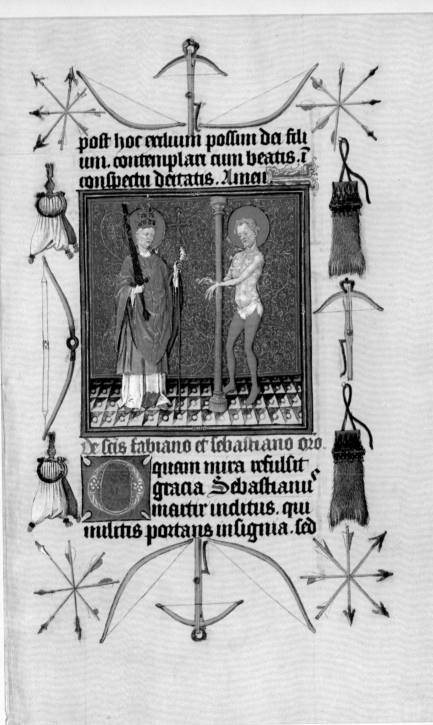

post hoc exilium possim dei fili
um. contemplari cum beatis. et
conspectu deitatis. Amen

De scis fabiano et sebastiano ora.
quam mira refulsit
gracia Sebastianus
martir inclitus. qui
milisis portans insignia. sed

124. *Conversion of Saint Hubert.*

The saint wears a gray hat with a high turned-up brim and two feathers, one crimson and one white, and is dressed in a crimson and white gown, slit front and back. He sits astride long-legged, short-bodied gray horse. Horse and rider have halted suddenly, for Hubert is still pulling back on the reins. Before him is a miraculous vision, a crucifix between the antlers of a deer who rears up and crosses its forelegs. Below the deer, the first of the saint's three hunting dogs sits back on its haunches, raising its forepaws in prayer. This, an early example of the Conversion, is unusual in such details as the praying animals. Contained in the border is a small scene of a fawn attacked by an eagle. This scene is obviously parallel to the miniature, but the precise meaning of the correspondence is not clear. A lost leaf with a portrait of Saint Quirinus originally followed this page. [M–p.256]

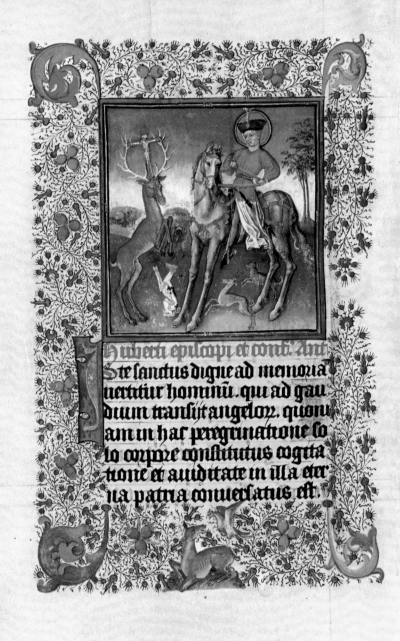

Hiuberti epilcopi et cōfe. Antī.
Iste sanctus digne ad memoriā
uertitur hominū. qui ad gau
dium transiyt angeloꝛ. quoniā
am in hac peregrinatiōe so
lo coꝛpꝛe constitutus cogita
tione et auiditate in illa eter
na patria conuersatus est.

125. *Martyrdom of Saint Erasmus.*

Naked except for his loincloth and miter, Erasmus is tied to a wooden pallet raised a few inches off the ground by two low "sawhorses." His intestines are being wound from an incision in his abdomen onto a wooden spindle rotated by two spoked wheels turned by two executioners. The scene takes place in a rather bare landscape. In the border, a small boy wearing a conical hat and a collar of long radiating sticks is riding a hobbyhorse. [M–p.258]

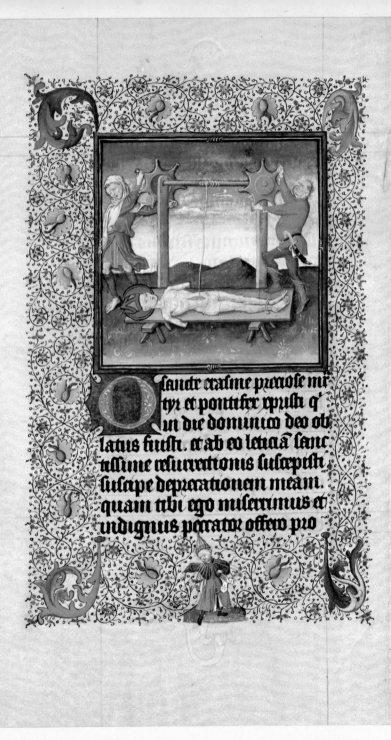

O sancte erasme preciose mr
tyr et pontifex xpisti q'
in die dominico deo ob
latus fuisti. et ab eo leticiā sanc
tissime resurrectionis suscepisti.
suscipe deprecationem meam.
quam tibi ego miserrimus et
indignus peccator offero pro

126. Ten Thousand Martyrs and Saint Acacius.

The legend of the martyrdom of the Roman centurion and his 10,000 legionnaires on Mount Ararat has been transformed here into a scene with ten men, naked except for loincloths and crowns of thorns, spitted on the spiny branches of three bare trees (due to a confusion of the centurion's name with the acacia tree). Standing beside the trees is Acacius, transformed into a bishop, probably through confusion with one of the bishop-saints of the same name; he carries a crozier and wears a miter and other pontifical vestments. At the feet of the saint are three tiny lions, two of which lick his feet—a puzzling detail. Around the edge of the page is a banderole with an abridgment of the Apostles' Creed winding between portraits of the apostles set into small white flowers. [M–p.262]

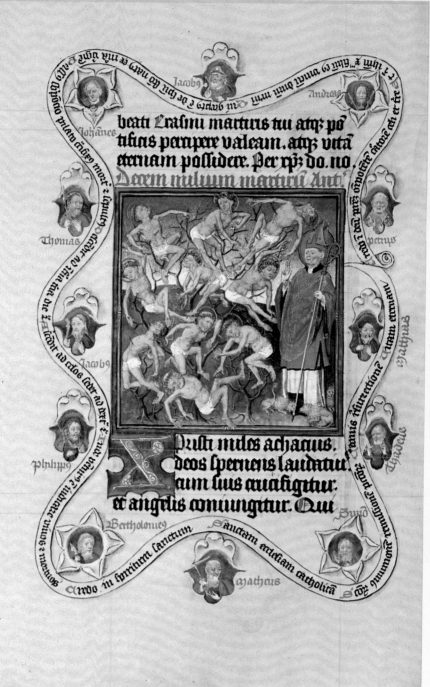

beati Erasmi martiris tui atq̃; pō
tificis percipere valeam. atq̃; vitā
eternam possidere. Per xp̃; do. no.

Decem milium martiri Ant.

Qusti miles achacius.
deos spernens laudatur.
cum suis crucifigitur.
et angelis coniungitur. Qui

127. *Saint Blaise.*

Dressed in bishop's vestments, including miter and crozier, the saint holds over his shoulder a long-tined wool comb, the instrument of his martyrdom. The textile behind him has a motif of ferocious animals chained together, a reference, no doubt, to his legendary triumphs over wild beasts. Saint Blaise is shown sometimes with the birds that brought him food, but they do not appear here. Instead, an antithesis is shown—a monkey leans from the border of spiraling leaves and steals birds from a nest within the initial O. [M–p.264]

presul xpisti blasi. p
quem meruisti. mar
tiriy palmã. suscipere
nobilis almam. Pro male
nunc passis. in gutture te pre
cor assis. Cetera plus qra sunt
mea membra bona. Absq;
mala pena. me fer ad gaudia

128. *Saint Lawrence.*

Vested as a deacon, Lawrence holds a book, a purse, and the instrument of his martyrdom, a gridiron. Some of the floor tiles have a design of two biting fish, a motif that is elaborated in the border of fish eating fish. Although fish and fishing do not belong to the legend or patronage of Saint Lawrence, he was the patron of the poor, as his purse here testifies, and the proverbial eating of the little fish by the big, a literary and pictorial theme of great popularity in the fifteenth and sixteenth centuries, was an allegory of the poor being devoured by the rich. That man, as the biggest fish, preys upon the others is implied by the fish-lines and hooks which have already caught some of the fish at the bottom of the page. Many of these fish are painted with silver to imitate the iridescence of their scales. [m–p.266]

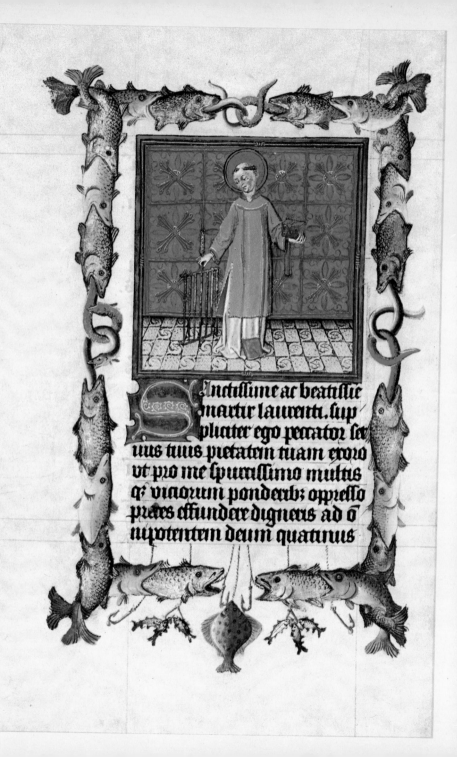

Nctissime ac beatissie
martir laurenti. sup
plicater ego peccator ser
uus tuus pietatem tuam exoro
vt pro me spurcissimo multis
q̅ viciorum ponderib; oppresso
preces effundere digneris ad o̅
nipotentem deum quatinus

129. *Saint Vincent.*

Wearing his deacon's vestments, the saint holds his attributes, a book and a rod with three hooks. Around the text is an unusual border consisting of a vine with clusters of blossoms or berries and several different kinds of butterflies. Why these elements, which do not belong to the usual iconography of the saint, are here connected with him remains to be fully explained. The use of a vine, though it is not a grapevine, can hardly be accidental, for the saint was widely regarded as the patron of viniculture and was often depicted with a pruning knife. The reason for this patronage is not to be found in the events of his life, but was probably a pun on or a confusion of the first syllable of his name—*Vincent*—with the Latin *vinea* or *vinum*. The explanation for the butterflies is even more uncertain. From antiquity butterflies have been thought of as souls, particularly immortal souls, although they have also been considered demons and omens. Perhaps it is the immortality of the soul that accounts for their presence here, as the butterfly in the upper left corner, a red admiral (*Vanessa atlanta*), has a fanciful, but nonetheless clear, death's-head painted on the underside of its wing. The notion of immortality or of the triumph over death would be especially appropriate in conjunction with Saint Vincent, who is frequently called the invincible martyr, in part because his name is connected with the Latin *vincere,* to conquer. It may be that the other butterflies can be explained in a similar way, but the reasons for their selection are still obscure. [M–p.268]

eatus uir qui inuentus
est sine macula et qui
post aurum nõ abijt
nec iperauit in thesauris pecu
nie. quis est hic et laudabimus
eum fecit enim mirabilia in
uita sua. V. Justus germina
bit sicut lylium: et florebit in

130. *Saint Valentine.*

Dressed in a deacon's dalmatic (with the names of Jesus and Mary in gold) rather than in his usual bishop's vestments, the saint holds a book and a sword, the instruments of his martyrdom. In the lower border, composed of feather-like leaves and delicate rose and crimson flowers, are two dragonflies devouring a fly or a bee. This subject may be explained by Saint Valentine's patronage of beekeepers. [M–p.269]

eternũ ãnte dominũ. Oremus.
Hesto domine Colle
suplicationibus nos
tris. vt qui ex iniquita
te nostra reos nos esse cognosa
mus. beati vincentij martiris
tui intercessione liberemur. P
christum dñm nŕm. Amen.
Valentini martiris Antypho.

131. *Lapidation of Saint Stephen.*

Already struck by one stone, Stephen, dressed in his deacon's dalmatic, begins to fall, as Christ blesses him from the arc of heaven above. Four executioners are shown: one raises a large rock over his head; another reaches back to throw one stone while holding a second one in his other hand; a third lies awkwardly on the ground, though about to throw a stone; a fourth removes the jacket which he will give to Saul (the future Saint Paul), who already holds the jacket of another executioner. In the lower border a man attacks an advancing boar with a spear; the reference of this scene to Stephen is not clear.

[M–p.271]

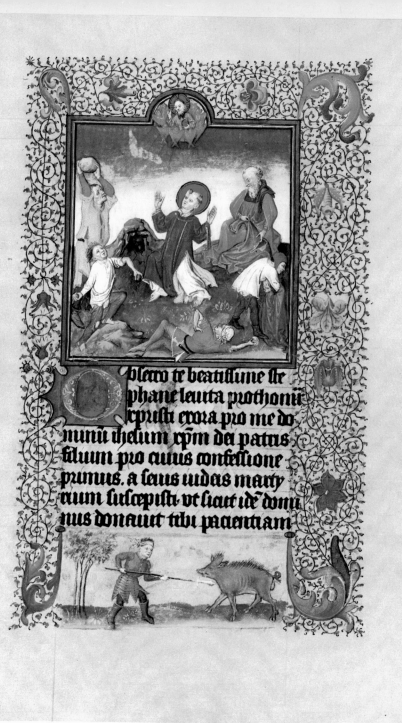

bleuo te beatiffime fte
phane leuita pthonű
cpusti exoza pzo me do
minű thelum xpm dei patris
filium pzo cuius confessione
pzimus. a feuis iudeis marty
rium suscepisti ut siaet idě domi
nus donauit tibi paaentiam

132. *Saint George Killing the Dragon.*

The knightly saint, wearing gilded body armor and a large wide hat with a red and a white feather, holds a shield with the cross of Saint George. He sits in a saddle with long steel leg shields reaching down to the stirrup. His richly caparisoned horse wears a steel poitrel and a red-lined white cloth over its hindquarters. The dragon, impaled by the saint's lance, has a yellow-bellied, lizard-like body. On a hillock behind kneels the princess, praying and holding the leash of a small white lamb; in the distance is a walled city. A virgin, in the border, holds in her lap the golden horn of a submissive unicorn that sits on its haunches beside her. The virgin and unicorn are obvious parallels to the princess and the lamb, both references to the Virgin and her Son. [M–p.272]

inter vulnera et ictus lapidū et ce
lum apertū uidere et pro persecuto
rib; exorare. sic concedat michi sal
tem inter temptationū verbera
esse patiente. et diuina semper
in mente habere contempla
ōne atq; ex caritate pro frater
nis delictis exorare. P xp̄s do .

De sancto Georgio mre Ant

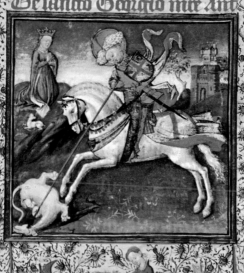

133. *Saint Christopher Carrying the Infant Christ.*

The giant, Christopher, balances himself with a long staff, while he wends his way precariously to the shore. On his shoulder he carries the infant Christ, who holds a golden globe and blesses the saint. The landscape is almost surrealistic. The mirror-like water reflects the cliffs and the distant fishermen standing in their boat. The surface is broken by a few ripples in the foreground and by the radiating wavelets made by a jumping fish in the background; a few ducks, almost microscopic in scale, float among the reeds in the far distance. The orange sunset sky shades off into deep blue night sky with gold stars and moon. On a ledge in the cliffs at one side, the traditional hermit ineffectually lights the saint's way with a lantern. In the lower border, a man pushes and pulls at the gateway in which he stands, probably a depiction of Samson pulling down the gates of Gaza before carrying them off, a conventional parallel for Saint Christopher. [M–p.275]

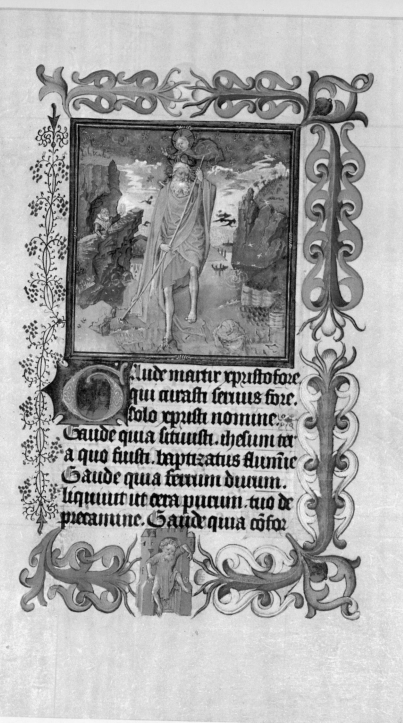

Aude martir xpristofore.
qui auasti seruus fore.
solo xpristi nomine.
Gaude quia sitiuisti. ihesum ter
a quo fuisti. baptizatus flumie.
Gaude quia ferrum durum.
liquiuit ut cera purum. tio de
precamine. Gaude quia cosor

134. *Saint Hadrian.*

Hadrian, as a soldier wearing plate armor, one side crimson and the other blue, and a tall hat with two white feathers, here holds the instruments of his martyrdom, a sword and an anvil. The white bands of his rose-colored cape bear a long illegible inscription. In the lower border, three winged animals, probably griffins, put their jaws together in such a way as to give the illusion of a single fang-filled mouth. [M–p.277]

tis et intercessione letificas. conce
de propicius: ut qui eius benesicia
a posamus. dona tue gracie con
sequamur. Per xpm do. nos. N.

Adriani martiris Antypho
c est vere martir qui
pro xpusti nomine san
guinem suu sudit qui

135. *Saint Martin Dividing His Cloak with a Beggar.*

The young, fashionably dressed saint turns in his saddle and cuts off a large piece of his cloak, the end of which is already draped over the head and shoulders of a scabby beggar standing with the aid of a crutch and a wooden leg. A second crippled beggar sits in the roadway, reaching up with his begging bowl. In the sky above, Christ appears holding the piece cut from the saint's cloak; a blank banderole issues from His mouth. The scene is set before a gate of Amiens, through which Martin has just come. The border of the page is composed of oblong gold cards, engraved with geometrical designs and, in two instances, with the names of Jesus or Mary. These cards, which may have been used for some special devotions, possibly connected with Saint Martin, are linked together by blank scrolls running through slits in the cards. [M–p.279]

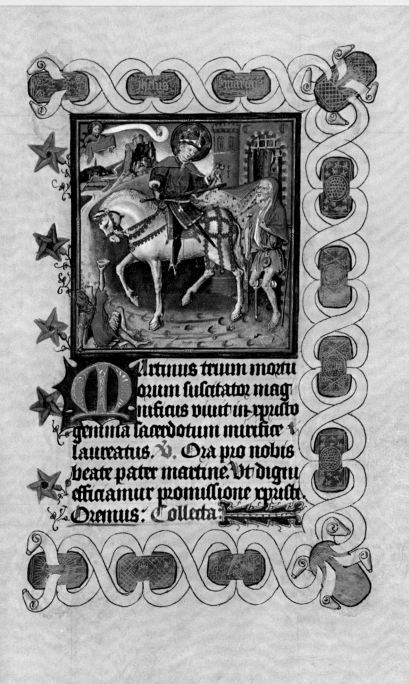

136. *Saint Nicholas.*

Although garbed in his episcopal vestments—crozier, miter, chasuble, gloves, etc.—the saint carries no special attributes and merely blesses with his right hand. This omission, surprising in a saint with so many traditional attributes, may be explained by the unusual border. The outermost band around the page is plain vellum, very delicately painted on its inner undulating edge to simulate clouds which appear to open on a calm deep-blue sky studded with gold stars. This opening in the clouds is an extraordinarily realistic, yet emblematic, representation of Saint Nicholas' miraculous calming of a storm at sea, an act that made him the patron of seafarers. In each of the four corners of the starry sky are three monstrous moon faces, each painted a different color (black, orange, or green), and all helmeted with a silver crescent. In the center of each group is a golden ball into which the monsters sink their teeth and over which they seem to struggle, each trying to push the others away with rudimentary arms and hands. Golden balls, sometimes depicted as golden apples, are a common attribute of Nicholas and are symbolic of the gifts of gold he made to three young women to provide them with dowries, thereby saving them from prostitution. Normally three in number, these golden balls became the emblem of pawnbrokers, of whom Nicholas was the patron saint. It is thus possible that the monsters are meant to be pawnbrokers; certainly they represent some form of greed. [M–p.280]

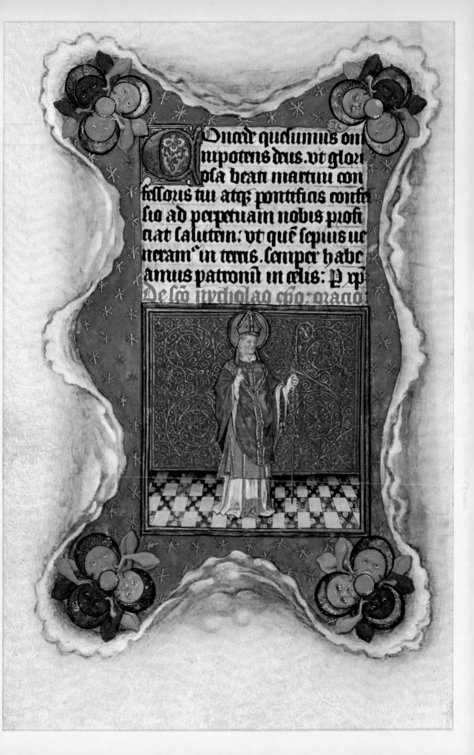

137. *Saint Benedict.*

The saint, silhouetted against a splendid crimson textile and standing upon blue and brown tiles, wears the black Benedictine habit. He holds a book and an abbot's crozier. In the blue floor tiles are some letters, usually PI and once a G or B, but they are too small to be read with any measure of accuracy. If they are unrelated to the saint, as seems likely, they may possibly be connected with Catherine or the artist. Below, Benedict's drowning disciple Saint Placidus is rescued by Saint Maurus, who miraculously walks on the water following Saint Benedict's instructions. [M–p.283]

bsecro te beate benedic
te dilecte dni. interede
pro famula tua. N.
et pro omni sancta ac tua con
gregatione. + p uniuersis sub
tuo magisterio militantibus
simul et pro omni populo
xpiano interede. et pro me

138. *Saint Servatius.*

The saint is depicted here as Bishop of Tongres, a city in northeastern Belgium, whence his cult spread into neighboring regions. Besides a crozier, he holds the two silver keys, according to legend given him by Saint Peter. In the lower border two dragons with entwined necks and biting a golden object may refer, if they are not mere decoration, to the dragon driven from the country by the saint. [M–p.284]

milcon peccatricc famula tua. vt
purget dominus cor meum et ac
tus meos a cunctis vicijs. Tribu
at michi seruare cuncta que pre
cepit et custodire sancte regule
tue tramitem quam me obser
uaturam spospondi. Amen.
Seruatij episcopi et conf Ana

139. *Saint Bernard.*

Instead of the proper white garb of the Cistercians, the saint wears a brown cassock and holds an abbot's crozier and a book. Around the page is a kind of chaplet of plumes (?) linked by interlace knots of gold bands, the significance of which has not been determined. In a small gap between two plumes is the bust of a praying monk, apparently dressed like Bernard, but without a halo. A gold crown is being placed on the figure's head by a hand which reaches down from the plume above. This figure may be William of Aquitaine, erroneously believed to have become a hermit to expiate his sins; he was saved from excommunication by Saint Bernard. If so, the hand might represent the church restoring William's crown. [M–p.286]

liberemur aduersis. et tranquilla
prosperitate in tua iugiter laude
letemur. ꝓ. Bernardi abbatis ꝗ

Onsurgens diluculo que
siuit bona pater sanctus
quasi florens lylium germina
uit. ℣. Ora pro nobis beate ber
narde. vt digni efficiamur xp̄i.

140. *Saint Thomas Aquinas.*

Holding no attributes save the open book from which he reads, the rotund saint is garbed in the Dominican habit, with the addition of gold stars studding his black cape. This motif derives presumably from the vision of Albertus Manducasinus of Brescia and is an allusion perhaps to Thomas being called *Doctor angelicus*. A pouch, a case, and keys hang from his girdle. [M–p.287]

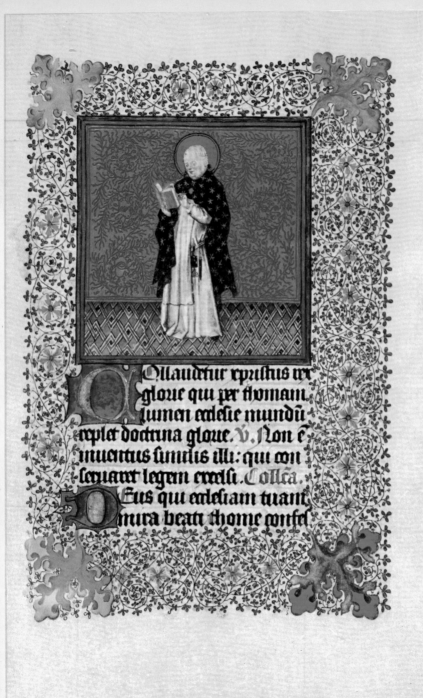

Ollaudetur ꝛpiſtus ꝛeг
gloꝛie qui per thomam.
lumen ecleſie mundū
replet doctrina gloꝛe. ℣. Non ē
muentus ſimilis illi: qui con
ſeruarꝛt legem ercelſi. Collc̄a.
Eus qui ecleſiam tuant
miꝛa beati thome confeſ

141. *Saint Leonard.*

Represented as an abbot, Leonard carries his attributes: a crozier, book, and fetters. [M–p.288]

lons tui eruditione claificas. et
lancta operatione fecundas. da
nobis quesumus. ea que docuit
intellecta conspicere. et que egit
imitatione complere. Per do.

leonardi Abbatis Ant.
te homo ab adolescentia
sua partim meruit infir

142. *Saint Alexis.*

This patron of pilgrims and beggars is barefoot, though well-dressed in a lavender houppelande and a mauve-rose cape. Holding only a ladder, his most common attribute, Alexis stands before a striking textile of crimson on green. In the lower border the saint, clasping a scroll, lies dead upon a bed in his cubicle beneath the ladder-like stairs of his parents' house. According to legend, after giving away all of his wealth and making a pilgrimage to the Holy Land, he lived unrecognized under the stairs of his parents' house. He was identified after his death by the letter clutched in his hands, until released by the benediction of Pope Boniface I.　　　　[m–p.290]

Eatus uir qui in lege
domini meditatur uo
luntas eius permanet
die ac nocte et omnia quecūcṛ
facet semper prosperabuntur
Tu es gloria mea tu es suscep
tor meus domine tu exaltans
caput meum et exaudisti me

143. *Holy Family:*
Saint Anne, Virgin, and Child.

Saint Anne sits on a high throne with a rectangular cloth canopy; between her knees, presumably on a step of the throne, sits the young Virgin with the naked Infant on her lap. The elderly Saint Anne wears an old-fashioned wimple; her daughter is very young with long golden hair. Encircling the miniature and text are two branches of a vine-like Tree of Jesse composed of twelve crowned portrait heads of the royal ancestors of Christ, each set within a flower, a seated figure of David playing his harp within a similar flower, and a black lion or dog, possibly the lion of Judah, in a fourteenth flower. At the base of the vine is Jesse, his eyes closed, reclining on a bed.

[M—p.292]

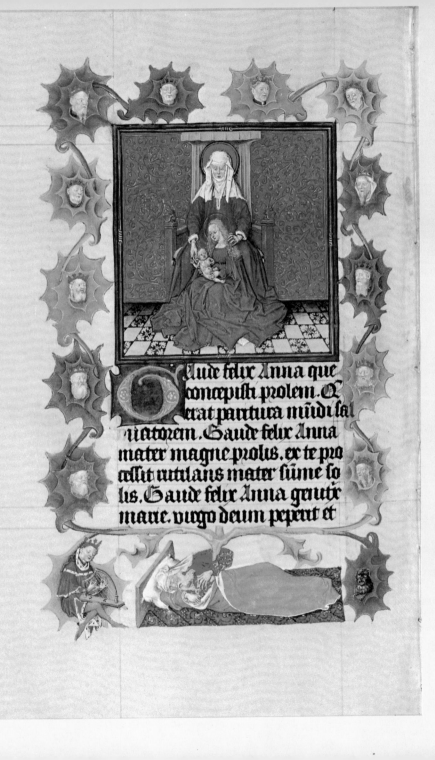

Aude felix Anna que
concepisti prolem. Q
erat paritura mūdi sal
uatorem. Gaude felix Anna
mater magne prolis. ex te pro
cessit rutilans mater sūme so
lis. Gaude felix Anna genitrix
marie. virgo deum peperit et

144. *Saint Mary Magdalene.*

Clothed in a houppelande, long blue cape, and wimple, the Magdalene holds an open jar of ointment in one hand and its lid in the other. The black tiles of the floor contain letters from the saint's name. Most of the border consists of orange angels encircled by blank scrolls, but at the top is God the Father blessing the Magdalene, who is shown again in the side border, barefoot and simply dressed, as she is often pictured in the wilderness. Along the inner edge of the page is a scroll held by angels and bearing the Latin text of Luke 7:47, in which Christ explains that many sins are forgiven her because she loved so much. [M–p.294]

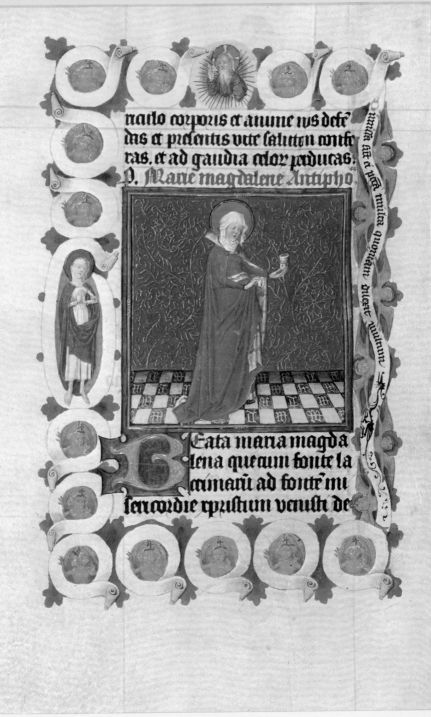

nrario corpozis et anime tus defe
das et presentis vite salutem confe
ras. et ad gaudia eior peducas.
P. Marie magdalene Antipho

Eata maria magda
lena que eum fonte la
crimarum ad fontem mi
sericordie xpistum venisti de

145. *Saint Catherine.*

Oblivious of the spiked wheel and the reclining executioner with a sword on the floor behind her, Catherine reads quietly from an open book. She is portrayed as a princess with a small circlet crown and a long ermine-lined cape. The black tiles of the floor bear designs based on the instruments of her martyrdom. The leaves of the border contain small balls, usually gold, and below a bear cub plays with a red and gold ball. The precise meaning of these motifs is not clear, but they are surely connected in some way with Catherine, who was patroness of most crafts and trades involved with wheels and turning machines. The cub (*catulus* in Latin) is probably a pun on her name. [M–p.296]

magdalena domunū nostrum
super omnia diligendo suox ob
tinuit ueniam peccatorum. ita
nobis apud misericordiam tu
am sempiternā imploret bea
titudinem. D̃ Katherine vgĩs.

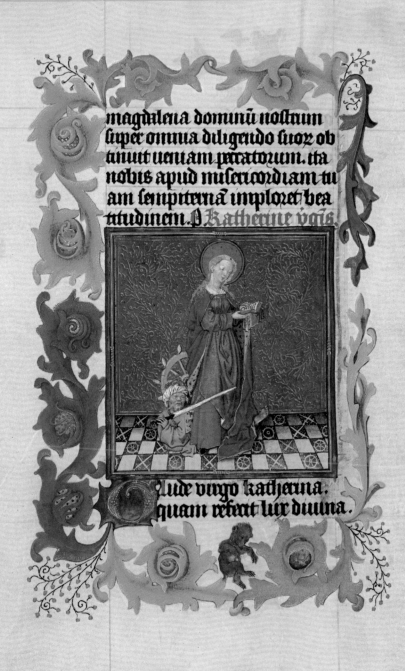

Aude virgo katherina.
quam referat lux diuina.

146. *Saint Barbara.*

Richly dressed, as befits the daughter of a satrap, Barbara wears a garland or crown with buds in her hair and holds her traditional peacock feather. Behind her stands a small tower with three windows at the top, symbolic of the Trinity. The tower motif is used schematically in some of the floor tiles. In the lower border is an animal with long quills or bristles, possibly the porcupine of chastity, but more likely an emblem of Barbara's patronage of a variety of trades related to hair or bristles, because of a crude Latin pun on her name. [M–p.298]

tuos mirabiliter collocasti. tri
bue quesumus: ut eius meritis
et precibus ad montem qui xpe
est peruenire valeamus. P do.

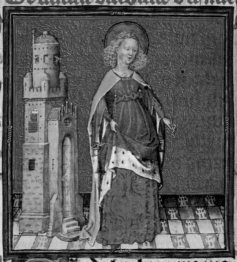

Aude barbara regina.
summa pollens in doc
trina xpisti magisterio. Gau

147. *Saint Agnes.*

As an embodiment of chastity, Agnes is accompanied by a small lamb, symbol of purity and a pun upon her name (*agnus* in Latin). She wears a garland of flowers around her head and carries a book and a martyr's palm. The border is formed of an elaborate piece of jewelry, probably a necklace, consisting of five engraved gold medallions, set with rubies and pearls and joined together by a multicolored band with several rows of pearls. This object is explained by the legend of Agnes, according to which she once preserved her chastity against the advances of a man seeking to tempt her with jewels by claiming to have a fiancé who had already given her "an invaluable bracelet" and a "necklace of precious stones." [M–p.300]

ceteras illustrare dignatus es. pre
tende ineffabilem misericordiã
tuam. nobis et langue ita deuo
tum eidem habere famulatũ.
ut diuinas gracias suscipiam?
quas omnibus ipsã colentibʒ
promeruit specialiter impetrare.
Ã do. Agnetis virgis et mris.

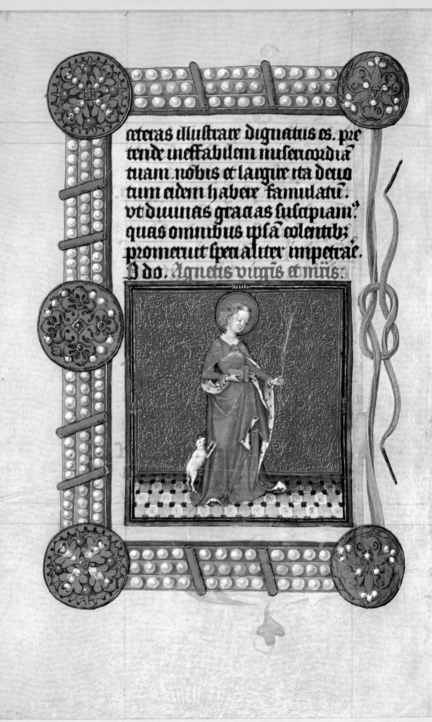

148. *Saint Dorothy.*

According to legend, Dorothy, on the way to her martyrdom, promised a doubting pagan scribe that she would send him flowers and fruits from Paradise. This story accounts for the garland of flowers in her hair and the golden basket of fruit in her hand. The backdrop is an unusual cherry-colored textile with elaborate patterns in black, gold, and white. Around the page is a bower of gold-leaved vines and gold latticework, while below, the garden of Paradise, enclosed by a low brick wall, contains two music-making angels and a castellated well or fountain, from which flow two of the rivers of Paradise.

[M–p.302]

et uíste uíuendo cum omníű bono
rum operum perseuerantía. ad íp
síus miserícordiam merear peruc
níre quem dílexíst mente et pu
ro corde. Quí cum patre et spíu sco
uíuít et regnat deus. per omnía
secula seculorum. Amen. De sca
dorothea uírgíne et mr. Ant

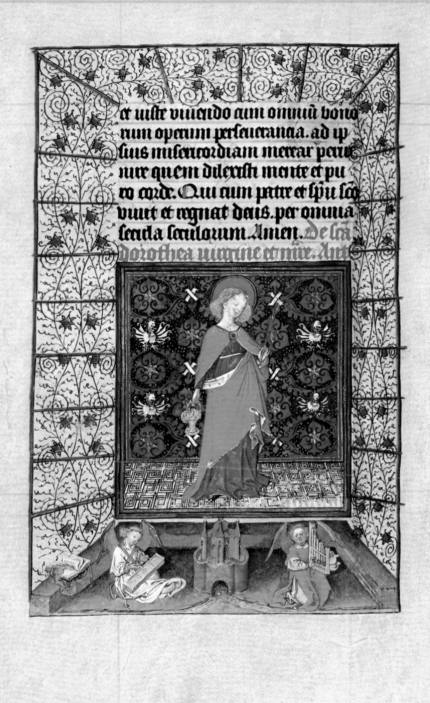

149. *Saint Apollonia.*

Although she carries a martyr's palm and wears a crown, the saint bears only one attribute of her own martyrdom, a tooth held in long iron pincers. In the black floor tiles are shown crouching and barking dogs, a motif that has no apparent connection with Apollonia. [M–p.304]

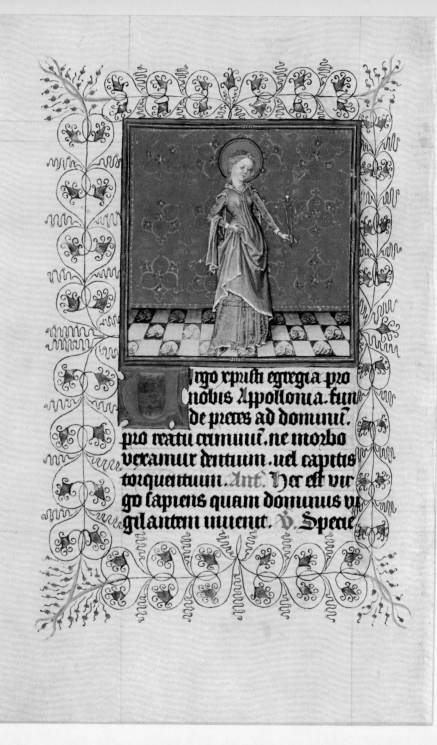

irgo xpisti egregia pro
nobis Appollonia. fun
de preces ad dominu.
pro reatu criminis. ne morbo
vexamur dentium. uel capitis
torqueamur. Ant. Her est vir
go sapiens quam dominus vi
gilantem inuenit. V. Specie

150. *Saint Agatha.*

Like Saint Apollonia, Agatha holds her attribute, a severed breast, with iron pincers. She stands against a dark crimson textile on which is represented a repeated motif in gold of a phoenix rising in flames toward a burning sun. This motif is appropriate to Agatha, known as the fire maiden through her association with volcanos and lava and her patronage of forging and casting. Reference to this patronage is to be found in the border: in her monograms wrought of gold, in the gold and enamel jewelry, and in gift-wrapped boxes of jewels. Also in the border are careful imitations of various kinds of weaving, another craft of which Agatha was a patroness. A leaf with Saint Margaret's portrait and part of her Suffrage originally followed this page. [M–p.306]

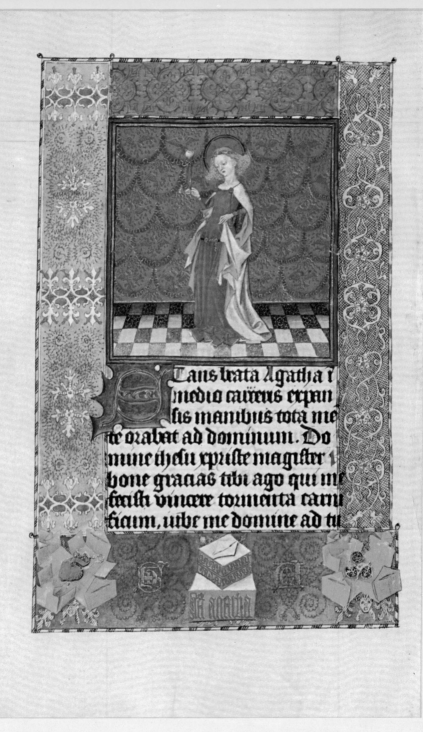

Lans beata Agatha i
medio carceris erpan
sis manibus tota mé
te orabat ad dominum. Do
mine ihesu rpiste magister
bone gracias tibi ago qui me
fecisti vincere tormenta carni
ficium, iube me domine ad tu

151. *Saint Cecilia.*

Deprived of her traditional attributes—musical instruments, garland, caldron, and sword—Cecilia holds a hawk on her gloved hand, feeding it meat held on a short stick. The theme of hawking continues in the textile background, which has the repeated motif of a winged boy holding a white hawk, and in the border of four large feathers charged with the gold letters C or E and D (as in nos. 116 and 121) linked by chains. Suspended from the chains are the paired wings of falconry lures, which are used for feeding the hawk and for enticing the bird back to the falconer. These letters and lures are represented as actual objects, for the little rings and straps by which they are attached and suspended are rendered in specific detail. Certainly these elements relate Catherine of Cleves to falconry and to Saint Cecilia, but the explanations for this connection and for this special iconography of the saint remain to be found. [M–p.308]

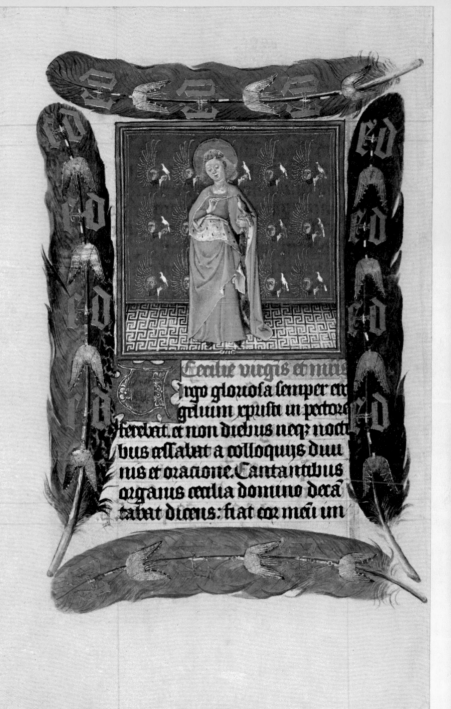

Cecilie virgis et mar
irgo gloriosa semper eu⟨an⟩
gelium xpisti in pectore
ferebat. et non diebus neq⟨ue⟩ noct⟨i⟩
bus cessabat a colloquiis diui
nis et oracione. Cantantibus
organis cecilia domino deca
tabat dicens: fiat cor meu⟨m⟩ im

152. *Saint Lucy.*

Lucy, her neck pierced by the sword of her martyrdom, carries the martyr's palm and a book covered in loose envelope-binding. Behind the saint hangs a textile with striking rosette patterns whose motifs, enlarged and transformed, have been used again in the border to make a necklace or girdle of silver conch-shaped units. To these units are attached gold tags bearing the legend *Luciae Virginis,* but the significance of the possessive form, "of Lucy the Virgin," is uncertain. [M−p.313]

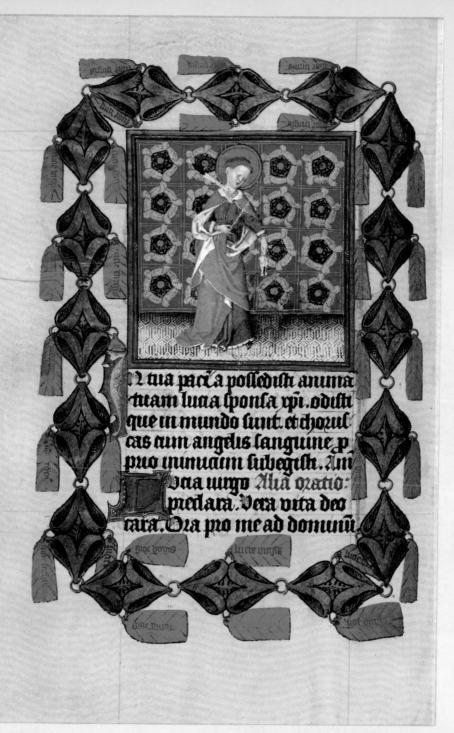

153. *Saint Scholastica.*

Wearing the habit of a Benedictine abbess, the order founded by her twin brother with her help, Scholastica holds a crozier and an open book, probably containing her rule. The usual attribute of a dove, the form in which she ascended to heaven after her death, is lacking, but in the border is an antithetical scene of two boys snaring a bird, though not a dove.

[M–p.313]

Raudi nos deus salu
taris noster. ut sicut de
beate luce virginis tue
commemoratione gaudem? ita
pie deuotionis erudiamur affec
tu. Per x." Scolastice virgis a

Egnum mundi et om
nem onatum seculi co

154. *Saint Gertrude.*

In front of a glowing red and gold textile Gertrude stands reading a book, holding the crozier of an abbess, and dressed in the habit of an Augustinian nun. Because she was a protectress against mice and rats, the pale blue floor tiles show black silhouetted rodents, and the brown tiles have schematic representations of mousetraps. In the lower border is a scene, set within a fenced garden, of a demon rousing a musing or sleeping peddler whose pack of gold he has just stolen. Behind the peddler are his staff and shield, the latter decorated with a minute image of a woman, probably Saint Gertrude, who was also a protectress of travelers. [M–p.315]

Ancte gertrudis virgo
xpisti gloriosa supplex
ac tremens ego humi
limus rogo vt me adiuues cū
tua virtute et virginitate mag
na. Peccaui nimis o sancta gee
trudis et coram angelis dei pec
cata mea non sunt abscondita

155. *Saint Martha, Sister of Lazarus.*

The "hostess of the Saviour" is represented as a housewife or kitchen maid with an apron, pot of steaming soup, and ladle. Letters, written in capitals, decorate the black tiles of the floor, but their function seems merely ornamental. The spinning female saint in the border seems also to be Martha, for although she is dressed differently, she wears an apron, and her bundle of wool is marked by the letter M. [M–p.316]

Depreror ergo vt sis interuetitir
ad dominum nostrum quia ni
mia sunt peccata mea. vt nuchi
det ueniam omniū peccator me
orum presentiū preteritoz et fu
turorum. Per eum qui uenturꝰ
est iudicare uiuos et mortuos et
seculum per ignē. Amē. De sāc
ta martha soronis lazari An.

156. *Saint Helena.*

Portrayed as an older woman with a wimple, the mother of Constantine wears a gold crown; she holds a book and the cross which was found and recognized by her almost three centuries after the Crucifixion. The reddish-purple textile behind her is decorated with gold motifs, the crossed whips of the flagellation and the crown of thorns encircling the abbreviated name of Jesus. [M–p.318]

bir indidisti. quo per martiru
palmā ad superne contemplati
onis pertingere gloriam. da que
sumus earum intercessionibʒ
nos adiuuari. quas transcen
so mortis stadio in celestibus
secisti triumphare. Per r. do.
Helene regine uirginis. Antiph

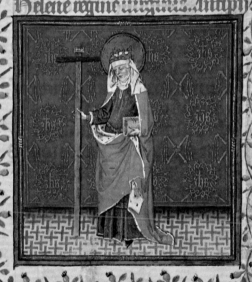

157. *Saint Elizabeth.*

As the embodiment of charity, Elizabeth is surrounded by three beggars; she assists one of them, a crippled man, to put on the shirt she has just given him. The other two reach up toward her, one with an open hand and the other with a begging bowl. As a gesture of humility she has removed her crown, but she is dressed in expensive, though simple, clothes rather than in the humble Franciscan habit in which she is often shown.

[M–p.321]

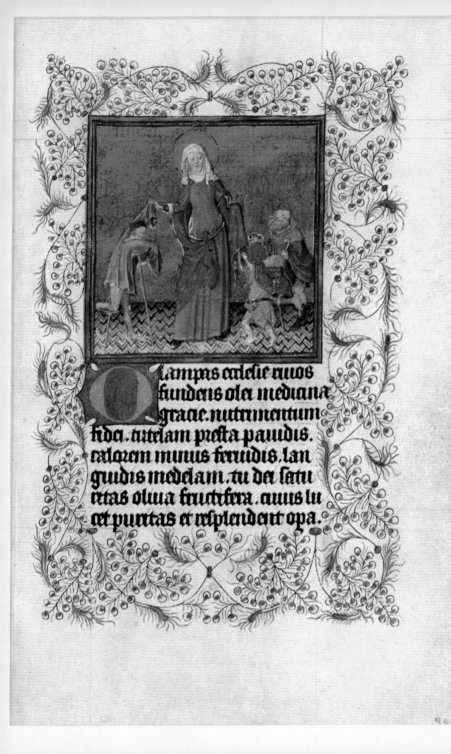

Lampas ecclesie riuos
ofundens olei mediana
gracie. nutrimentum
fidei. tutelam presta pauidis.
calorem minus feruidis. lan
guidis medelam. tu dei satu
ritas oliua fructifera. cuius lu
cet puritas et resplendent opa.

TEXT PAGES – 158, 159, 160.

Three Different Styles of Decoration.

Unlike the elaborately decorated text pages in some contemporary French, Flemish, and Dutch manuscripts, these margins are relatively free of decoration. The warm ivory tones of their exceptionally fine vellum serve thereby as a rich, resonant background for the black, densely written script. Even the lavender or purple rulings play a conscious role in the design of the pages. It should be noted that the margins were somewhat larger originally and thus more effective, for the outer edges have been trimmed by at least a quarter of an inch in subsequent rebindings.

All text pages are either embellished with penwork flourishes or illuminated by a vertical bar from the ends of which two horizontal leaves or flowers grow into the upper and lower margins. The penwork flourishes develop out of the minor initials of the text, marking the beginnings of brief passages or verses, and the illuminated, that is, painted, leaves are connected with the major initials marking the larger textual divisions. Within the limited scope of the decoration, the artists—there are at least three distinct hands—created a remarkable variety. These artists were probably assistants in the master's shop, although one of them, the particularly fine hand of plate 158, is very close to the master in style and may have been responsible for some of the later manuscripts now associated with the Cleves Master.

Plate 158 is from the Friday Hours of the Compassion of God; plate 159, from the Mass of the Dead; and plate 160, from the Monday Hours for the Dead.

[M–p.103, M–p.46, G–f.103v]

neq; absorbeat me profundū: neq;
vrgeat super me puteus os suum.
raudi me domine quoniā
benigna est misericordia tua: se
cundum multitudinē miserati
onū tuarum respice in me.
loria patri et filio et spū
sancto. icut erat in princi
pio et nunc et semper. et in secula
seculoz amē. Ant. emo
te condempnauit mulier nemo
domine. nec ego te condempna
bo: iam amplius noli peccare.
dit deus opera Capl.
eorum quia conuersi
sunt a via sua mala.
et misertus est super maliciā quā
loautus fuerat ut faceret eis et
non fecit. Deo gracias. espm
eus misereatur nostri. Et

fuerit viuet. Et omnis qui vi
uit et credit in me: non morietur
in eternum. Credis hoc? Ait illi.
Utiqz domine. Ego credidi qa
tu es xpistus filius dei viui: q
in hunc mundu uenisti. Deo
gracias. Domine exaudi
oracionem mea. Et clamor me
us ad te ueniat. Orem? Offertt
Domine thesu xpiste rex
glorie libera animas omniu
fidelium defunctorum de ma
nu inferni et de profundo lacu
libera eas de ore leonis ne ab
sorbeat eas tartarus ne cadant
in obscura sed signifer sanctus
michael representet eas in luce
sancta. Quam olim abrahe
promisisti et semini eius. vs
Hostias ac preces tibi domine

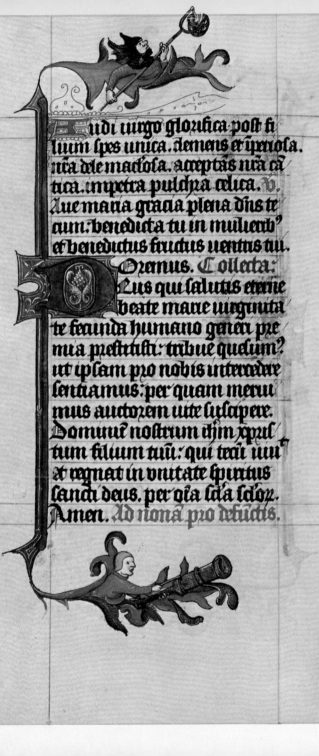

udi uirgo glorifica poſt fi
lium ſpes unica. clemens et iperioſa.
nra dele maculoſa. acceptas nra cā
tica. impetra pulchra celica. v̄.
Aue maria gracia plena dn̄s te
cum. benedicta tu in mulierib'
et benedictus fructus uentris tui.

Oremus. Collecta:
Eus qui ſalutis eterne
beate marie uirginita
te fecunda humano generi pre
mia preſtitiſti: tribue quesum'
ut ipſam pro nobis intercedere
ſentiamus: per quam merui
mus auctorem uite ſuſcipere.
Dominum noſtrum ihm xpūſ
tum filium tuū: qui tecū uiu
et regnat in unitate ſpiritus
ſancti deus. per ōīa ſēc̄a ſēc̄oꝝ.
Amen. Ad nonam pro defūctis.

APPENDICES

GUENNOL VOLUME: Guennol Collection, New York. 193 leaves (present foliation in upper corners ends on folio 192, because one leaf between folios 51 and 52 is unnumbered; also an earlier pagination in lower corners, which postdates the division of the manuscript). Leaves are 7 9/16 x 5 1/8 inches (192 x 130 mm); text area is 4 3/16 x 2 7/16 inches (105 x 62 mm). 20 lines per page. 27 gatherings, normally of 8 leaves; often with catchwords, all of which appear to be by the same hand, but not by the scribe. Some notes in black ink in the gutters, most of which are directions for the rubricator. Latin texts, whole or part: Hours of the Virgin, Hours of the Cross, Sunday Hours and Mass of the Trinity, Monday Hours of the Dead, Tuesday Mass of the Holy Ghost, Wednesday Hours and Mass of All Saints, Thursday Hours and Mass of the Sacrament, Penitential Psalms, and Office of the Dead. 63 miniatures, 15 large (about 6 x 4 1/4 inches with borders) and 48 small (2 3/8 x 2 1/2 inches without borders), listed by plate numbers used here: 1–3, 5–13, 15, 17–19, 21–40, 42–48, 60–61, 63–67, 69–78, 98–100. Most text pages decorated with illuminated and penwork initials, with simple illuminated or penwork line endings, with penwork flourishes and occasional drawings, and with a border decoration consisting of a vertical illuminated bar in the left margin from which a leaf extends horizontally in the upper and lower margins.

MORGAN VOLUME: M. 917, The Pierpont Morgan Library, New York. 164 leaves (numbered 1–327, odd numbers only, in present pagination in lower right corner of each recto; an earlier pagination in upper right was made after the initial division of the manuscript, but while the Guennol portion was still available, and before the final inclusion of three leaves from the Hours of All Saints [pp. 39–44] and of four text-less leaves with large miniatures [pp. 38, 120, 144, 180]). Measurements and number of lines are identical with Guennol. 28 gatherings, varying from 2 to 8 + 1

leaves; often with catchwords, all by the same hand as Guennol, except those on page 172 which appear to be by the scribe. Same notes in gutter as Guennol. Two lines of Dutch (pp. 38 and 75), otherwise Latin texts: calendar, Mass of the Dead, Tuesday Hours of the Holy Ghost, Wednesday Hours of All Saints, Friday Hours of the Compassion of God and Mass of the Cross, Saturday Hours and Mass of the Virgin, Office of the Dead, and Suffrages. 94 miniatures, 10 large and 84 small (same measurements as Guennol), listed here by plate numbers, but arranged according to their order in the Morgan volume: 49–50, 20, 62, 68, 51–54, 56–59, 55, 79–86, 16, 87–89, 4, 91, 90, 92–94, 14, 95–97, 41, 101–157. Decoration of text pages as in Guennol.

Detailed Reconstruction of Manuscript

ORIGINAL GATHERING	NO. OF LEAVES ORIGINALLY	VOLUME	PAGE OR FOLIO NUMBERS [−1] = Leaf now missing*	TEXT H = Hours M = Matins T = Terce V = Vespers Ms = Mass L = Lauds S = Sext C = Compline O = Office P = Prime N = None	MINIATURES Plate numbers H = Hypothetical missing miniature*
I	6	M	pp.1–10 [−1]	two blanks (first missing), calendar	
II	8	M	pp.11–26	calendar	
III	8+1	G	ff.1–9	H–Virgin (M)	1–2
IV	8+1	G	ff.10–17 [−1]	H–Virgin (M,L)	H,3
V	8+1	G M	ff.18–25 pp.143–4	H–Virgin (L,P,T)	4–7
VI	8	G	ff.26–33	H–Virgin (T,S,N)	8–11
VII	8+1	G M	ff.34–41 pp.155–6	H–Virgin (N,V)	12–14
VIII	8+1	G M	ff.42–9 pp.119–20	H–Virgin (C). H–Cross (M)	15–17
IX	8	G	ff.50–6(51 bis)	H–Cross (M,L)	18–19
X	8+2	G M	ff.57–65 pp.37–8	H–Cross (L,P,T,S)	20–25
XI	8	G	ff.66–73	H–Cross (N,V)	26–30
XII	8	G	ff.74–81	H–Cross (C). H–Trinity (M,P)	31–34

*Of the twelve leaves listed as now missing, one was blank; seven are conjectural leaves with one blank page and one full-page miniature, whose existence is predicated on the consistency of the program of illustration; four leaves are certainly missing from the Suffrages, as is indicated by the gatherings and by the missing texts between M pp. 256–7, 286–7, 306–7, and 316–7; the first and third of these four leaves must have had portraits of Saints Quirinus and Margaret.

ORIGINAL GATHERING	NO. OF LEAVES ORIGINALLY	VOLUME	PAGE OR FOLIO NUMBERS [−1] = Leaf now missing*	TEXT H = Hours M = Matins T = Terce V = Vespers Ms = Mass L = Lauds S = Sext C = Compline O = Office P = Prime N = None	MINIATURES Plate numbers H = Hypothetical missing miniature*
XIII	8	G	ff.82–9	H–Trinity (T,S,N,V,C)	35–39
XIV	8+2	G M	ff.90–7 [−1] pp.179–80	Ms–Trinity. H–Dead (M)	H,40–42
XV	8	G	ff.98–105	H–Dead (M,P,T,S,N,V)	43–47
XVI	8+1	G M	ff.106–8 pp.27–34,45–8	H–Dead (V,C). Ms–Dead	48–50
XVII	8	M	pp.49–60, 35–6,73–4	Ms–Dead. H–Holy Ghost (M,P,T,S)	51–55
XVIII	8	M G	pp.61–72 ff.109–10	H–Holy Ghost (S,N,V,C) Ms–Holy Ghost	56–60
XIX	8	G M	ff.111–6 pp.39–42	Ms–Holy Ghost H–All Sts. (M,P)	61–63
XX	8	G M	ff.117–23 pp.43–4	H–All Sts. (P,T,S,N,V,C)	64–68
XXI	8+2	G	ff.124–31 [−2]	Ms–All Sts. H–Sacrament (M)	H,69,H,70
XXII	8	G	ff.132–9	H–Sacrament (M,P,T,S,N,V)	71–75
XXIII	8	G	ff.140–7	H–Sacrament (V,C). Ms–Sacrament	76–78
XXIV	8+1	G M	ff.148–50 [−1] pp.75–84	Ms–Sacrament. H–Compassion (M)	H,79
XXV	8	M	pp.85–100	H–Compassion (L,P,T)	80–82
XXVI	8	M	pp.101–16	H–Compassion (S,N,V,C)	83–86

ORIGINAL GATHERING	NO. OF LEAVES ORIGINALLY	VOLUME	PAGE OR FOLIO NUMBERS [−1] = Leaf now missing*	TEXT H = Hours M = Matins T = Terce V = Vespers Ms = Mass L = Lauds S = Sext C = Compline O = Office P = Prime N = None	MINIATURES Plate numbers H = Hypothetical missing miniature*
XXVII	8+2	M	pp.117–34 [−1]	H–Compassion (C). Ms–Cross	H,87
XXVIII	8+1	M	pp.135–42, 145–54	Ms–Cross. Sat. H–Virgin (M,P,T,S,N,V)	88–94
XXIX	8	M	pp.157–72	Sat. H–Virgin (V,C), Sat. Ms–Virgin	95–97
XXX	3	M	pp.173–8	Sat. Ms–Virgin	
XXXI	8+1	G	ff.151–8 [−1]	Penitential Pss.	H,98
XXXII	8	G	ff.159–66	Penitential Pss.	
XXXIII	8+1	G	ff.167–75	Penitential Pss. O–Dead	99–100
XXXIV	8	G	ff.176–83	O–Dead	
XXXV	8	G	ff.184–91	O–Dead	
XXXVI	8	G M	f.192 pp.181–94	O–Dead	
XXXVII	8	M	pp.195–210	O–Dead. Suffrages	101–104
XXXVIII	8	M	pp.211–26	Suffrages	105–111
XXXIX	8	M	pp.227–42	Suffrages	112–118
XL	8	M	pp.243–56 [−1]	Suffrages	119–124,H
XLI	8	M	pp.257–72	Suffrages	125–132
XLII	8	M	pp.273–86 [−1]	Suffrages	133–139
XLIII	8	M	pp.287–302	Suffrages	140–148
XLIV	8	M	pp.303–16 [−1]	Suffrages	149–150,H. 151–155
XLV	6+1	M	pp.317–28 [−1]	Suffrages, blank	156–157

351

The feasts are transcribed as they appear in the calendar, except that abbreviated words are spelled out, and letters i and j, u and v are normalized. Ordinary feasts in the calendar were written in black, and red was used for major feasts, which are here printed in SMALL CAPITALS; there are no other distinctions of grading in the calendar. In this transcription the golden numbers, dominical letters, and notes on the solar and lunar months are omitted.

JANUARY

1. CIRCUMCISIO DOMINI
2. Octava Sancti Stephani
3. Octava Sancti Johannis
4. Octava Sanctorum Innocentum
5. Vigilia
6. EPYPHANIA DOMINI
7. Ysidori martiris
8. Eugenii episcopi et martiris
9. Juliani martiris
10. Pauli primi hermite
11.
12. Johannis pape
13. Octava Epyphanie
14. PONCIANI MARTIRIS
15.
16. Marcelli pape
17. Anthonii abbatis
18. Prisce virginis
19. Marii et marthe
20. Fabiani et Sebastiani
21. AGNETIS VIRGINIS
22.
23. Emerentiane virginis
24. Tymothei apostoli
25. CONVERSIO PAULI
26. Policarpi martiris
27. Johannis crisostomi
28. Octava Agnetis
29. Valerii episcopi
30. Aldegundis virginis
31. Ignatii episcopi

FEBRUARY

1. Brigide virginis
2. PURIFICATIO BEATE MARIE
3. Blasii episcopi
4.
5. Agathe virginis et martiris
6. Amandi et Vedasti
7.
8. Helene virginis
9. Appollonie virginis
10. Scolastice virginis
11.
12. Dorothee virginis
13.
14. Valentini martiris
15. Faustine virginis
16. Juliane virginis
17.
18. Symeonis confessoris
19. Gabini pape
20. Eucharii episcopi
21.
22. CATHEDRA SANCTI PETRI
23. Vigilia
24. MATHIE APOSTOLI
25.
26. Alexandri episcopi
27.
28. Romanii episcopi

MARCH

1. Albini episcopi et confessoris
2. Lucii episcopi
3.
4. David confessoris
5. Foce martiris
6.
7. Perpetue et Felicitatis
8.
9.
10. Clodonii Abbatis
11. Gorgonii martiris
12. Gregorii pape et confessoris
13. Leonis pape et confessoris
14. Innocentius papa
15. Longini martiris
16. Hylarii episcopi et confessoris
17. GERTRUDIS VIRGINIS
18.
19. Johannis heremite
20.
21. Benedicti abbatis
22.
23.
24.
25. ANNUNCIATIO MARIE
26.
27. RESURRECTIO DOMINICA
28. Guntrami regis
29. Gregorii pape
30. Domicii episcopi
31. Sabine virginis

APRIL

1. Walrici episcopi
2. Nychasii episcopi
3.
4. Ambrosii episcopi
5. Claudiani confessoris
6.
7.
8. Celestini pape
9. Marie egypciace
10. Appollonii presbiteri
11. Leonis pape et confessoris
12.

13. Eufemie virginis
14. Tyburcii et Valeriani
15. Helene regine
16. Kalixti pape
17. Petri confessoris
18.
19. Anthonii martiris
20.
21.
22. Gay pape
23. Georgii martiris
24. Sydrac. Misaac. Abdenago
25. Marci ewangeliste
26. Cleti pape et martiris
27. Anastasii pape
28. Vitalis martiris
29. Petri mediolanum
30. Sophie virginis

MAY

1. PHILIPPI ET JACOBI APOSTOLORUM
2. Athanasii episcopi
3. INVENTIO SANCTE CRUCIS
4.
5.
6. Johannis ante portam latinam
7. Juvenalis martiris
8. Wyrronis episcopi et confessoris
9. Gengulfi martiris
10. Gordiani et Epymachi
11.
12. PANCRATII MARTIRIS
13. SERVACII EPISCOPI
14.
15. Ysidori martiris
16. Peregrini episcopi et confessoris
17.
18.
19. Potentiane virginis
20.
21. Valerii episcopi
22.
23.
24.
25. Urbani pape
26.
27. Bede presbiteri

28.
29. Maximini episcopi
30. Felicis pape
31. Petronille virginis

JUNE

1. Nychomedis martiris
2. Marcellini et petri
3. Erasmi episcopi et martiris
4.
5. BONIFACII EPISCOPI
6.
7.
8. Medardi episcopi
9. Primi et Feliciani
10.
11. Barnabe apostoli
12. ODULFI CONFESSORIS. Cunera
13.
14. Valerii episcopi
15. Viti et modesti
16. Aurei et iustine
17.
18.
19. Gervasii et Prothasii
20. Regine virginis
21.
22. Decem milium martirum
23. Vigilia
24. NATIVITAS JOHANNIS BAPTISTE
25. LEBUINI CONFESSORIS
26. Johannis et pauli
27. Septem dormientium
28. Vigilia
29. PASSIO PETRI ET PAULI
30. Commemoratio pauli

JULY

1. Octava Sancti Johannis baptiste
2. VISITATIO MARIE. Processus
3. Translatio Sancti Thome
4. TRANSLATIO MARTINI
5. Nychomedis martiris
6. Octava Petri et Pauli
7.

8. Translatio Barbare
9. Octava Visitationis
10. Septem fratrum martirum
11. Translatio Benedicti
12.
13. Margarete virginis
14.
15. Divisio apostolorum
16. Hylarii episcopi
17. Alexis confessoris
18. Frederici episcopi et martiris
19.
20.
21. Praxedis virginis
22. MARIE MAGDALENE
23. Appollinaris martiris
24. Cristine virginis. Vigilia
25. JACOBI APOSTOLI. Cristofel
26. Jacincti martiris
27.
28. Panthaleonis martiris
29.
30. Abdon et Sennes
31. Germani episcopi et confessoris

AUGUST

1. AD VINCULA SANCTI PETRI
2. Stephani pape et martiris
3. Inventio Sancti Stephani
4. Justini presbiteri
5. Marie Ad nives
6. Sixti pape et martiris
7. Transfiguratio christi
8.
9. Vigilia
10. LAURENTII MARTIRIS
11. Tyburcii martyris
12.
13. Ypoliti martiris
14. Vigilia
15. ASSUMPTIO MARIE VIRGINIS
16. Arnulfi confessoris
17. Octava Sancti Laurentii
18. Agapiti martiris
19.
20. Bernardi Abbatis
21.
22. Octava Assumptionis

23. Vigilia
24. BARTHOLOMEI APOSTOLI
25. Gregorii episcopi Traiectensis
26.
27. Rufi martiris
28. Augustini episcopi
29. DECOLLATIO JOHANNIS BAPTISTE
30. Felicis et Adaucti
31. Paulini episcopi

SEPTEMBER

1. Egidii Abbatis
2. Translatio Agnetis
3. Remacli martiris
4. Marcelli martiris
5. NATIVITAS MARIE
6. Magni confessoris
7. Evorcii episcopi et confessoris
8.
9. Gorgonii martiris
10. Othgeri confessoris
11. Prothi et Jacincti
12.
13.
14. EXALTATIO SANCTE CRUCIS
15. Nychomedis martiris
16. Eufemie virginis
17. LAMBERTI EPISCOPI
18. Columbani confessoris
19.
20. Dyonisii episcopi. Vigilia
21. MATHEI APOSTOLI ET
 EWANGELISTE
22. MAURICII ET SOCIORUM EIUS
23. Tecle virginis
24. Conceptio Johannis baptiste
25.
26.
27. Cosme et Damiani
28.
29. MICHAELIS ARCHANGELI
30. Jheronimi presbiteri

OCTOBER

1. REMIGII ET BAVONIS

2. Leodegarii episcopi
3. Duorum ewaldorum
4. Francisci confessoris
5. Appollinaris episcopi
6.
7. Marci pape
8.
9. Dyonisii cum sociis tuis
10. GEREONIS ET VICTORIS
11.
12. Felicis presbiteri
13.
14. Kalixti pape
15.
16. Galli confessoris
17. Elyfii martiris
18. Luce ewangeliste
19.
20. Quirini martiris
21. Undena milia virginum
22. Severi episcopi
23. Severini Archiepiscopi
24.
25. Crispini et crispiniani
26.
27. Vigilia
28. SYMONIS ET JUDE
29.
30.
31. Vigilia

NOVEMBER

1. FESTIVITAS OMNIUM SANCTORUM
2. COMMEMORATIO ANIMARUM
3. Huberti episcopi
4. Modeste virginis
5. Felicis presbiteri
6. Leonardi Abbatis
7. WILLIBRORDI EPISCOPI
8. Quatuor coronatorum
9. Theodori martiris
10. Martini pape
11. MARTINI EPISCOPI
12. LEBUINI CONFESSORIS
13. Brictii episcopi
14.
15.

16. Othmari episcopi et confessoris
17.
18. Octava Sancti Martini
19. Elyzabeth vidue
20.
21. Mauricii Abbatis
22. Cecilie virginis
23. Clementis pape
24. Crisogoni martiris
25. KATHERINE VIRGINIS
26. Lini pape
27. Vitalis martiris
28.
29. Vigilia
30. ANDREE APOSTOLI

DECEMBER

1. Eligii episcopi et confessoris
2. Veri et Severi fratrum
3.
4. Barbare virginis
5.
6. NYCHOLAI EPISCOPI
7. Octava Sancti Andree

8. CONCEPTIO MARIE VIRGINIS
9.
10.
11. Damasi pape
12.
13. Lucie virginis
14. Nychasii episcopi
15. Maximini episcopi
16. Valentini episcopi confessoris
17. Ignatii episcopi
18.
19.
20. Vigilia
21. THOME APOSTOLI
22. Dydimi martiris
23. Victorie virginis
24. Vigilia
25. NATIVITAS DOMINI
26. STEPHANI PROTHOMARTIRIS
27. JOHANNIS APOSTOLI ET
 EWANGELISTE
28. SANCTORUM INNOCENTIUM
 MARTIRUM
29. Thome cantuariensis
30. David regis
31. Silvestri pape

Litany. "Letania Maior"

Only the lists of saints, beginning with the apostles, are transcribed here. The names are spelled as in the manuscript, except that the letters i and j, u and v are normalized.

Petre
Paule
Andrea
Jacobe
Johannes
Thoma
Jacobe
Philippe
Bartholomee
Mathee
Symon
Thadee
Mathia
Barnaba
Luca
Marce
Omnes sancti apostoli
 et ewangeliste
Omnes sancti discipuli
 domini
Omnes sancti inno-
 centes
Stephane
Line
Clete
Clemens
Sixte
Corneli
Cypriane
Laurenti
Vincenti
Crisogone

Johannes
Paule
Cosma
Damiane
Ignati
Alexander
Marcelline
Petre
Fabiane
Sebastiane
Ponciane
Lamberte
Dyonisi cum
 sociis tuis
Bonifati cum
 sociis tuis
Mauriti cum
 sociis tuis
Gereon cum
 sociis tuis
Omnes sancti
 martires
Augustine
Martine
Silvester
Leo
Gregori
Ambrosi
Jheronime
Nicholae
Remigi
Hylari

Servati
Willibrorde
Benedicte
Egidi
Bernarde
Francisce
Dominice
Anthoni
Odulphe
Lebuine
Omnes sancti
 confessores
Maria Magdalena
Felicitas
Perpetua
Agatha
Lucia
Agnes
Cecilia
Anastasia
Scolastica
Walburga
Ghertrudis
Margareta
Katherina
Barbara
Ursula cum sodalibus
 tuis
Elyzabeth
Omnes sancte virgines
 vidue et continentes
Omnes sancti

APPENDIX D *Selective Bibliography*

This bibliography includes only the most prominent works on the Cleves Hours and the Master of Catherine of Cleves.

AMSTERDAM, RIJKSMUSEUM. *Middeleeuwse Kunst der noordelijke Nederlanden.* Amsterdam, 1958. Pp. 19–20, 30, 119–20, 122–27; figs. 83–84.

BEISSEL, S. "Un Livre d'Heures appartenant à S. A. le duc d'Arenberg à Bruxelles: Etude iconographique," *Revue de l'art chrétien,* ser. 4, vol. XV (1904), pp. 437–47.

BYVANCK, A. W. *La Miniature dans les Pays-Bas Septentrionaux.* Paris, 1937. Pp. 65–70, 117–18, 141, 142–43, 145, 146, 149–50, 160; figs. 130–52.

BYVANCK, A. W. and HOOGEWERFF, G. J. *La Miniature hollandaise.* The Hague, 1922–26. Pp. xxii, 12–13, 21–24, 28–29; figs. 40–48, 55; pls. 25–27, 63–64, 85–90, 110–11, 184, 205–6.

DELAISSE, L. M. J. *A Century of Dutch Illumination.* Berkeley, California [1966].

GORISSEN, F. "Historische-heraldische Betrachtungen über ein Stundenbuch der Katharina von Kleve, Herzogin von Geldern," *Gelre: Bijdragen en Mededelingen,* LVII (1958), pp. 201–18, 2 figs.

GORISSEN, F. "Das Stundenbuch der Katharina von Kleve," *Bulletin van de koninklijke nederlandsche oudheidkundige Bond,* LXIV (1965), pp. 1–7, 4 figs.

HOOGEWERFF, G. J. *De noord-nederlandsche Schilderkunst,* vol. I. The Hague, 1936. Pp. 447–71, figs.

PANOFSKY, E. *Early Netherlandish Painting.* Cambridge, Massachusetts, 1953. Pp. 103ff, 122, 176ff, 242; notes 102[4], 103[7], 118[4]; figs. 128–30.

PIEPER, P. ["Das Stundenbuch der Katharina von Lochorst," *Westfalen,* to be published in the summer of 1966.]

358

PLUMMER, J. *The Book of Hours of Catherine of Cleves.* New York, 1964.

WIT, KEES DE. "Das Horarium der Katharina von Kleve als Quelle für die Geschichte der südniederländischen Tafelmalerei und der nordniederländischen Miniaturen," *Jahrbuch der preuszischen Kunstsammlungen,* LVIII (1937), pp. 114–23, figs.